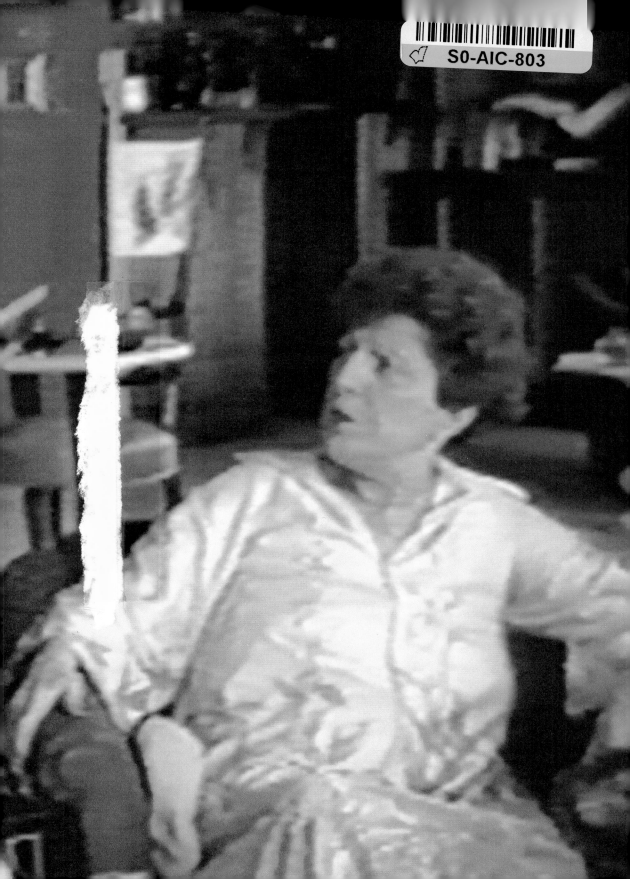

Bertha Alyce: Mother ex**Posed**
Gay Block

I dedicate this book to all daughters and sons,
especially those who didn't learn to love.

And to Malka, who loves.

Photographs and accompanying text
© 2003 by Gay Block

"The Photographs: A Consideration"
© 2003 by Kathleen Stewart Howe

"Hungry" © 2003 by Eugenia Parry

Quote on p. 7 used with permission. From
"Camera Lucida," *Reflections on Photography*
by Roland Barthes, translated by Richard Howard
(NY: Hill and Wang, 1981) p. 96.

René Magritte, "La Viol (The Rape)" 1934 on
p. 283 used with permission from The Menil
Collection, Houston. © 2001 C. Herscovici,
Brussels/Artists Rights Society (ARS), New York.

First edition

Library of Congress Cataloging-in-Publication Data
Block, Gay.
Bertha Alyce: Mother Exposed / Gay Block.
 p. cm.
ISBN 0-8263-3094-0 (pbk. : alk. paper)
1. Mothers—Portraits. 2. Portrait photography.
3. Bertha Alyce—Portraits. 4. Block, Gay.
I. Bertha Alyce. II. Title.
TR681.M67 .B56 2003
779'.2'092—dc21 2002151257

This book is published by the University of
New Mexico Press on the occasion of the
exhibition of *Bertha Alyce: Mother exPosed*
at the University of New Mexico Art Museum,
Albuquerque, New Mexico, July–September 2003.

Bertha Alyce: Mother exPosed
Gay Block

table of contents

redemption

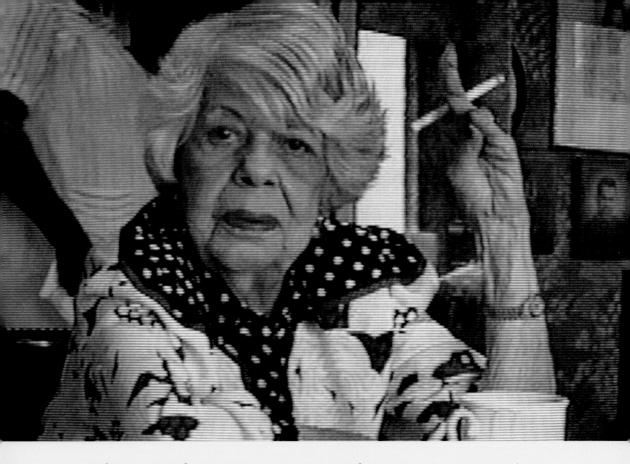

The only question I have is, Why are you writing this book?

I didn't know whether there was something you felt you had to be forgiven for, which flashed through my mind. Maybe you have some guilt? That you felt this might cover up the feelings of guilt between Bertha Alyce and yourself that you must have experienced along the way. I'm just curious. Or whether you were trying to heal some misunderstandings, because as a child I didn't think you and Bertha Alyce were that close. I did feel that there was a schism between the two of you that you might feel that possibly by writing this book you could heal some of the scars that you might have.

— Jean Kaufman, friend

I can't understand it. I can't understand this project. I used to understand you pretty good, Gay. This is nuts! It is, it really is. I don't know what you are looking for. Whether you feel you're going to gain something by it. Something is missing. I know there was something missing. All the time there was something missing. You can't recapture that. It just wasn't there. You don't have to try to justify yourself because you were a good daughter, as good as you could possibly be.

You can't redeem her. I don't think so. Un-uh. I don't think there's anything to redeem. What she was, she was, and she didn't care who knew it. The things she did she did because she wanted to. The good things she did 'cause she wanted to and the bad things she did 'cause she wanted to. I don't see how to redeem it.

— Sabina Block, friend

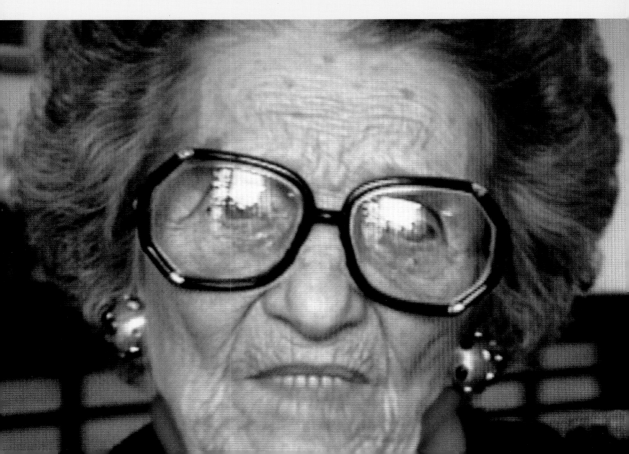

In front of the photograph
of my mother as a child,
I tell myself: she is going to
die: I shudder…over a
catastrophe which has
already occurred. Whether
or not the subject is already
dead, every photograph
is this catastrophe.

— Roland Barthes

mother nude

It's August, 1973, a few days before Mother's sixtieth birthday. I bought a camera yesterday for my first photography course, and now I'm standing in Mother's apartment. I never like visiting her, so I don't really know why I drove here this morning.

The bath water is running and she's on the phone, characteristically nude. I wait. What am I waiting for? I decide to snap one picture. She ignores me but doesn't seem to object. She hangs up and tries to show me some business papers, which don't interest me. I take another picture. Then she starts to pose, so I take another picture, forgetting that I don't really know anything about photographing. But I do know that she's enjoying being photographed. And she's seeing me differently. I've become the camera.

Later, I develop the film and make a few 8 X 10s to show to Mother. She's amused but seems indifferent to them. I hide the negatives and contact strip. I wouldn't want anyone to see I have nude pictures of my mother; somehow it doesn't seem right. Over the years, I search through my early negative books to make sure I can still locate them. Five precious frames. I won't make good prints from them until twenty-three years later, after she has been dead five years.

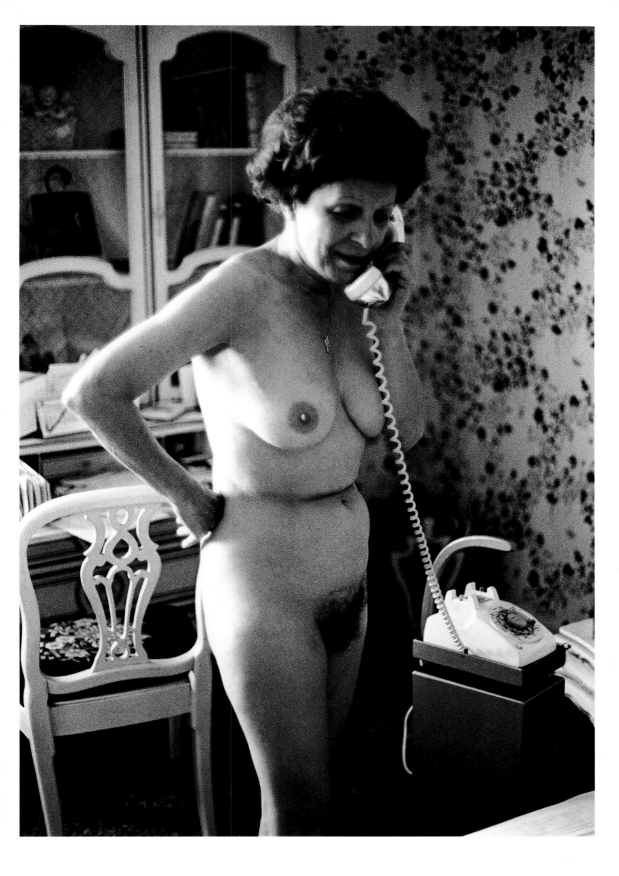

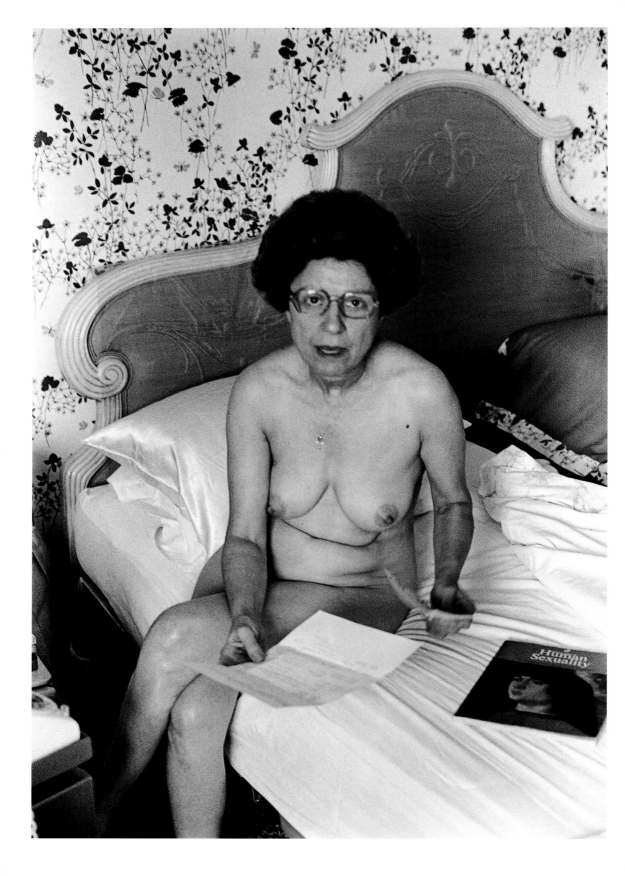

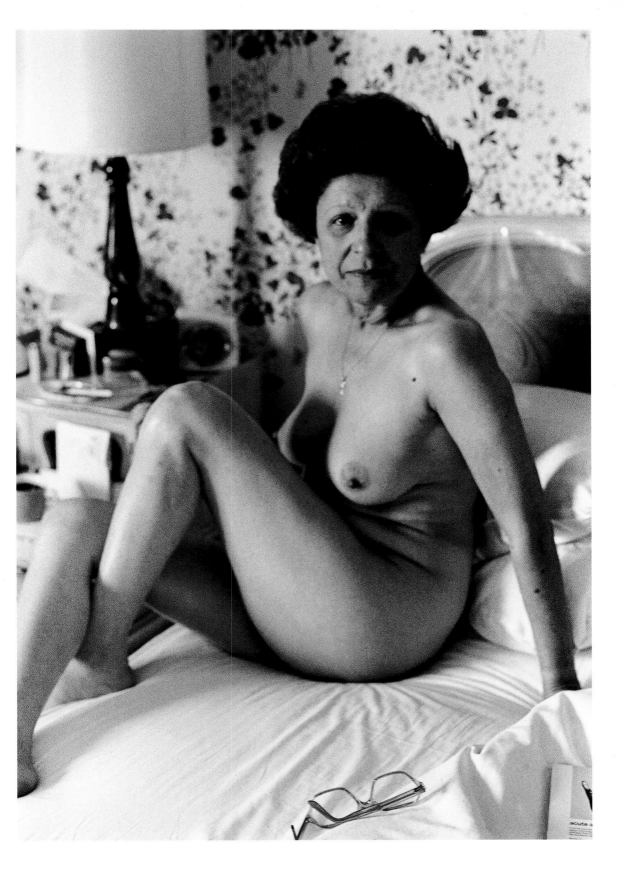

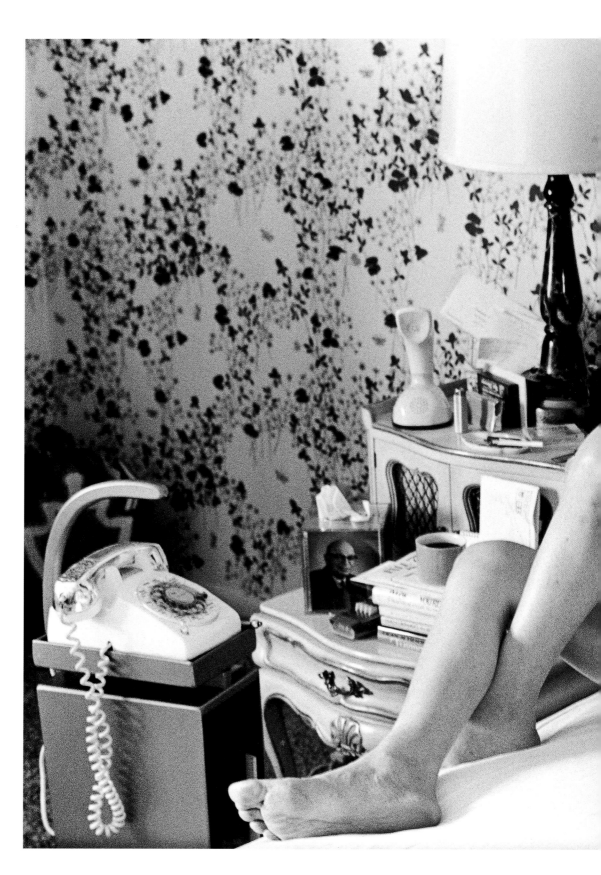

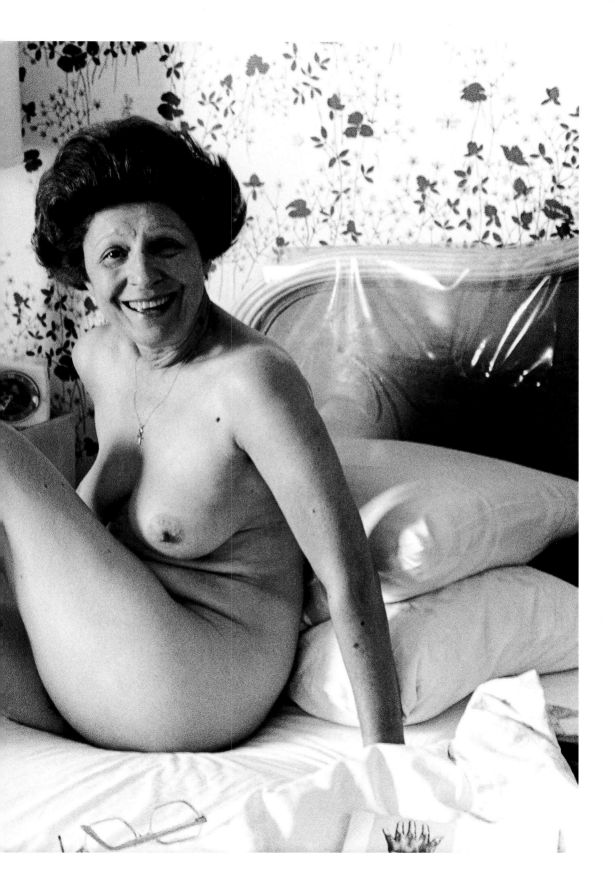

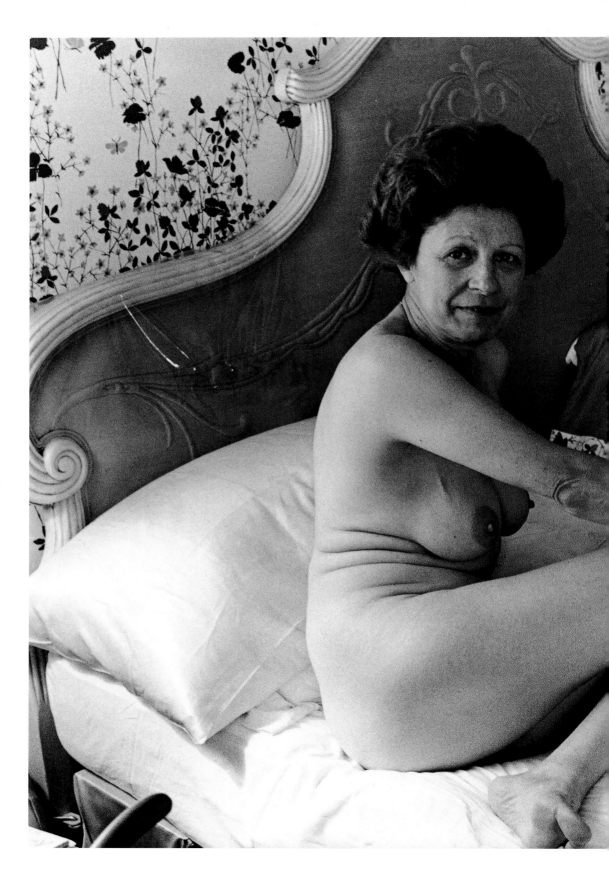

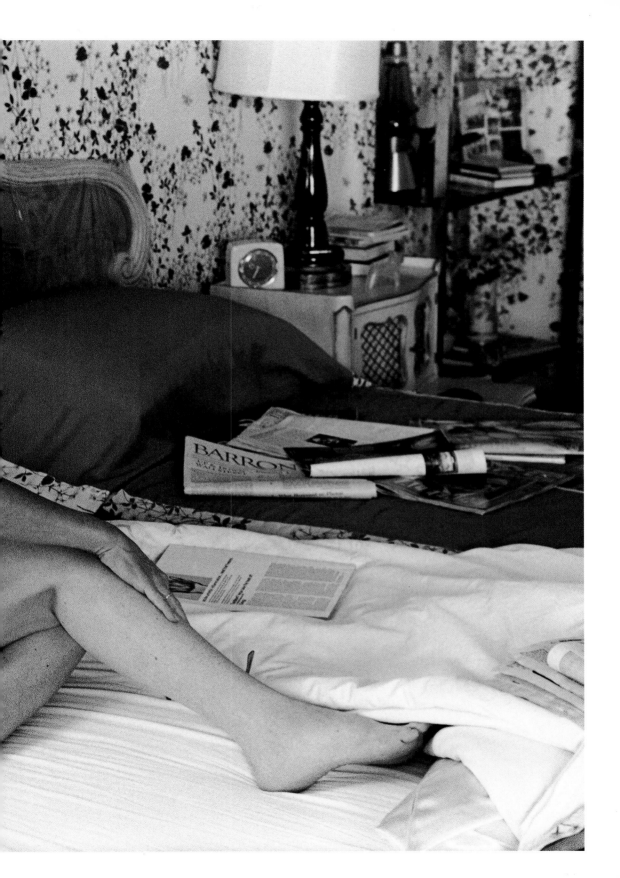

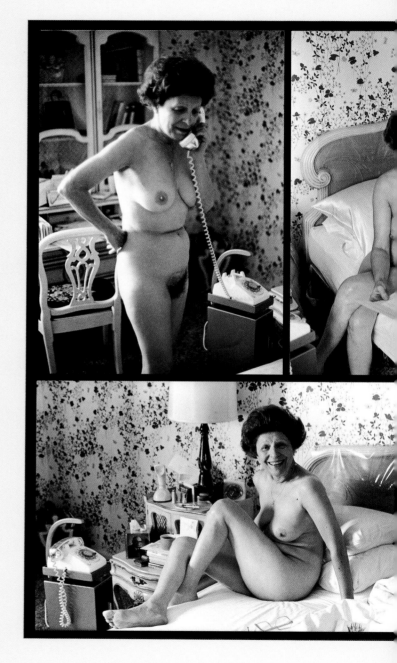

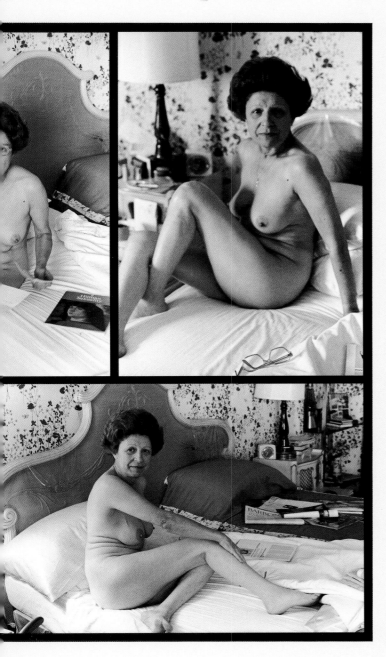

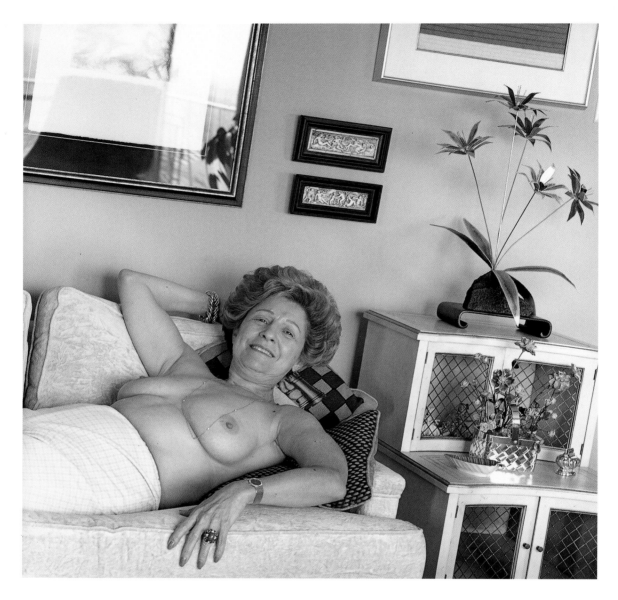

I ring the doorbell and wait in the hall. Yesterday would have been Daddy's birthday, and I didn't call you. I never want to call you.

"Hi, Darling. This is a nice surprise."

"I was in the neighborhood and I thought we'd take some pictures together."

"That would be lovely."

I suggest we pose bare-breasted. You like the idea, even want me to take some pictures of you alone.

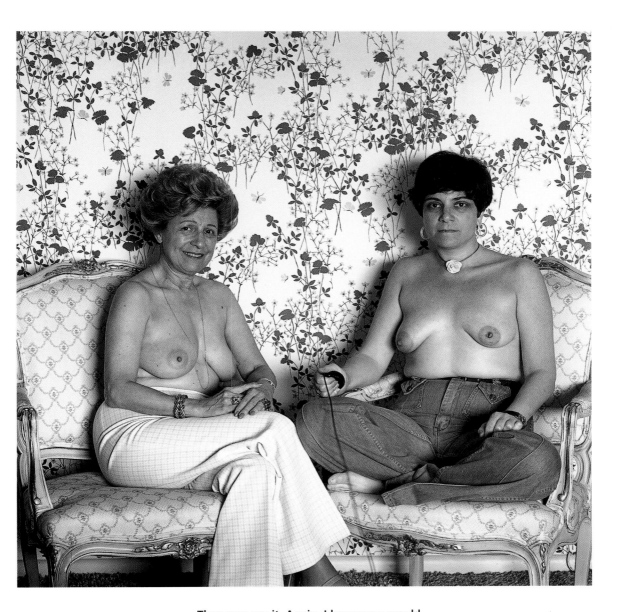

Then you say it. Again. I knew you would.

"It's too bad your breasts aren't as pretty as mine."

You interlace your fingers, lick your lips, and smile, as so many photographers have directed you to do. I don't.

Two years later, you allow me to exhibit this image in Houston. What do your friends think? Say? My children don't like it.

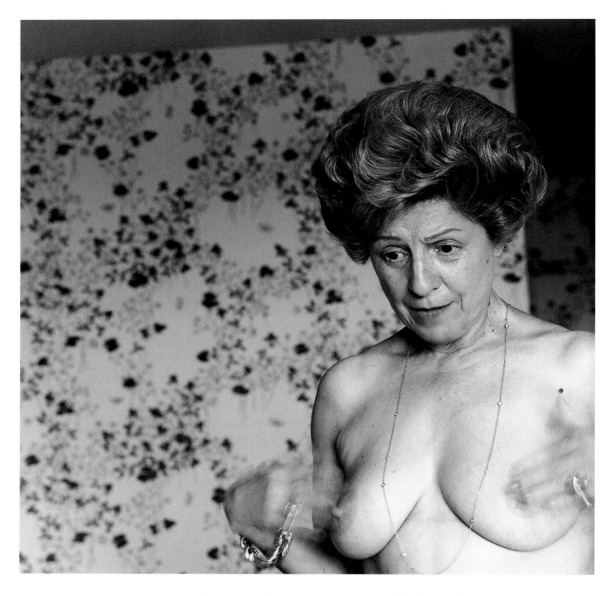

I've gone behind the camera to check the focus. You begin tweaking your nipples, talking to them:

"Come on, little fella! Wake up! Stand up! Come on!"

Do you hear me take the picture? You have to. My camera is very loud.

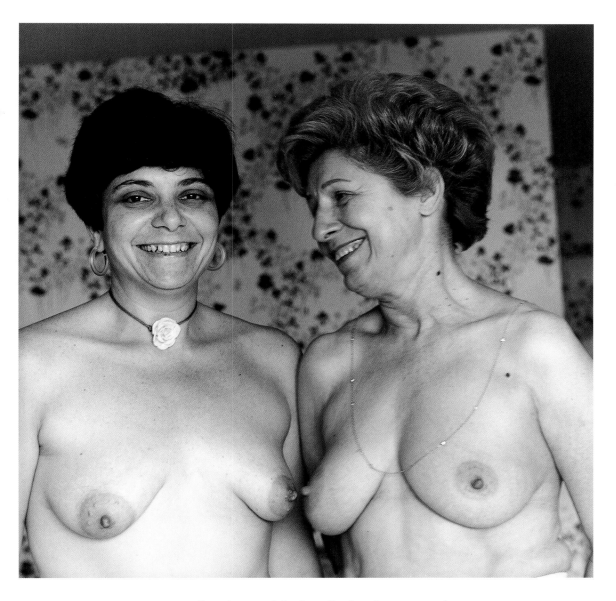

Twenty years later I see the love in your eyes here.
I never saw it before, not in person, not in a picture.
And now you've been dead six years.

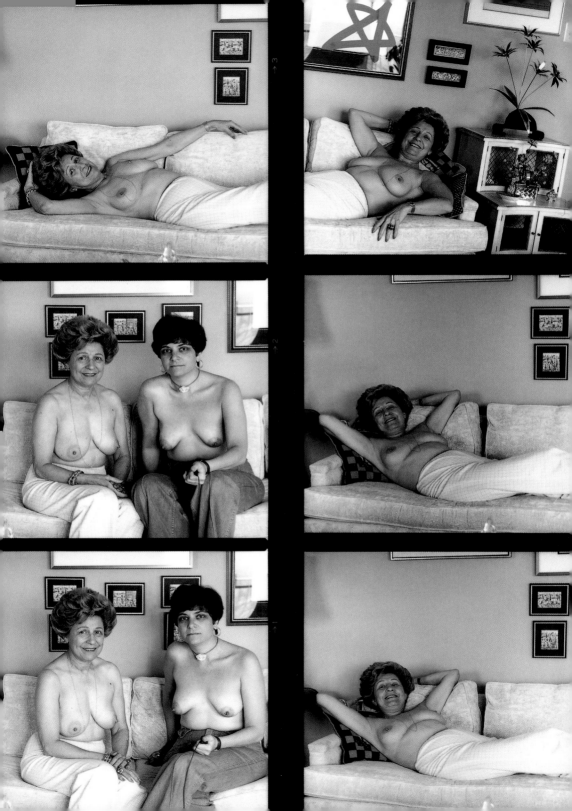

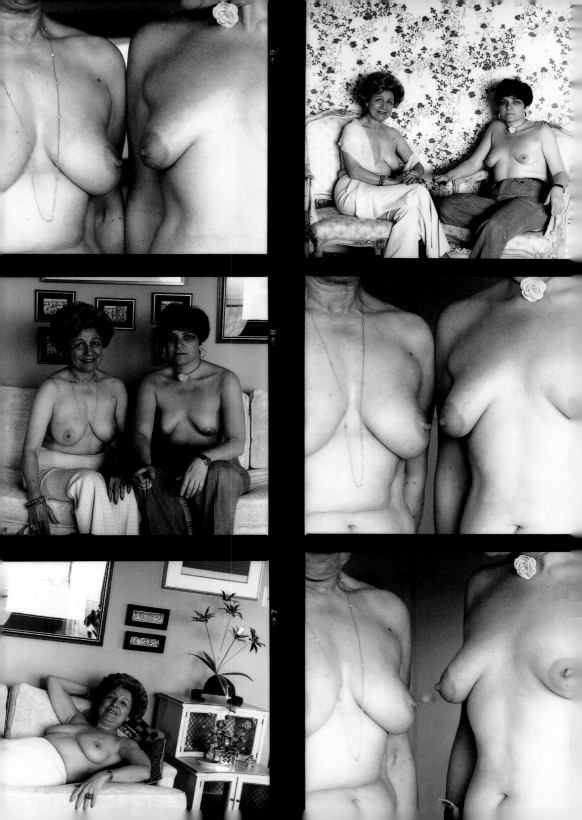

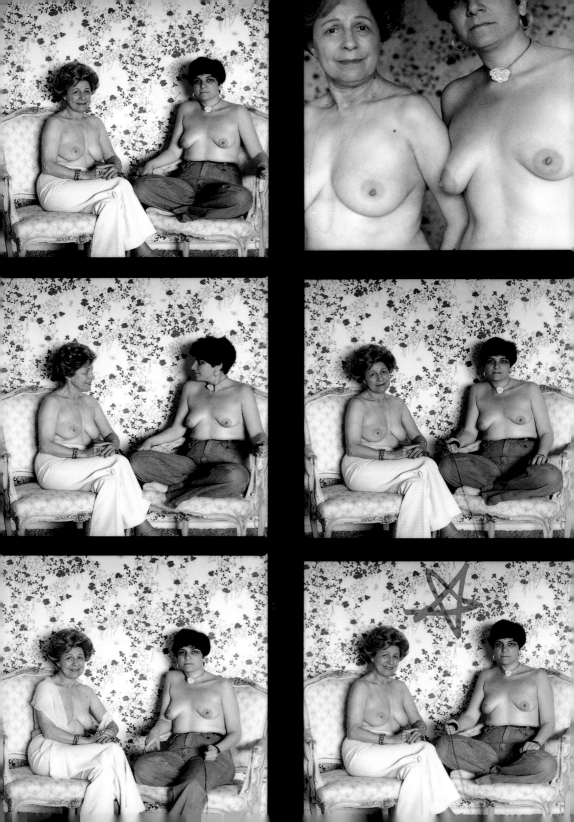

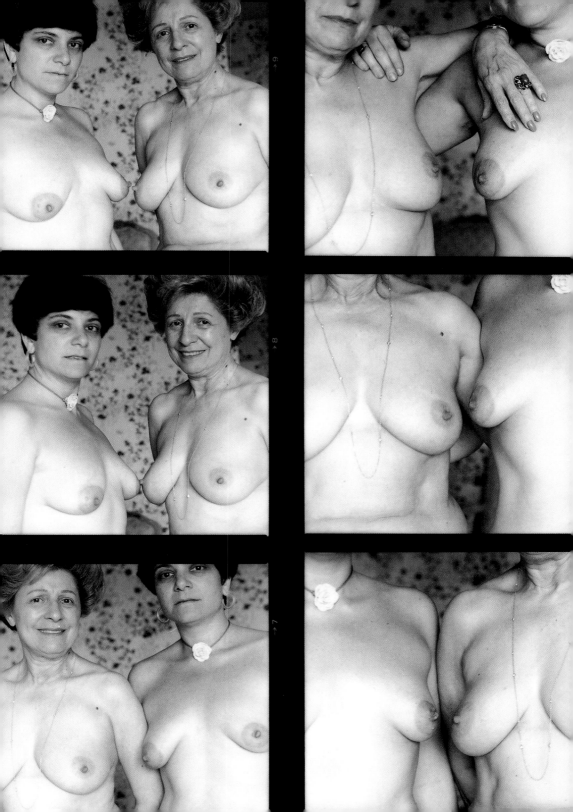

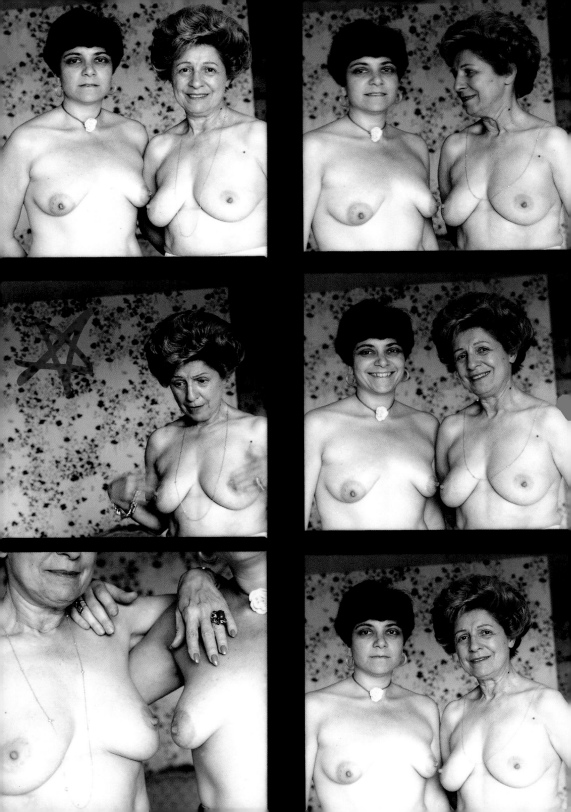

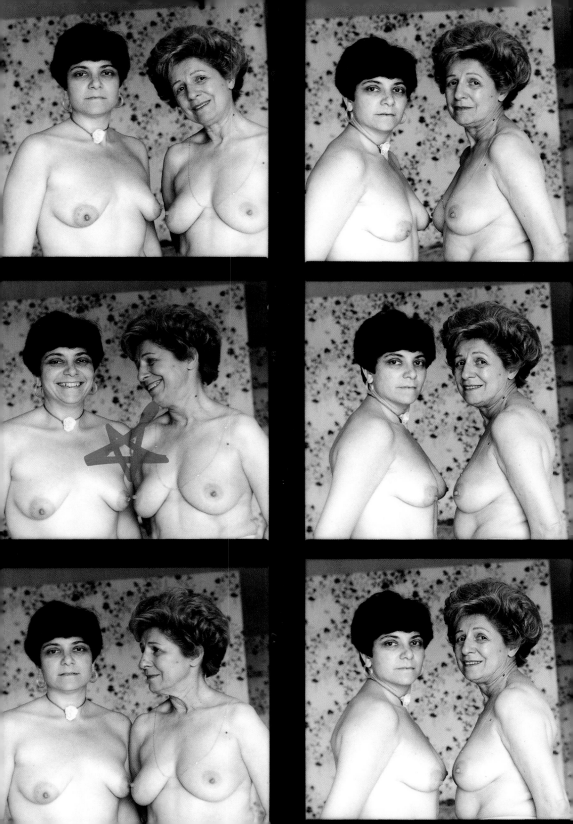

My first series consisted of portraits of people who were friends of my parents, mostly affluent, reform Jews who lived in Houston. The camera enabled me to enter these people's homes and hear the stories of their lives. From these stories I learned that they were simply products of their times, not the people with bankrupt values I was judging them and my parents to be.

The camera made me different from Mother even as it gave me access to her. It occurred to me much later that no matter who was in front of my camera, I was always photographing Mother.

mothers and anti-mothers

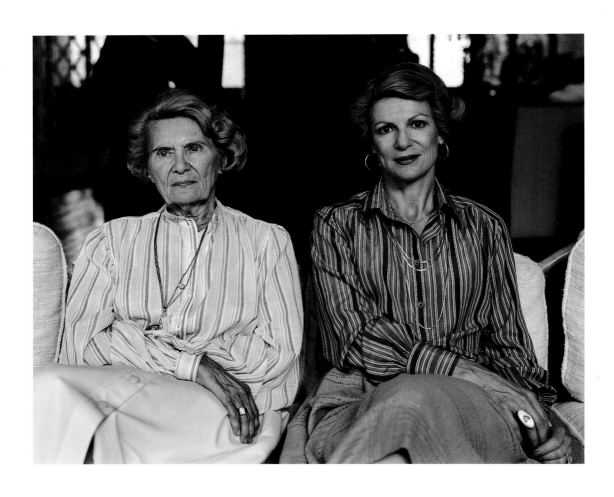

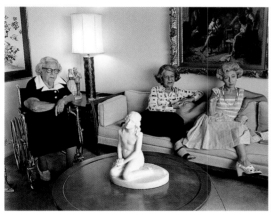

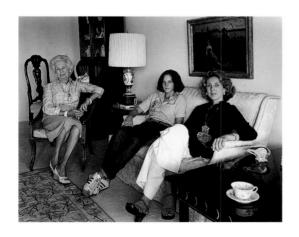

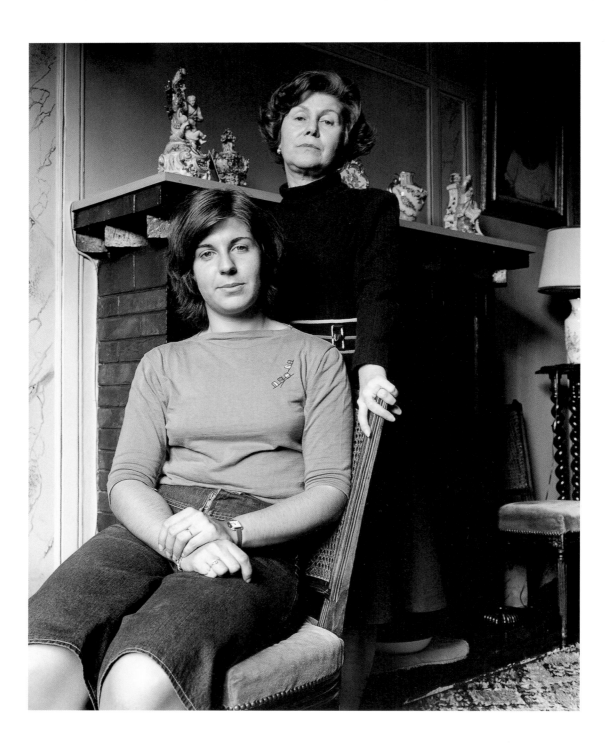

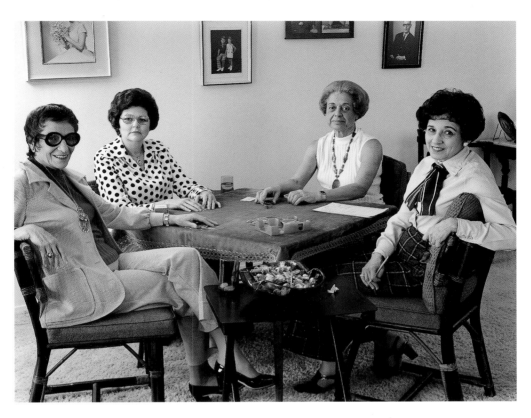

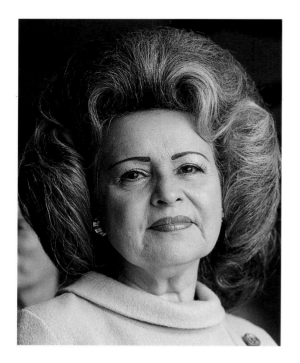

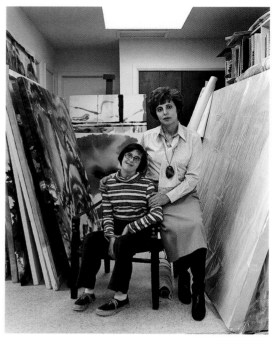

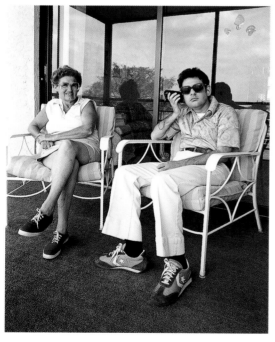

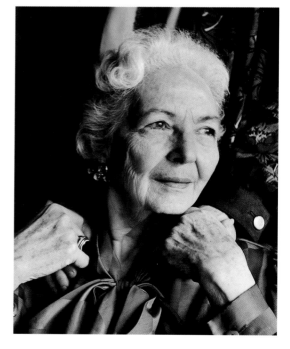

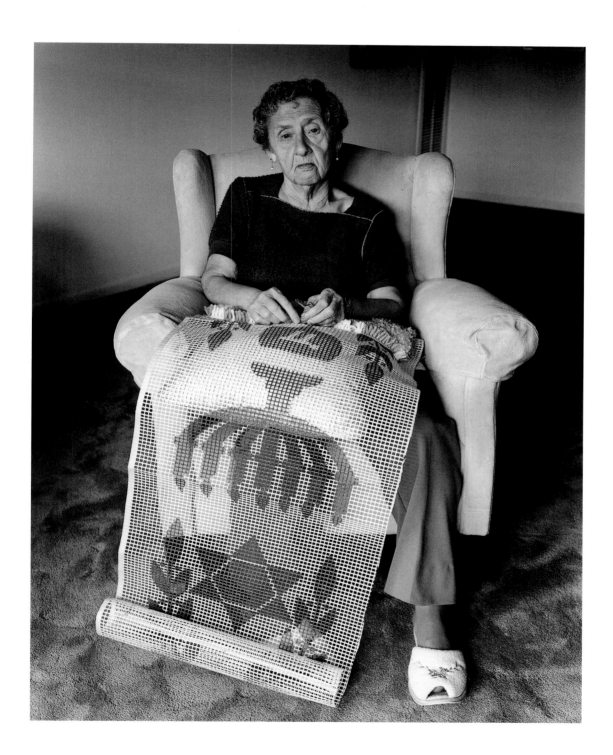

My Mother's mother, whom everyone called Dear, wanted to be a Southern aristocrat, and she was as much of one as a Jew could be. She was one of those ladies with her nose in the air; you could tell she thought she was better than other people. Dear never learned to drive, so she did her shopping and paid her afternoon visits in her chauffeur-driven Cadillac.

Dear grew up in New Orleans where social position was important, and she could trace her lineage in this country back to the American Revolution. When he was twelve, my grandfather emigrated with his large family to Louisiana from Germany, becoming a successful retailer and landowner. I know these few facts about my grandparents, but I know nothing of their childhoods or their thoughts about life. They weren't storytellers.

As a child I watched my grandfather kill chickens he raised in the backyard. He ate no meat except for these chickens and fish. Because these are the practices of Jewish dietary laws, I'm sure he kept kosher but when I asked Mother she said, "He never said he did." It isn't surprising that a Jew in the South would want to hide any observance that might separate him from other Americans. Even in my generation when, at fourteen, I said "Oy Vey" to my mother, she quickly informed me, "We don't talk that way, Gay."

In 1982, on a trip to Miami's South Beach, I finally found the Yiddish speaking Bubbies and Zeydes I'd always wanted. Here were people with little money but lives so rich in experience that they were eager to share their stories with me. They told me about their childhoods in "the old country," how hard it was to be a "greenhorn" in America, and how much of their culture had been lost with each generation. I loved their Yiddish accents and that they called me a "nice Yiddishe Maidel" (Jewish girl), including me in their families to which I felt I'd always belonged.

the bubbies i wish i'd had

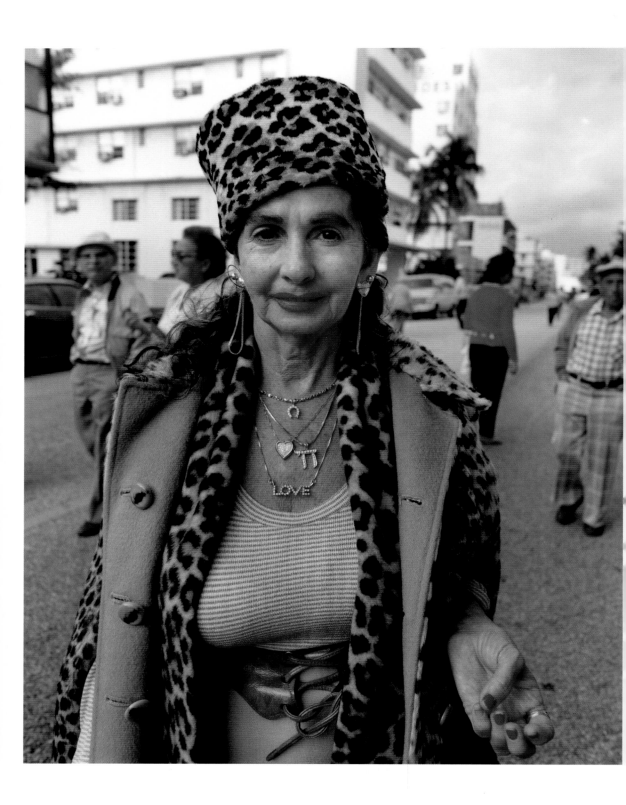

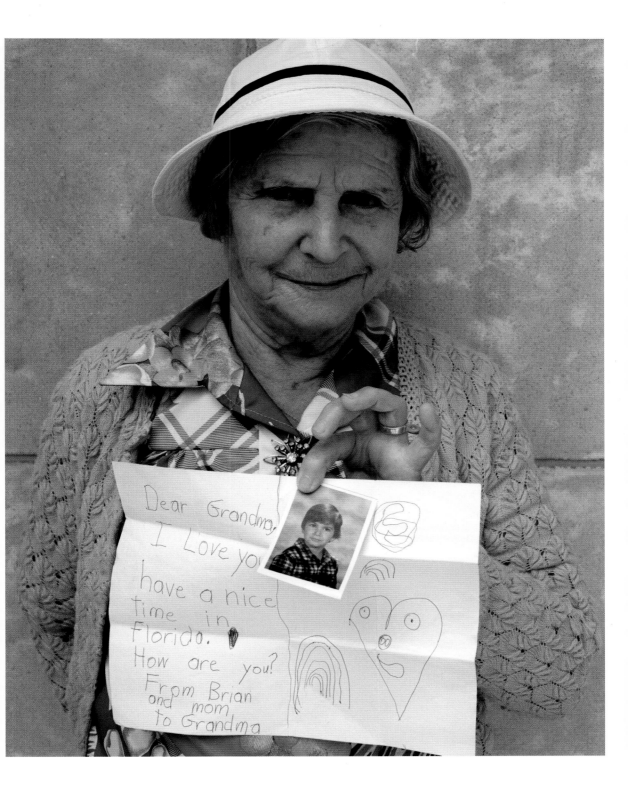

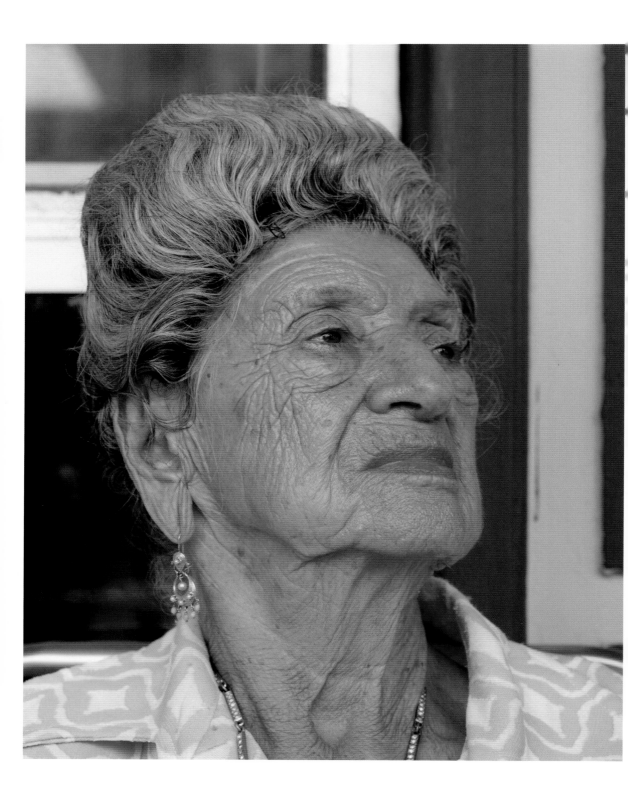

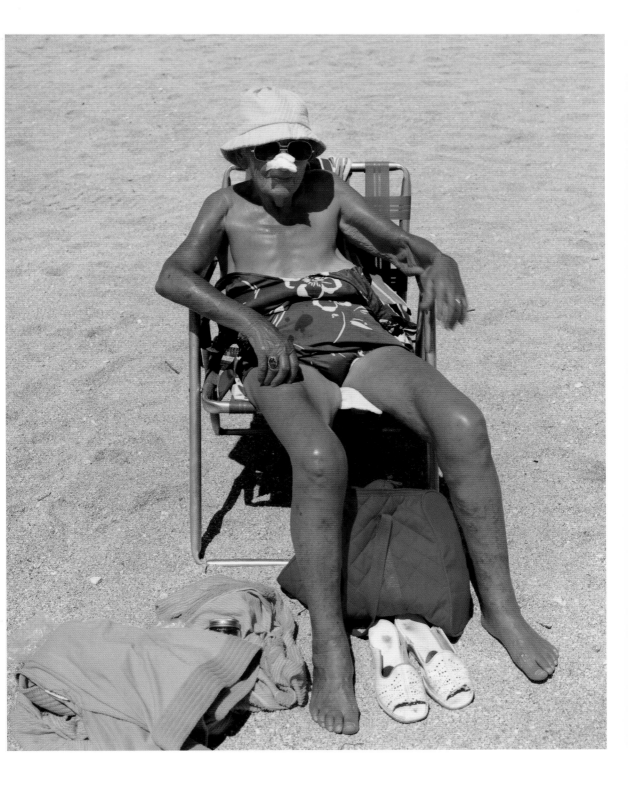

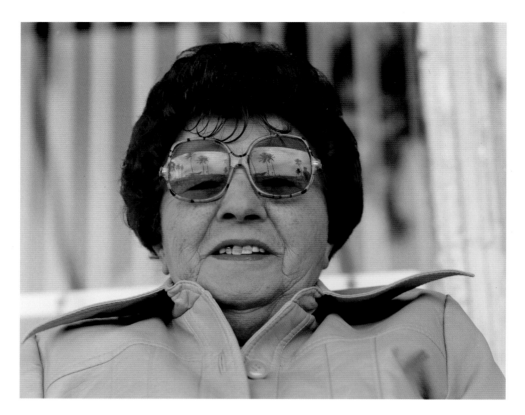
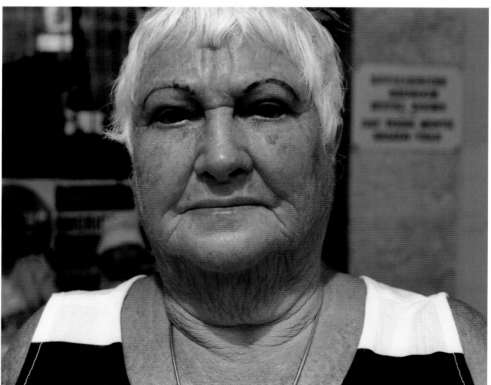

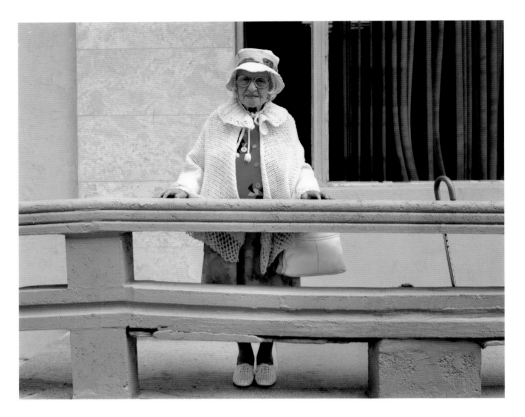

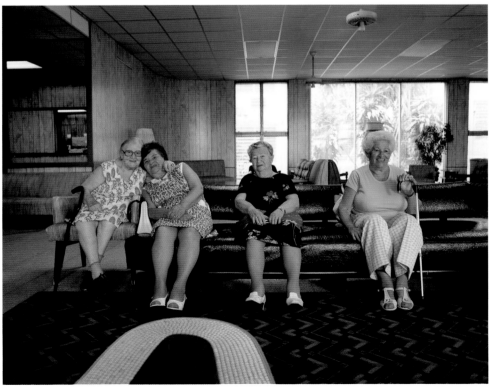

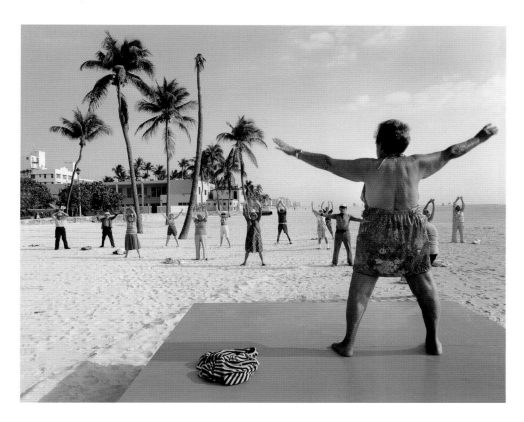

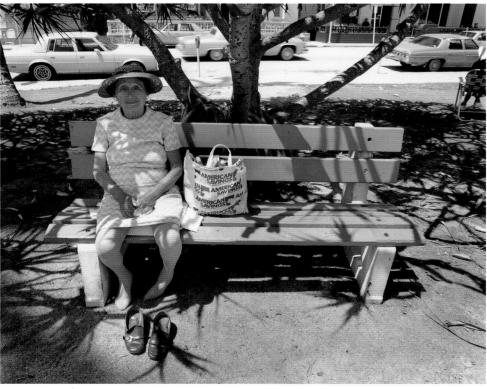

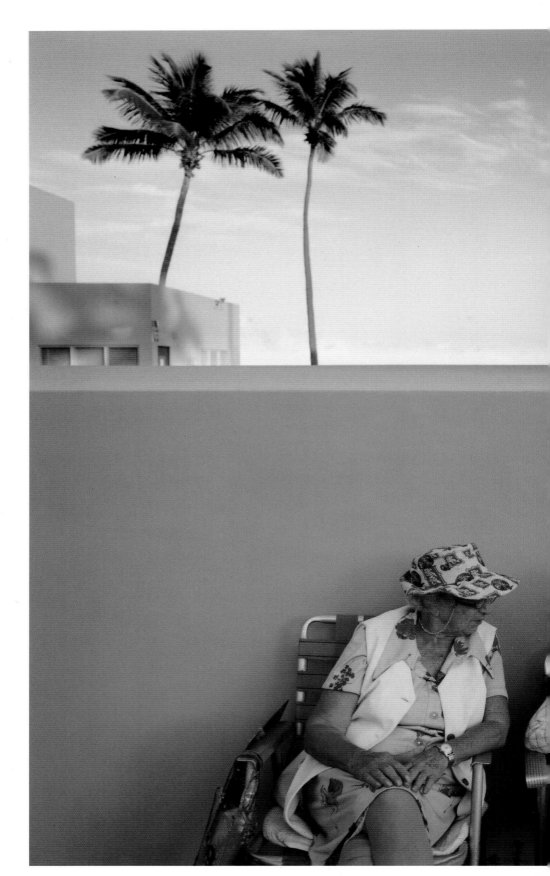

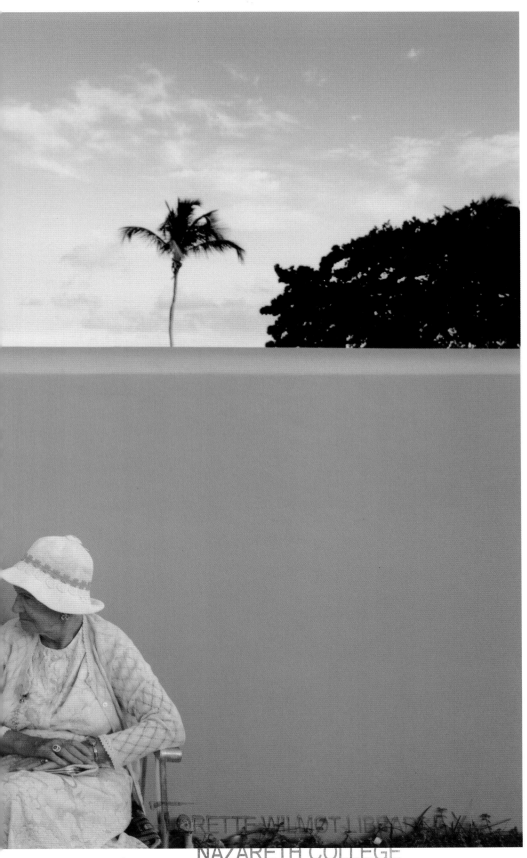

Whenever I photograph people I ask them to tell me
their life stories. Now I give that same courtesy to Mother.
Her life was shaped by her circumstances of birth:
Born in 1913, she was an only child of doting parents
in Monroe, Louisiana.

privilege

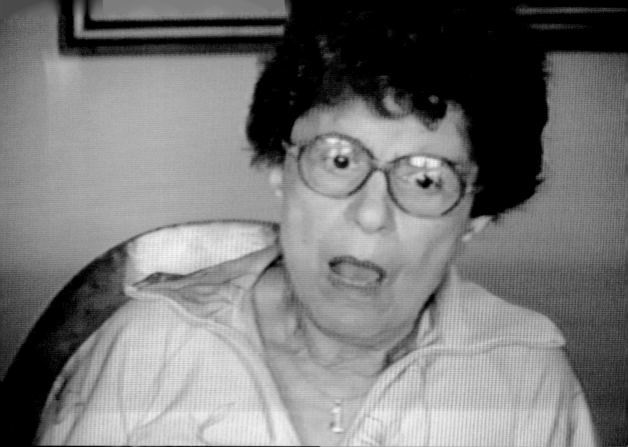

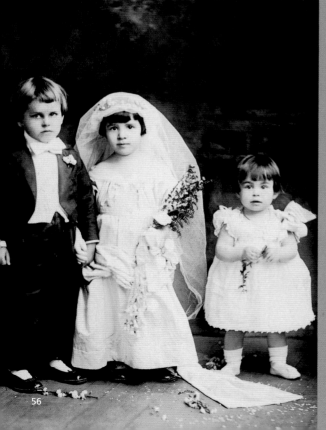

I was a namby-pamby little girl who did the right thing all the time. Anything my mother or I wanted, Daddy never said no to, but I was taught not to want too much. I had nice things and I was careful about how I spent my money. I didn't have to make my bed or do any household chores because we always had help. And I don't remember ever being punished, but I don't think I merited any punishment. Now you might think I was spoiled, but I wasn't. If I was ever spoiled, it was my husband who spoiled me.

— Bertha Alyce

56

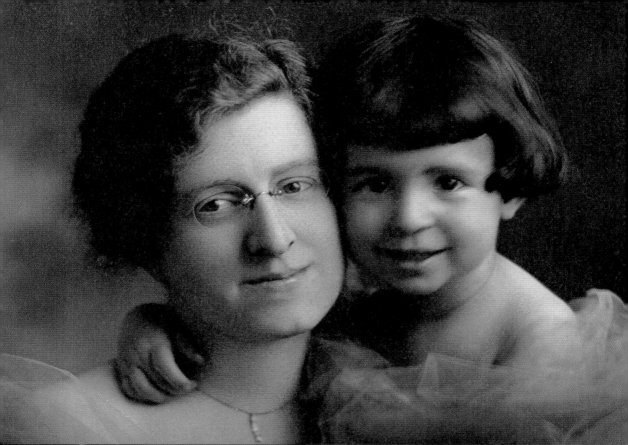

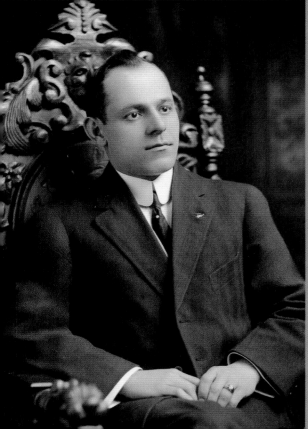

I think you're always influenced more by one parent than another. Constantly, I'm doing or saying something and afterwards I'll think: "My daddy would have done or said that, or he would have felt that way." Rarely a day goes by that I don't think about my daddy. I'm so much like him.

— Bertha Alyce

Your grandmother obviously was an extremely spoiled woman and I thought your mother was an extremely spoiled woman. I didn't think that about you.

— Former son-in-law

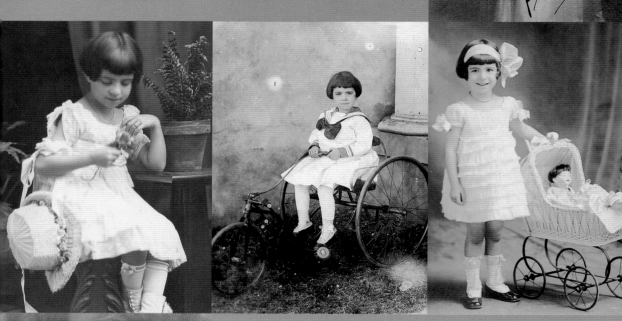

I went to college at Newcomb when I was sixteen, in 1929. I knew there was a depression, but it didn't affect us. In fact, my daddy loaned money to several Monroe banks to keep them from going under, so people wouldn't lose their savings.

— Bertha Alyce

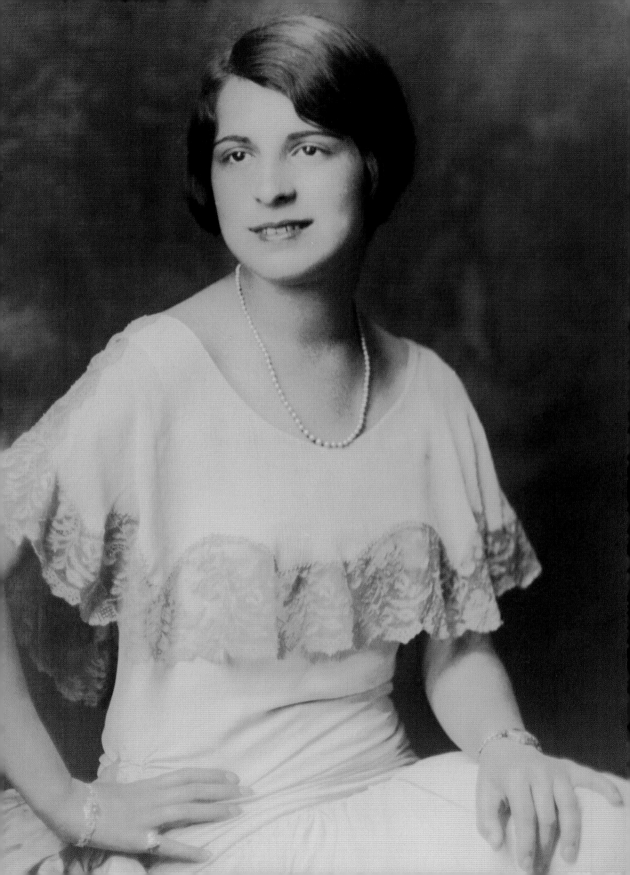

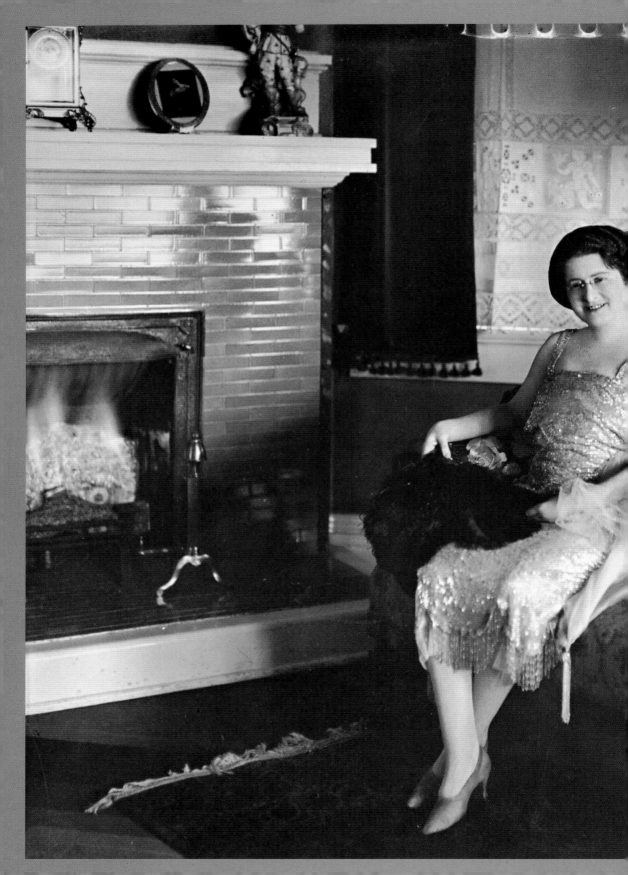

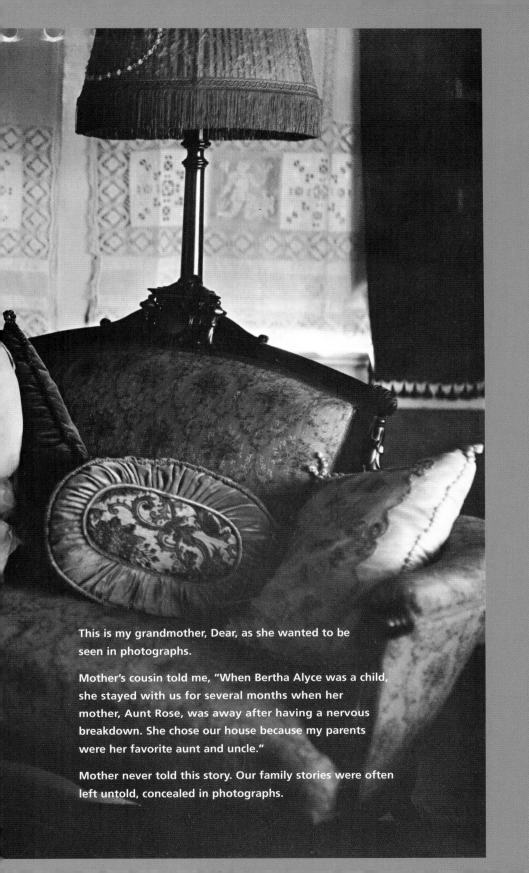

This is my grandmother, Dear, as she wanted to be
seen in photographs.

Mother's cousin told me, "When Bertha Alyce was a child,
she stayed with us for several months when her
mother, Aunt Rose, was away after having a nervous
breakdown. She chose our house because my parents
were her favorite aunt and uncle."

Mother never told this story. Our family stories were often
left untold, concealed in photographs.

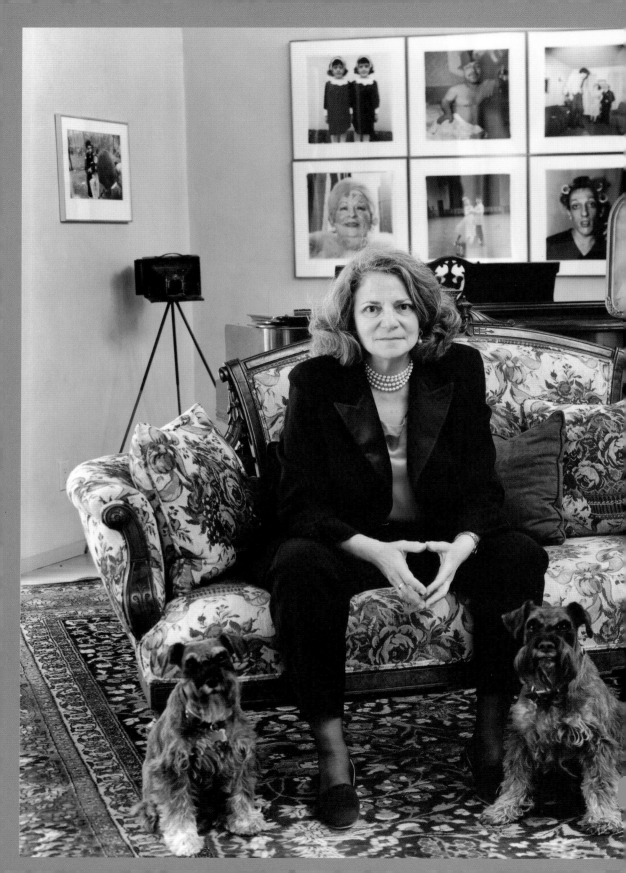

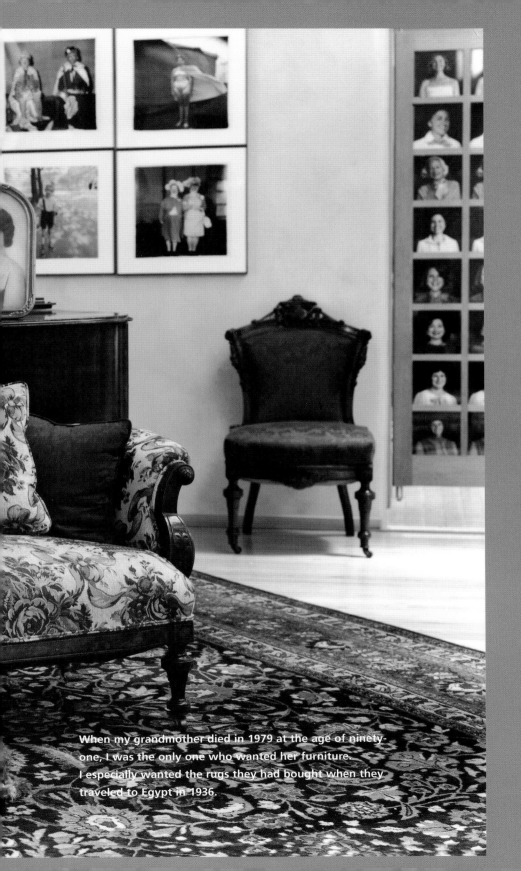

When my grandmother died in 1979 at the age of ninety-one, I was the only one who wanted her furniture. I especially wanted the rugs they had bought when they traveled to Egypt in 1936.

When Mother died I found a shoebox neatly stuffed with her and Daddy's courtship letters written in 1933 and '34. These letters belie the disparities in their circumstances, characters, and personalities. She's a flapper spending the summer with her mother in New York to escape the Louisiana heat, and he's a depression-era poor boy working in Monroe at a wholesale liquor and food distributorship.

Through the lens of her letters, I can see her laughing in Broadway shows, drinking and dancing in the speakeasies, and swooning over the concerts and operas she says she loves. But Daddy's portraits show him working behind a desk, playing poker with cronies, being dutiful to his parents, and having fun with friends. Even though she had the money, he determined their future social life. None of us ever went to a concert or museum, but we often attended baseball and football games.

Bertha Alyce seems to orchestrate everything, but Irvin gets everything he wants.

love letters

We've rented a car to use while here, with chauffeur, of course. It's a 1933 Auburn convertible sedan, and with a radio. The chauffeur is so cute, I may fall for him.... Last night, in addition to the regular concert program, they had a Russian ballet. I knew that it would be a marvelous spectacle and was glad when he suggested going there, for so few boys like that sort of thing. Then we went to a very swell speakeasy, just off Fifth Ave.... How I do love a good Tom Collins.... Have you heard of Hank Greenberg of the Detroit Tigers? Well, I went to a party with him the other night and he's awfully nice. Not a showoff, as one might expect.... Today I saw a girl I met last summer. She's very intelligent and the thing about her that is so attractive is that she is different from the average New York girl. She graduates from Law School next year, and this summer she is clerking in a law office.

All my love, Bertha Alyce

As I sit here and write, the sweat is pouring off and I have to be careful that I don't blot the letter with perspiration.... I am writing from here as Pap has bought a Frigidaire office icer that keeps the room at 75 all the time and it's swell in here.... The faculty of the mind's eye is a great companion. These past three weeks you have not been out of my "sight" a moment.... I love you with every fibre [sic] of my being and your happiness will always be my first consideration.... Well, as I wrote, I played poker, and as I've often written, I lost. I do wish you'd come on home, then maybe I won't want to play so much.... Tonight is a big Saturday night with no plans. The picture last night, The Thin Man, *with Wm. Powell and Myrna Loy was one of the most entertaining I've seen in a long time. Try to see it, dear.*

Your ever devoted, Irvin

Darling:

Thursday our truck and two drivers were stopped and arrested at Strong, Ark., for possession and transportation of alcoholic beverage—

Tonight is a big Saturday night with no plans.

Each time you ride me about those liquor customers calling you at such ungodly hours of the morning, they had a Russian Ball, & knew furious! They know I get so little consideration for others! My baby needs his rest.

You've rented a car to use while here, with chauffeur, of course. It's a pretty car — 1933 Auburn convertible sedan, and with a radio. It will really be a comfort to have the use of a car in New York — and the chauffeur is so cute, you may fall for him —

Last night, in addition to the regular concert program, they had a Russian Ball. I knew that it would be a marvelous spectacle and was glad when he suggested going there for a few of the boys like that sort of thing.

Had a perfectly marvelous Saturday night! Went to the Mallory Arlington Long for dinner — Tony Tomkins is there. Tony was in my house. He was just as wonderful as ever and my boy-friend is the sweetest man so happy to see me again.

Dearest, my dear, last night and had a perfectly marvelous time —

Went to a concert and to the program and Powell Roland (old friend we tried to listen in N.O.) — for more in my glory!

The Rabbi's reception was almost a flop — very few people.

My Darling Sweetheart: I lost at poker last nite, $1.85, in a penny ante game.

Well, as I wrote I played poker, and as I've often written I lost — & so with another come on home, then maybe I won't want to play so much.

Tomorrow nite I have a date with Jimmy Denney. I suppose we'll go to the Frances. The Virginia is closed, due to a law suit by Irving Berlin for infringement upon certain music they played —

In the step show was this Sally Rand, who recently received so much publicity here. She is a fine publicity received here — publicity received by erecting the show at the fair with her too large fans — and that's all! So was the show & drew the crowds. Damn clever!

As I sit here and write the sweet so pouring off and I have to be careful that I don't blot the letter with perspiration.

Have you ever heard of Hank Greenberg of the Detroit Tigers? Well I went to a party with him the other night — and he's awfully nice. Not a show-off such as one might expect.

I am at the office writing this tho', I've been home and had my bath. I am writing from real a Pop has bought a Frigidaire office icer, that keeps the room at 75° all the time and it's swell in here.

I love you so with every fibre of my being, and your happiness will always be my first consideration.

We are going to have a sales meeting tomorrow nite at the Frances Hotel. Clifford & I have taken a course in sales, and we're going to try to pep the boys up a bit.

I guess I'll play poker. My luck at poker has been very good of late. I've only made three or four losings of $1.75 each and have won several times & L. H. C.

Dearest Sweetheart,

Darling. I wonder how soon you are to come home? — I am really longing for your return with a beautiful enthusiasm of a five year old boy and a love sick youth —

Had my hair cut today, and the barber here is a very stubborn piece of humanity, and would it cut it as I wished. I told him to either I want to be heartily rude and had a girl there cut it as it should be done.

I'd have enjoyed the evening much more without the company we had the other men were so sad, but, oh, the girls that they had for dates! The minute I looked at them I shut up like a clam, and completely lost all my pep for at least an hour. They were what I have classified as the typical New York girl except they were a little bit worse — So loud and rowdy! Such show-offs! And how drunk they did get!

The faculty of the mind's eye is a great companion — these past three weeks you have not been out of my "sight" a moment —

Went to the Franconia Roof last night for dinner and dancing. My heart cares for that thing there, patronized by our out of town crowd, for the most part travelling men and their families or wives, but the crowd was swell behaved, and the music very good, so I enjoyed myself.

Went to the movies Sunday nite, then to a very swell speakeasy just off Park Ave. Had I old have a good Tom Collins!

and dancing on the stage, quite a novelty. The show was organized pretty & good talent, for there were three lines or more but were then something on going on every minute to keep the guests fully occupied & there once, but I figure have to go again it's marvelous how much nicer and stuff dull.

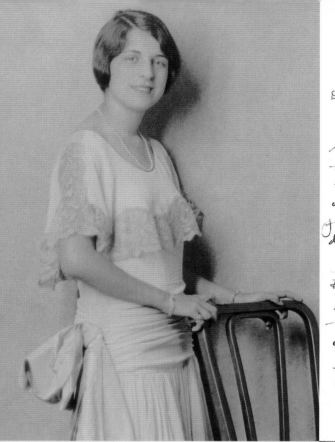

Dearest Sweetheart

As for paying for the ring, Sweetheart. the man who has been nice enough to scout about looking for a bargain for me, has to pay for it now, and he doesn't have enough money to have that much outstanding for so long. & don't you think, Darling, that you could send him a check for so much every week or every month (whichever way you prefer it)?

Monroe, Louisiana

Sunday
6-P.m.

My Darling Sweetheart:

I am really today the happiest man I know— I agree thoroughly with all your plans as outlined in your letter, and you should not even have had the thought of it being forward. It is all so beautiful and sensible.

I have not saved any money for us this summer, but each week finds my indebtedness less and by the first of the year I shall be practically free of all monetary obligations. I am also sure of a nice bonus from Strauss & Son after Jan 1st.

I love you so much, sweetheart, that you cant realize how happy your way of doing things has made me. All I can say is everything makes me more + more

Your undevoted

Tommy

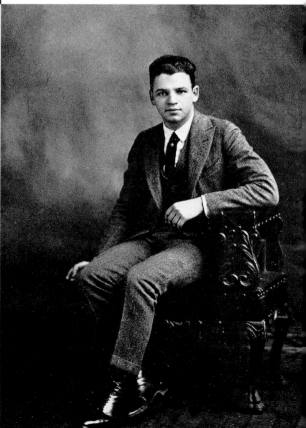

9.6.34

Dearest Sweetheart, It's agreed that we want to be married, isn't it? Well, I've been thinking, and I have plans. This friend of ours here who is in the diamond business will be able to get a stone for me at a very low cost — that is, stone, setting, and all — so, if you like, perhaps I could select it — even buy it while I'm here — and you could pay him when you are able to do so. — All my love, Bertha Alyce

> *9.9.34*
>
> *My darling Sweetheart, I am really today the happiest man I know. I agree thoroughly with all your plans as outlined in your letter. I have not saved any money for us this summer, but each week finds my indebtedness less, and by the first of the year I shall be practically free of all monetary obligations.*
> *— Your ever devoted, Irvin*

9.13.34

Dearest Sweetheart, New developments — After you have read this paragraph you may open the enclosed envelope and see how you like what's inside. It's a diagram for my ring — life size. I can get a diamond that size, which is a little over one and one-forth carats, and the setting for $305.28.

> *9.15.34*
>
> *My Darling Sweetheart, Darling, the ring is beautiful, I am delighted with it and it is, as you wrote, very reasonable. I won't be able to pay for it, though, until the first of January when I will remit for it at once.*

9.17.34

Dearest Sweetheart, As for paying for the ring, sweetheart. The man who has been nice enough to scout about looking for a bargain for me has to pay for it now, and he doesn't have enough money to have that much outstanding for so long. So don't you think, Darling, that you could send him a check for so much every week or every month (whichever way you prefer it)?

> *9.22.34*
>
> *My Darling Sweetheart, Sweetheart, I have about $200.00 saved up and I would like to make a substantial payment on our ring at once. Please send me the man's address to remit to.*

9.22.34

Dearest Sweetheart, Sweetheart, where did you get all that money? That sounds like a million dollars. You may send the check to "Uncle Louis" (that's what I call him). He's been a dear about this ring, so you could add a little personal note.

> *9.27.34*
>
> *My Darling Sweetheart, I'll mail "Uncle Louis" a check for $150 tomorrow; many thanks for his address. I'll write the personal note you suggest. — Your ever devoted, Irvin*

10.1.34

Dearest Sweetheart, I've shown the ring to several people, and how they have raved about it! I'm so anxious for you to see it, Darling, and give it to me. — All my love, Bertha Alyce

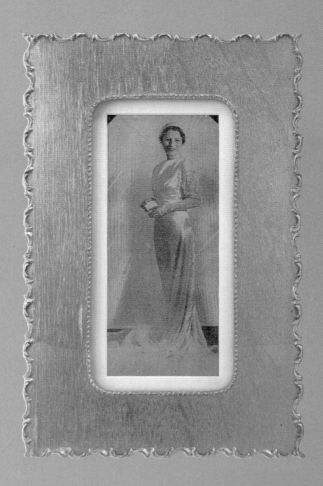

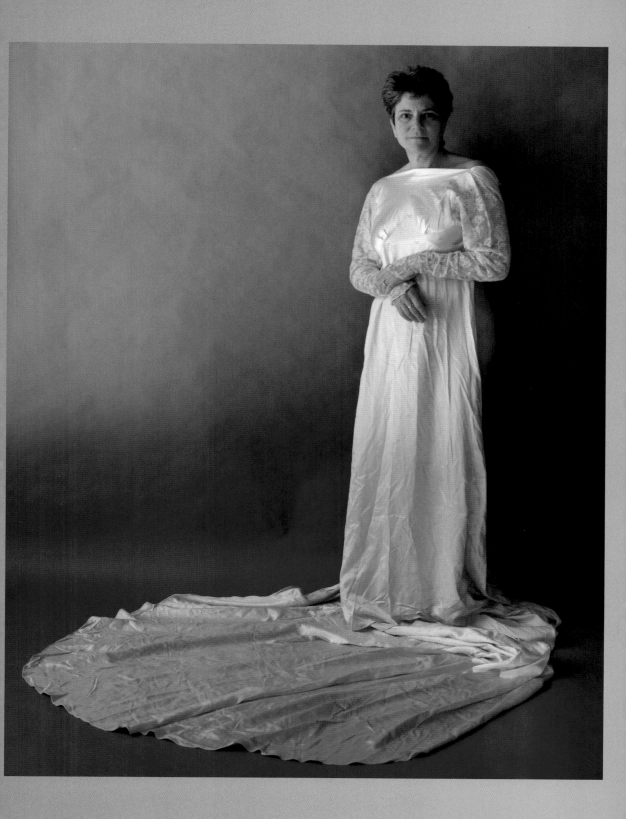

heartbreaking

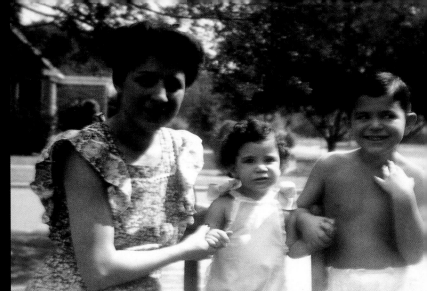

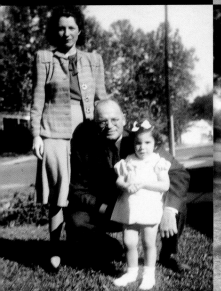

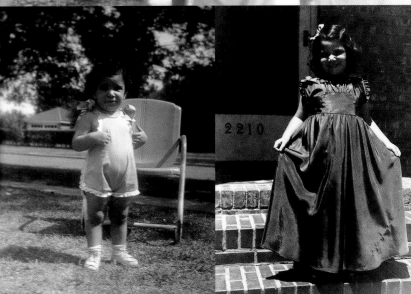

She didn't want anybody to look after. Bertha Alyce loved her independence. I don't think she was ever fair to you and Sidney. I don't think they ever gave y'all what you really wanted. Or needed. You know, it was a strange, rich life that you all lived.

— Sabina Block, friend

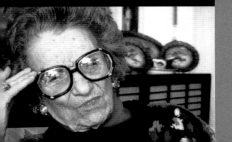

…I don't think mother or dad, either one, were ones who were at the top of the list of being able to show love and affection. I don't think it was that they weren't willing or didn't have it, I just think they weren't able to show it.

— Sidney Shlenker, son

I'm ten years old. I call up to mother from the bottom of the winding staircase. "Mommy, Mommy!" I hear her reply coming from the corner bedroom. "Don't call me Mommy. My name is Mother."

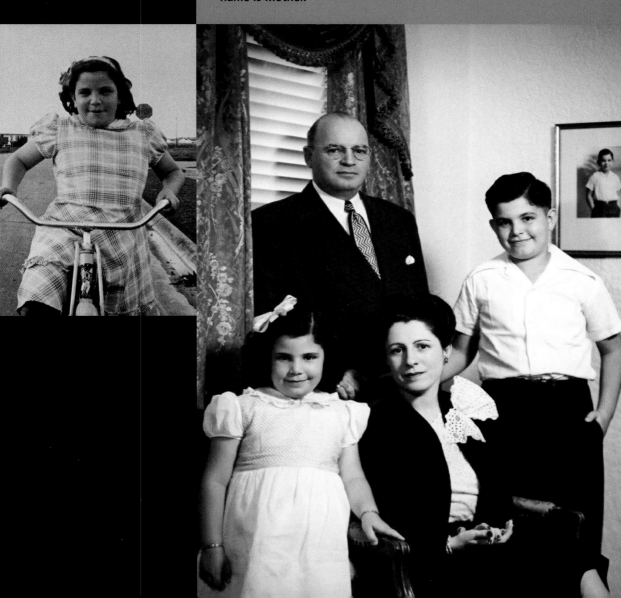

Bertha Alyce: We were out of town and some friends took you out to dinner with them one evening. You were walking around the table, or something, and one of the men said to you, "Gay, you're a very pretty little girl. You look so much like your mother." And you said, "I don't want to look like my mother. I don't like my mother." You were five years old, and that came back to me. I was very upset about this and I put myself out tooth and nail to cater to you, to be with you, to take you out, to do

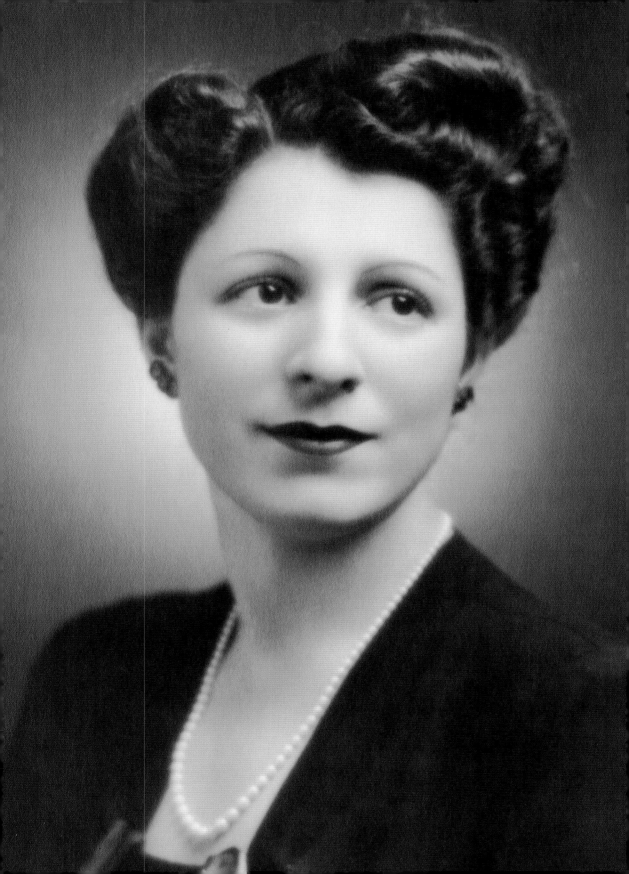

Bertha Alyce: I was the happiest person in the world the day you were born because this is the way I ordered my life to be, and I ordered my children. I wanted a boy first and then I wanted a daughter, and I got it. I remember saying to somebody one day when I was dressing you or doing something for you — you were maybe not quite a year old — "I have to be careful. I could spoil Gay terribly because I'm so wild about her. I've wanted this daughter so badly."

And then, the next thing — well, you were a different kind of child. As you were getting older, you were two or three years old, and Sidney was so sweet to you. He would play with you; he was like a little father to you because he was five and a half years older, and you were a little devil. I didn't know where you came from. No matter what you could find to pick up, you'd haul off and you'd hit him with it. Finally Sidney got to the point where he would hit you back, and then you'd come crying, "Waah, Sidney hit me, waah." And your daddy would say, "Sidney, come here! What do you mean, hitting that baby?" And I said, "Hold the detail. Gay, come here! Who struck the first blow?" And Gay always said, "I did." And I said, "Well, if you did, Sidney was supposed to hit you back, and he doesn't get punished for that. Now I call that being fair."

It must have been very hard
for you to have a daughter
who didn't like you.

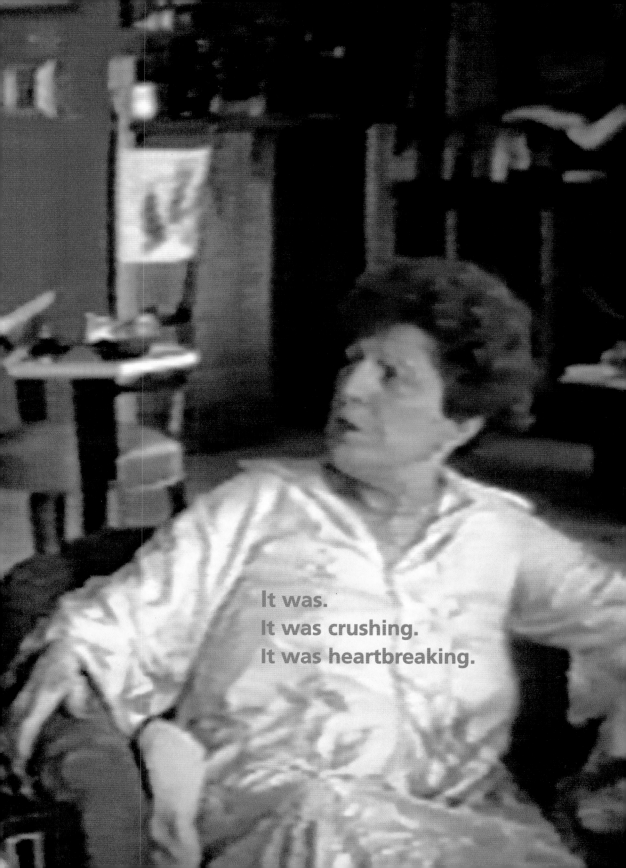

It was.
It was crushing.
It was heartbreaking.

From the minute I saw this little girl, I couldn't stop staring at her. She looked just like I looked at her age, but the difference was her seeming intimacy with her mother and father. I followed her for a few minutes, talked with her, and when I returned with my camera, I found her holding her father's hand.

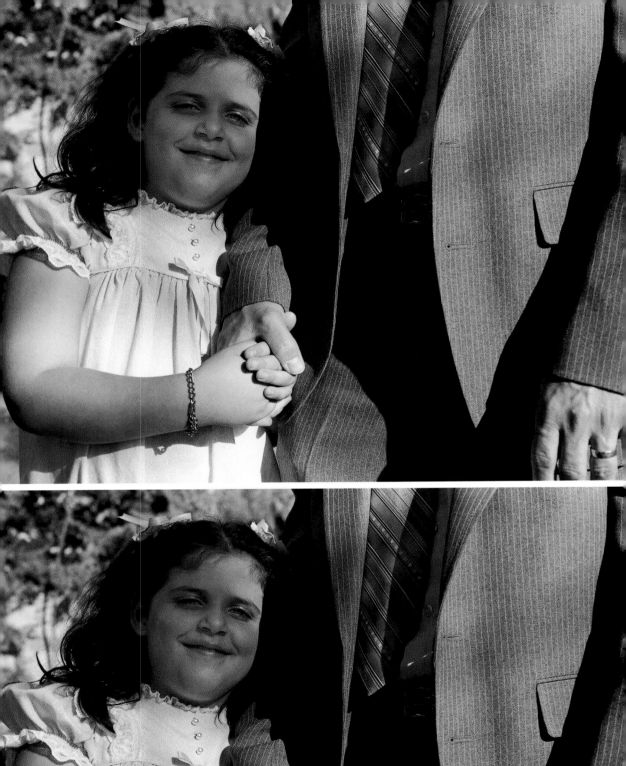

You know, those were the days when if you worked for a family you lived in this place called "servants' quarters," which was one very big room, and it was very nice. You would have a bed or a sofa bed or sometimes a Murphy bed that came down from the wall at night. And you had a bathroom and even hot water. And a radio. It was very exciting.

And I would say that on the whole she was as good a mother as she was capable of being. You know, because at that time the style was not like it is today. If you had a person that was good to your child and trustworthy, that was considered as being very motherly. If you kissed your child good night and you took her shopping in certain places, and when the company came the baby was dressed and the mother took it downstairs and they looked and oohed and aahed and then when it was time, the nanny came and took the baby and put it to bed, and if you didn't hear any screaming and crying you considered, "Oh, well, Bertha Alyce is really taking care of the kid." That's what was happening in that era. The mother who took care of finding a good nanny was a good mother.

Mrs. Shlenker changed when she became pregnant with you. We used to laugh in the kitchen because we had this gentleman, the chauffeur, Haywood, and he said he could always tell when he would take her breakfast up on the tray. He'd come back down and he'd say, "It's not going to be a good day because she didn't say, 'Good morning, Haywood.' We would laugh, but then everybody would try very hard. They'd knock themselves out to do everything, but sure as heck something would go wrong and she would scream and stomp and cuss and slam doors and then go upstairs and cry.

I used to say she had the personality like that movie I saw, *Three Faces of Eve*, where this person could just change. Even she would not look like the same person. She would scream at Sidney for whatever reason, like I think screaming was just her thing. She would scream and try to beat him, but we would run in between. She would sit you down really hard on something if you ignored her.

And then there were times like…she would feel good and go out and bring us back lunch. She knew we liked chopped barbecue sandwiches and she'd come in with them: "I brought you lunch." And we'd sit down and eat, and then she…I mean I guess she thought we'd gobble it up. Five minutes later she'd be back down. "Are you still eating?" And then she told the chauffeur, Haywood, "Now that you've eaten a horse's bait, go out and do a horse's job."

One time, we were walking down the alleyway behind the house on Bolsover, and the gentleman across the way had just cut some rose bushes, and they had flowers on them. But rose bushes have thorns, right? And you wanted to get into them, and I'm saying, "No, you can't do it," and then you started crying, and I said, "No, you can't do it." And we were close enough to the house that she heard, and she hollered from the upstairs window, "What's the matter with her?" I said, "She wants to pick flowers over here and she can't because they got thorns on them." She said, "Let her pick 'em," and I said, "Okay." So you got your hands all torn up.

She entertained a lot and those were the times she could make my mother cry because Mother was kind of submissive. Mrs. Shlenker liked to serve these long beef tenderloins and they had to be cooked just right. Then the butler would have to walk in and parade the meat around the table before it was cut. And then they'd carve it and she'd send it back, "It's not done right," she'd be screaming from the table. "Take it back to her, take it back." The whole block could hear that Mother did something wrong, didn't cook the meat right.

I was very different from my mother. One time Mrs. Shlenker said to me, "I'll slap your face." And I walked up to her and said, "Well, you better slap both sides because I'm going to slap you back."

But you know, we had everything that a person needed to be happy. Mother and I felt like family. They made us feel like family. I don't think that anywhere else in Texas or in the South at that particular time would we have been treated as well.

— Freda Pettis, housekeeper

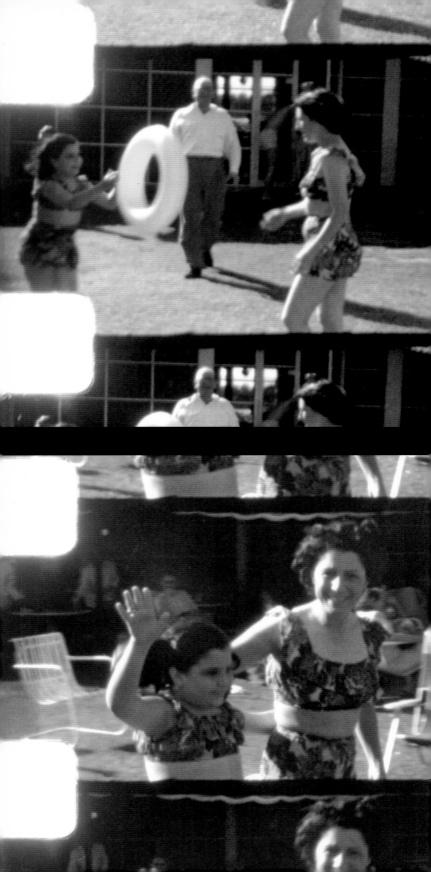

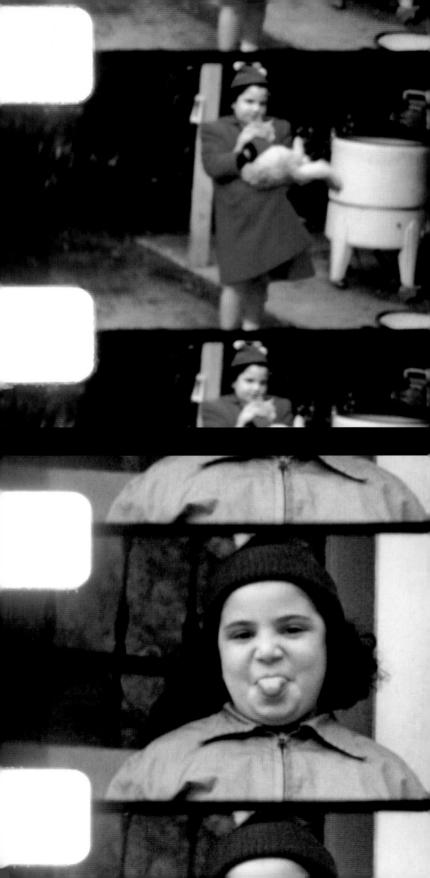

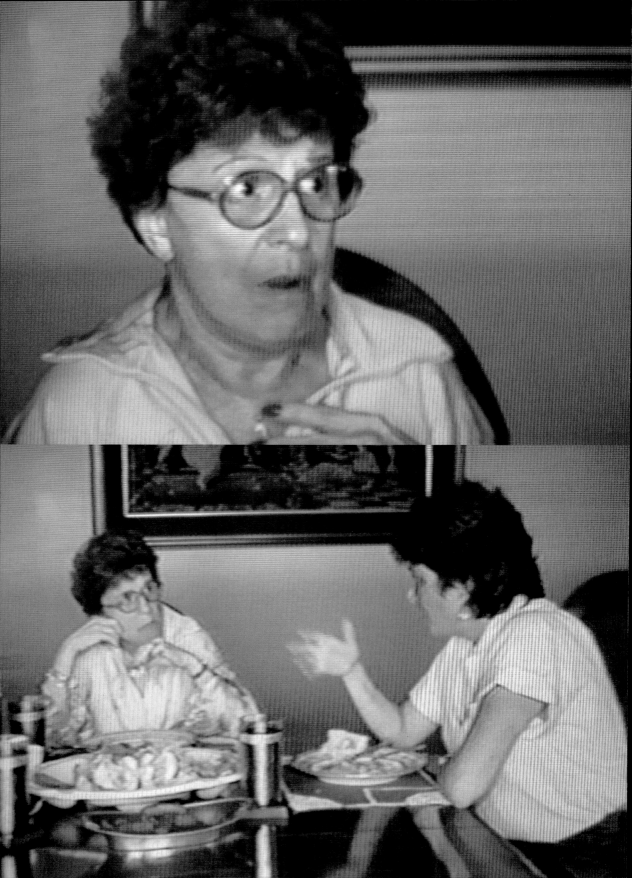

Gay: I didn't learn love from you. This was a big problem because when my children were young and I was supposed to be loving them, I didn't know how. I didn't choose a loving nanny for them, I didn't see them as separate beings who needed and deserved my love. Sometimes I saw you hugging Sidney, but I don't remember you touching me. Probably I didn't *let* you touch me. I think I decided when I was about six months old that I wouldn't let you love me because you weren't dependable enough. You might love me one day, but the next day you were either gone or angry and cruel to me, so I rejected all your love because it hurt me too much when I didn't get love.

Bertha Alyce: I never made an independent decision until I moved to Houston because my mother told me everything. That's why I wanted to make you independent from the start.

Gay: You can't make an infant independent; it won't feel loved. My decision to reject you was worse for me than you, and perhaps a different kind of daughter wouldn't have made that decision. I remember you trying to hold my hand, at home or in public, and when I'd pull away you'd call me a cold fish. But really, I wanted to touch your hands. This may be why one of my favorite childhood memories is you washing my hands before dinner. You'd take me into the powder room and soap up your hands, then rub my hands between yours. That felt delicious because I loved your soft hands. This was the only way I let you touch me, let you love me.

Bertha Alyce: Now I really think you've had too much psychoanalysis, Gay.

Gay: And you had too little, like none.

Photography was magic to me from the time I got my first Brownie camera. I loved that I could push a button and later see that moment again. But I knew I would never understand its magic. I was just a girl who was supposed to get married, have babies, grocery shop, plan dinners that others prepared, play cards, or tennis, but definitely not know the secrets of the world.

I kept taking pictures and when I was twelve I caught Mother in her dressing room. I spent a lot of time here, wondering, Will I grow up to wear a girdle and stockings every day? Will there be no underpants or sox in my drawers? I may have nightgowns, but I won't wear perfume because hers made me choke.

I took pictures of her reading in bed, taking a bubble bath, dressed to go out with Daddy, talking on the phone. Mother spent the late afternoons in the bedroom waiting for Daddy to come home. If she was lying down, she often asked me to massage her stockinged feet. She said I did it better than anyone else. She was proud of her fabric headboard and of the bedroom's colors which had been carefully chosen for their stage of life. "A man in the ambitious period of his life needs restful tones in his home, Gay."

brownie pictures

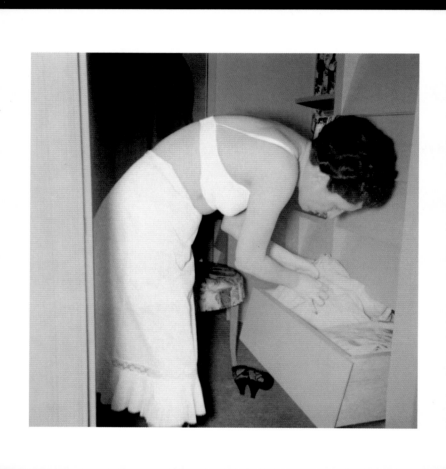

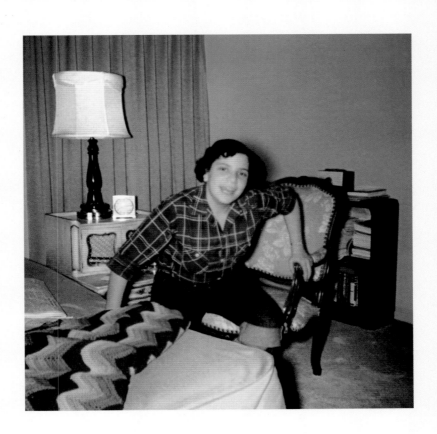

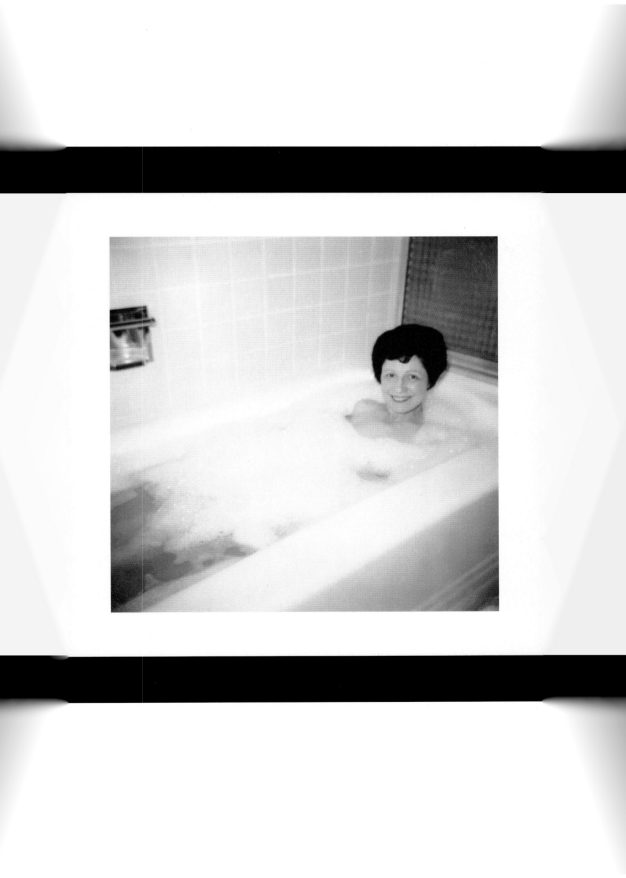

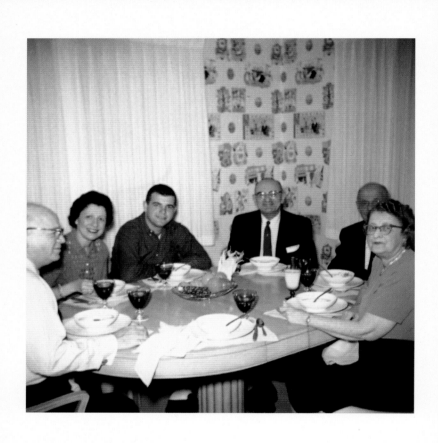

To discover details about Mother's social life I turned to her friend and sometime rival Jean Kaufman because I knew she would be frank with me. I suspected some wild times in their young married lives, which Jean confirmed.

"The Cotillion days…no one had the fun that we used to have. It was a very selective group and Bertha Alyce was always very popular. We had lots of unbelievably wonderful costume parties and sometimes we even went away for weekends to someone's ranch. Al and I were the first to resign because we just did not like some of the things that were going on. Once we walked accidentally into a room where a couple were making love who weren't married to each other, and it just turned our stomachs. Because they were good friends of ours."

social life

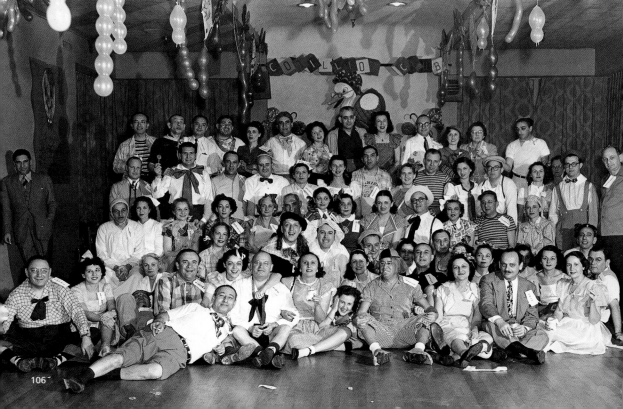

Shortly after they moved in they gave a party at their new house, and I wore a bright red dress, As soon as I got there Bertha Alyce told me, "Come upstairs, Jean, I want to talk to you about something." So I go upstairs and I said, "What is it?" She said, "I want you to put on some rouge." I said, "I have on rouge." She said, "You do not have on enough rouge. When you wear red, you have to wear an extra amount of rouge." So I smeared up more rouge on my face. Funny things you remember.

— Jean Kaufman, friend

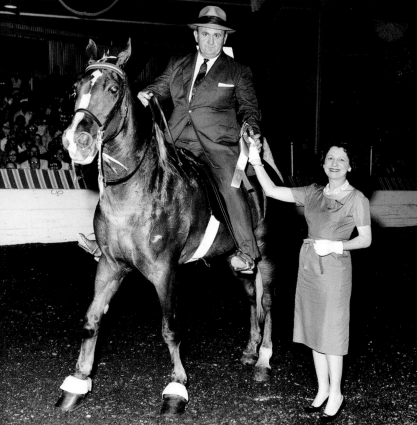

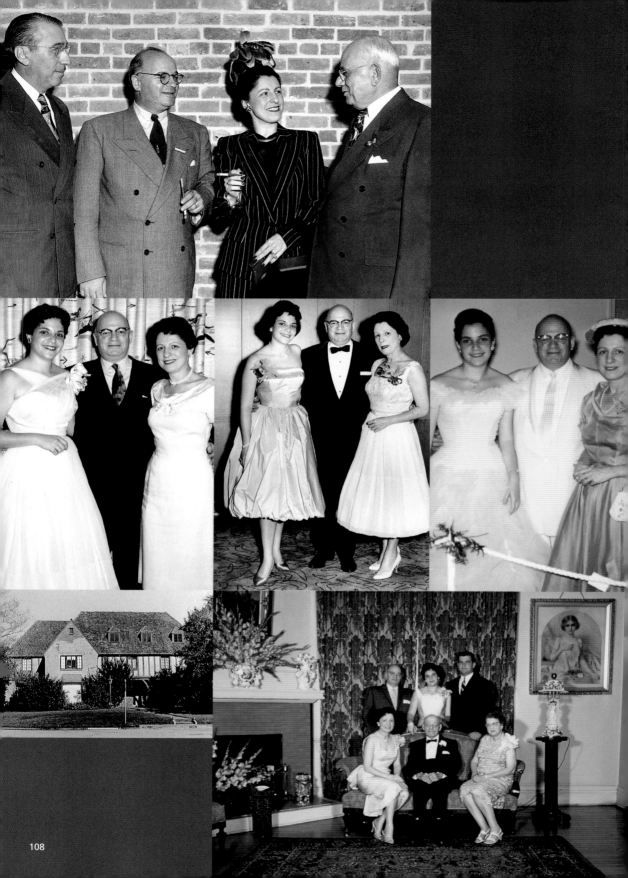

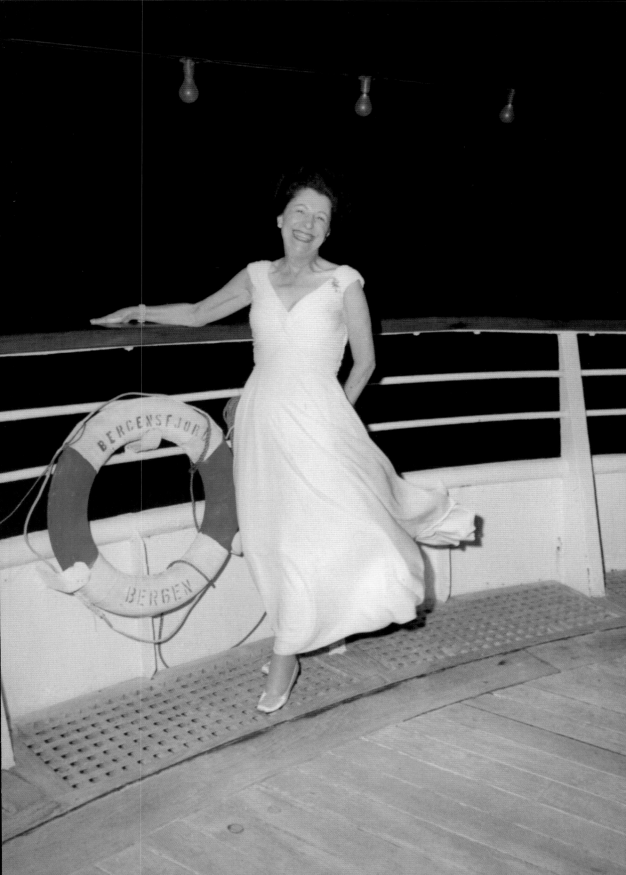

In my teens I began going to charity dinners that honored Daddy. I felt proud of him. Most of the time I didn't like being me; but at those times I liked being Gay Shlenker, liked the prominence of our family. I later understood that this public life took its toll on our family intimacy, of which there was very little.

Mother did some volunteer work when I was young, but after Daddy died, she began giving large sums of money in her own name and she became the honoree at these dinners. By then I hated going, and could only attend if armed with my camera. It became my shield and gave me an identity separate from hers. Perhaps I was shooting so that I could be seen.

When Mother was asked to fund an early childhood education center, she couldn't name it for Daddy because there was already a temple day school named for him, so she chose to call it "The Bertha Alyce Center." I was embarrassed to imagine "Bertha Alyce" as the name for a school. Now I can see that she was trying to establish herself, to become known as a philanthropist, just as I wanted to be known as a photographer.

Perhaps her most positive legacy is philanthropy.

philanthropy

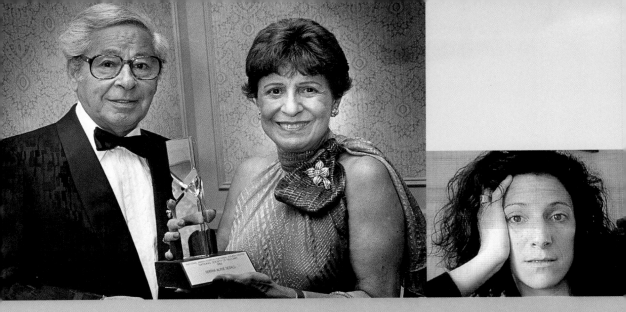

Gay, I can only say nice things about your mother. She was the most generous person that I've ever encountered in my life. All you had to do was just call, or write her a letter, for monies, for any cause, and she was there, helping out. Small sums, big sums, she gave generously.

— Al Segall, second husband

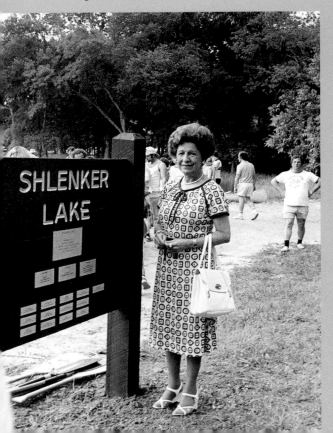

SHLENKER LAKE

First of all, her legacy is philanthropy, which is also *your* legacy. Which is even more than my grandfather's. As much as he was involved in community, I think she took that to a new level. She was extraordinarily generous and wanted to do things that would better the community. Sure, a lot of her things that she did were tied up in her ego, in what she got out of it, you know, in terms of how she was viewed. But I think a lot of it was her desire to do good things, to make good things happen. And she did that in abundance. She was not stingy with anyone.

I think that the way money has been handled in the family has been good because it was never handled in a dishonest way. Nobody ever pretended that there wasn't what there was or that there was what there wasn't. And people weren't kept without any money until someone died, and it wasn't held over you that if you did or didn't do this or that, you would or wouldn't get money. All that made the situation more healthy and natural.

— Alison Block Gerson, granddaughter

The year after my husband left, I guess around Thanksgiving, I got a check from her for $10,000. I was totally hysterical. It wasn't...it *was* the money, okay, but that's not what it felt. It was that she cared. I called her and I said, "I can't take this." She said, "Yes, you can. I give money to charity and all kinds of people I don't know. You're a face and a name and somebody I care about, and I want you to have the money." I credit Bertha Alyce with making me grow up, making me the person I am now. She was the first person who ever really told me that I was good.

— Lynn Masur, cousin

She liked being on the board of big institutions. She liked being honored and was willing to do what you had to do. It was the way she wanted to spend her money. That wasn't to show she was rich. And by the way, people always thought your parents were richer than they were, because they gave so much. That was to show she was important. And good.

— Former son-in-law

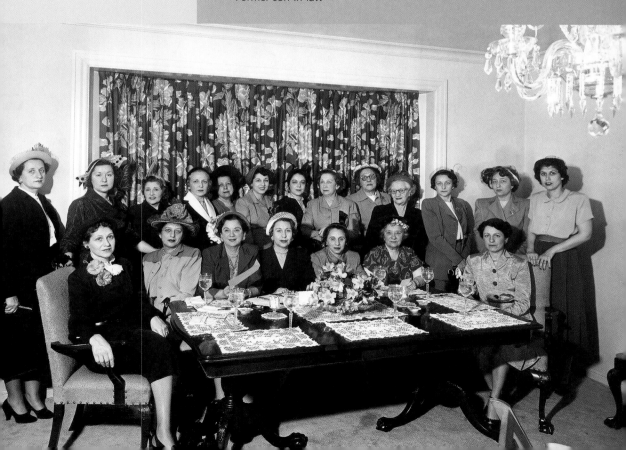

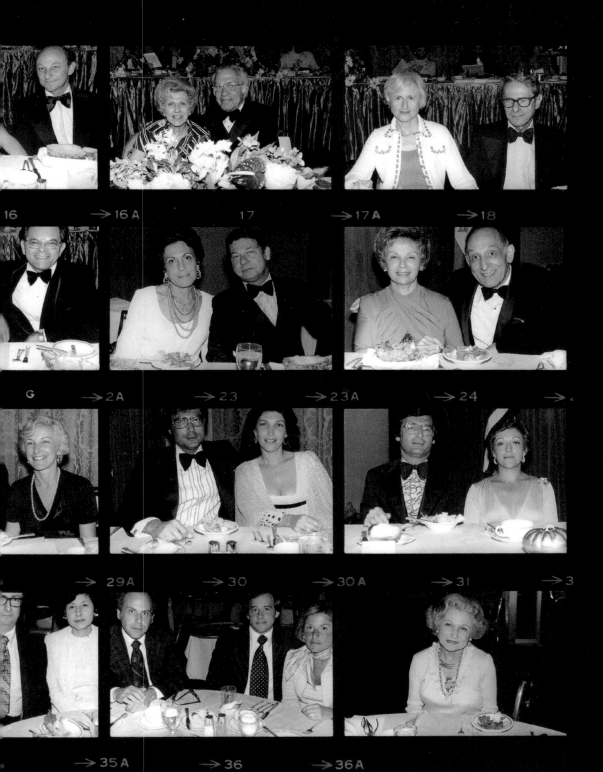

16　　→ 16 A　　17　　→ 17 A　　→ 18

G　　→ 2A　　→ 23　　→ 23 A　　→ 24　　→

→ 29A　　→ 30　　→ 30 A　　→ 31　　→ 3

→ 35 A　　→ 36　　→ 36 A

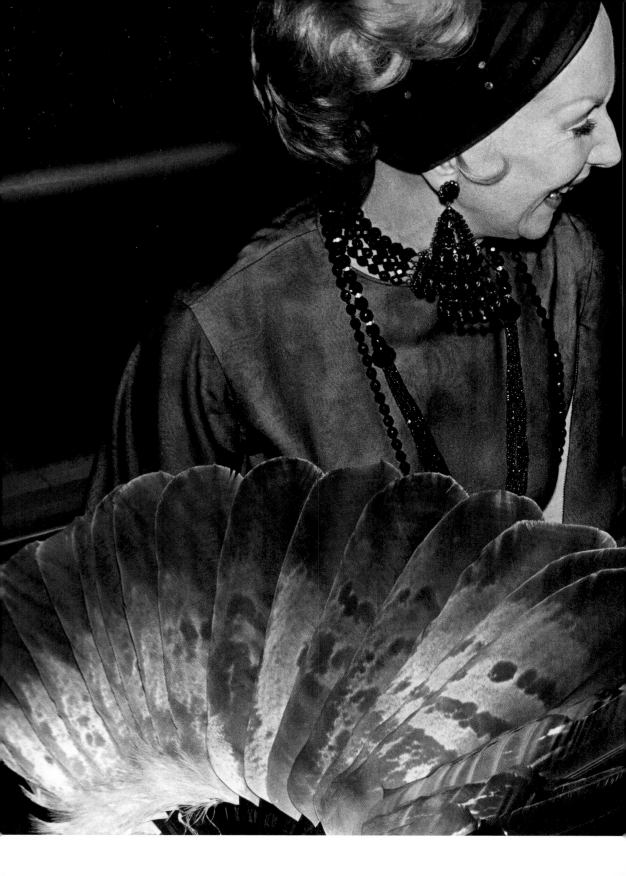

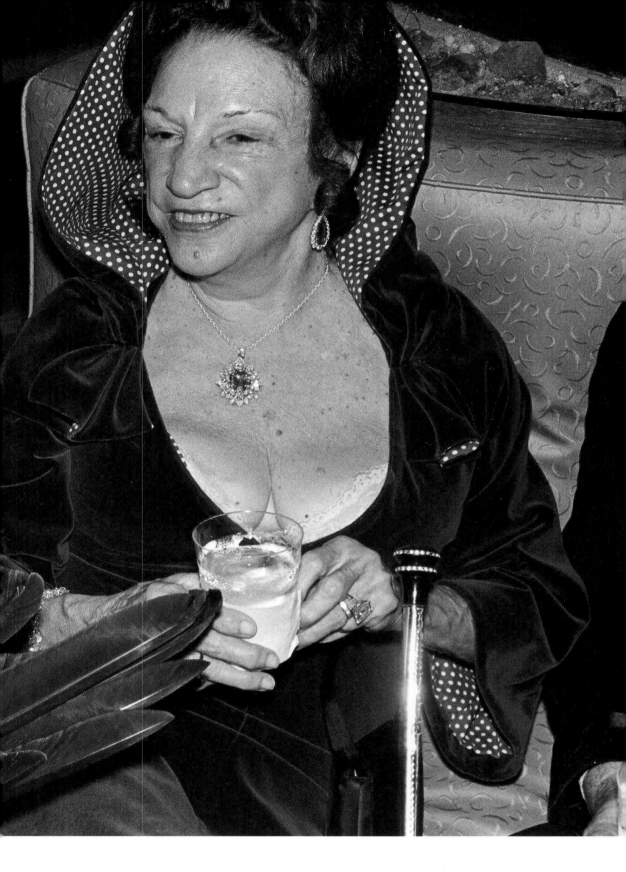

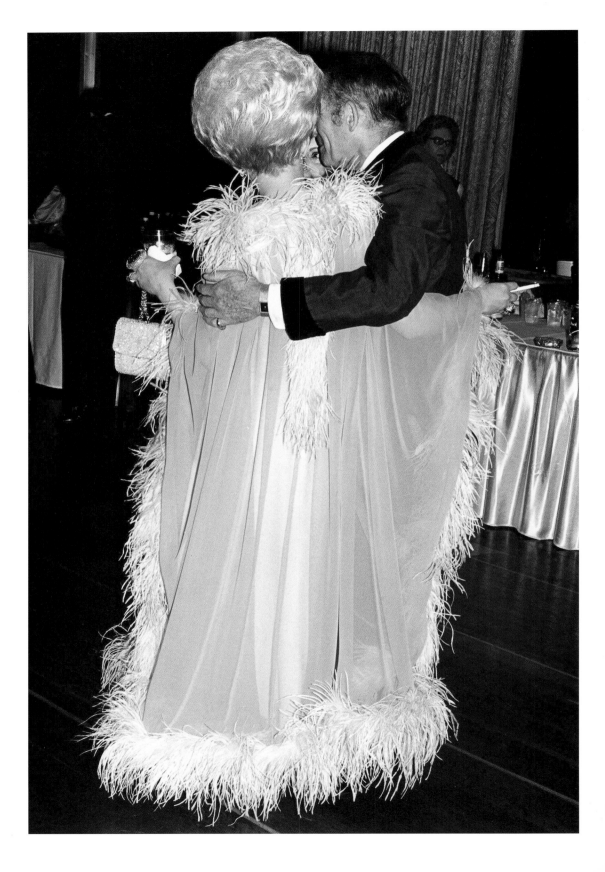

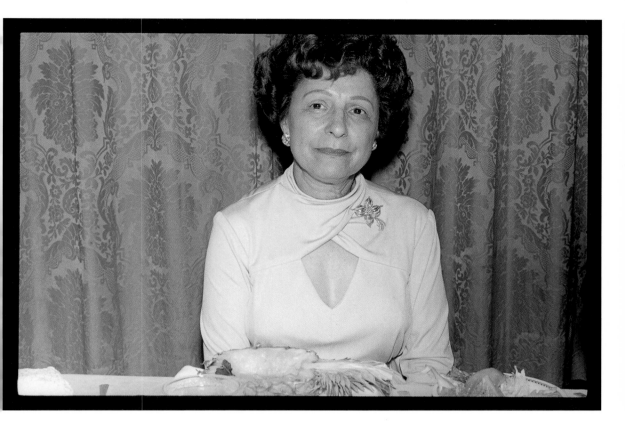

When Mother and I were asked to make a large donation to the Temple Endowment Fund, she asked me to do it with her. I agreed, but only if she'd do it anonymously. She consented but now I've amended our listing in the fund and attributed it to her.

I always made things difficult for her as she had for me.

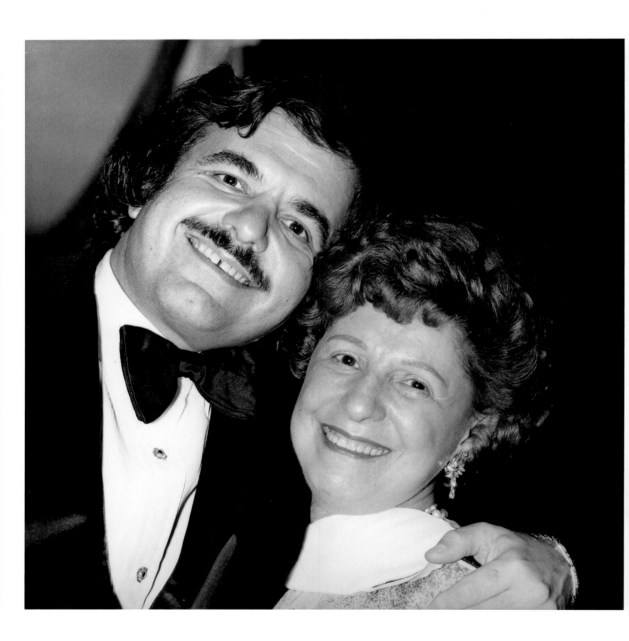

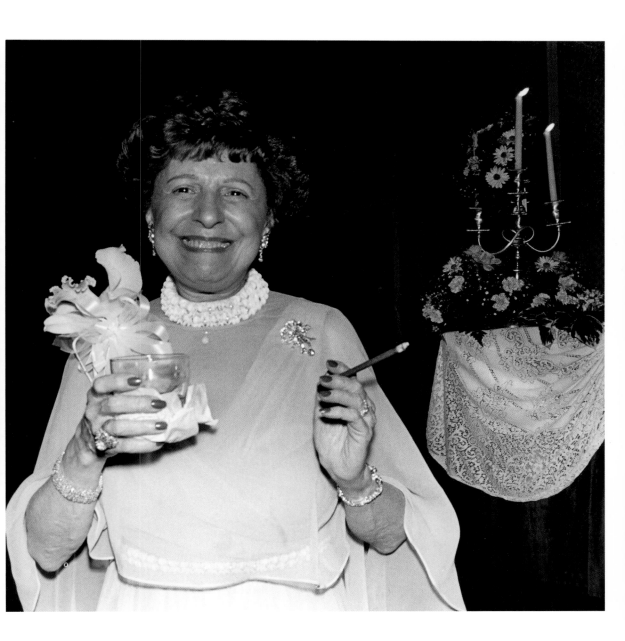

family

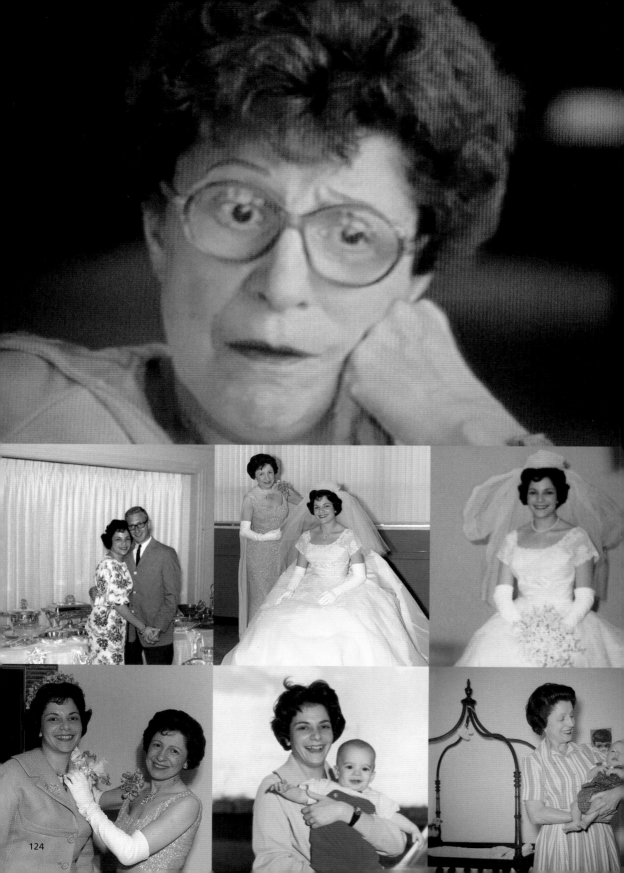

And then when you became engaged to Gus and we went shopping for your trousseau and made the plans for your wedding, I thought, "At last, I've found a meeting ground. Gay and I are getting together. We're getting together and it's great. I thought I had it made with you. But once you were married, pfft, you were through with me.

— Bertha Alyce

I think that everything Bertha Alyce did was power based, not love based. Purely power-based thinking provides only a rationale of winning, never loss or compromise or affection or compassion or understanding.

The chances of your standing on the courage of your convictions in the face of Bertha Alyce's windforce was tough. She had been a queen all her life and queens don't have to be civil. Her queenliness was probably just part of her natural tendency to remain spoiled and above it all, but along the way she showed all of us what it took to stand your ground, and then when we'd stand our ground with her, she sure as hell didn't like it, and the more she didn't like it the better she became at making the immediate environment miserable, which she could clearly do.

We would all talk about her, especially her family, about the things she said or did. You didn't confront her unless it was your job to do so, and third-party consultation wasn't something this family did well; we rarely closed ranks against the enemy. It was more likely that others would watch to see how you did.

— Andy Beck (Shlenker), grandson

After you and I had children I was really quite surprised that she was not involved with either of the children, although she was more with Barry than with Alison. But being a grandmother was not her number-one job in life. Or even one that interested her a lot.

— Former son-in-law

When I was young the two of us never did anything together. She never took me shopping, never had me over for lunch, never invited me to spend the night. Actually, there was not even an extra bedroom in her large apartment.

When I was older, we went for lunch together one day and I asked her why she found the company of men more stimulating than women. She said women were often petty and their interests did not go as deep as hers. With men she found her conversations were more animated, intelligent and sophisticated.

It wasn't a shock to me. I had known my whole life that Mimi preferred my brother just as she preferred my uncle over Mom, who didn't keep this a secret from us. And it was obvious with my brother. I think possibly if my mother hadn't told me that Mimi preferred Uncle Sidney to her, I might not have noticed that she preferred my brother and I might have taken it personally, but since I knew that, I wasn't as hurt as I might have been.

— Alison Block Gerson, granddaughter

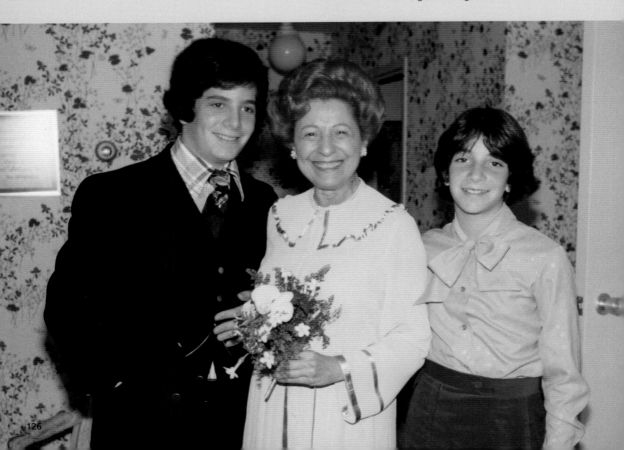

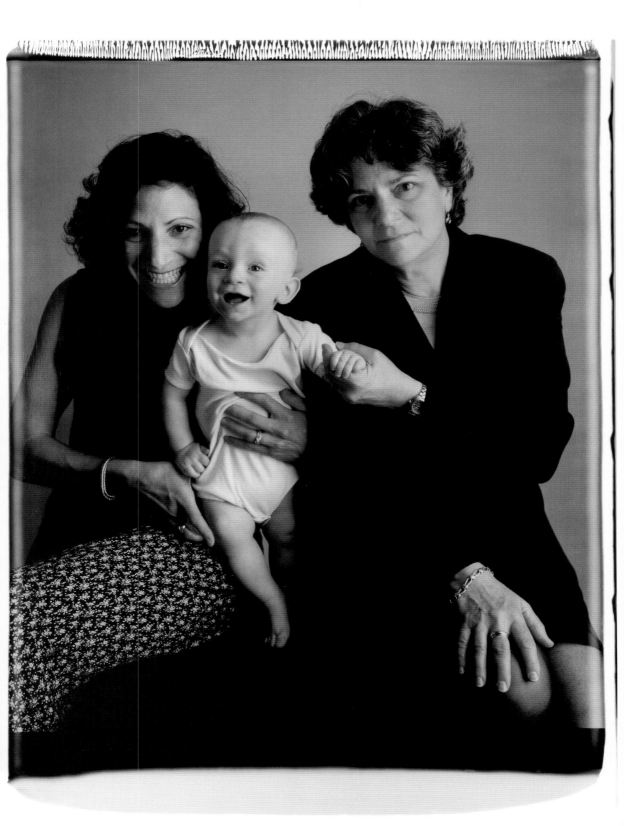

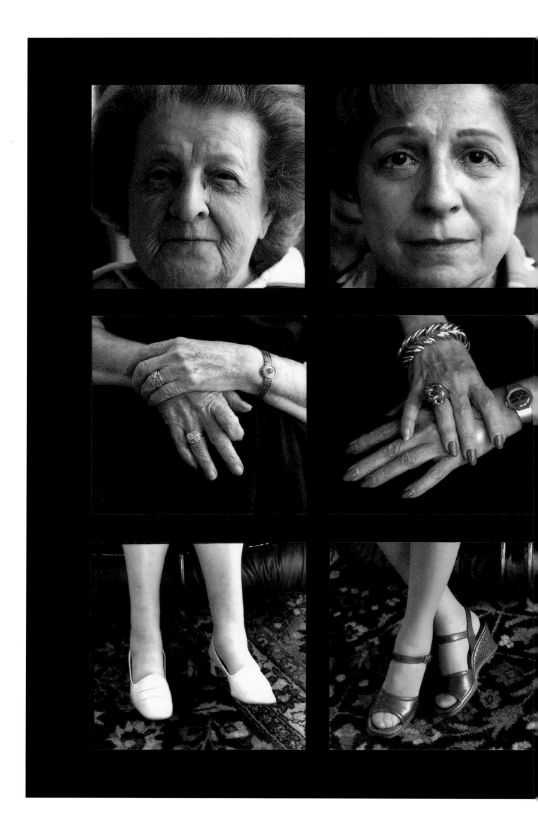

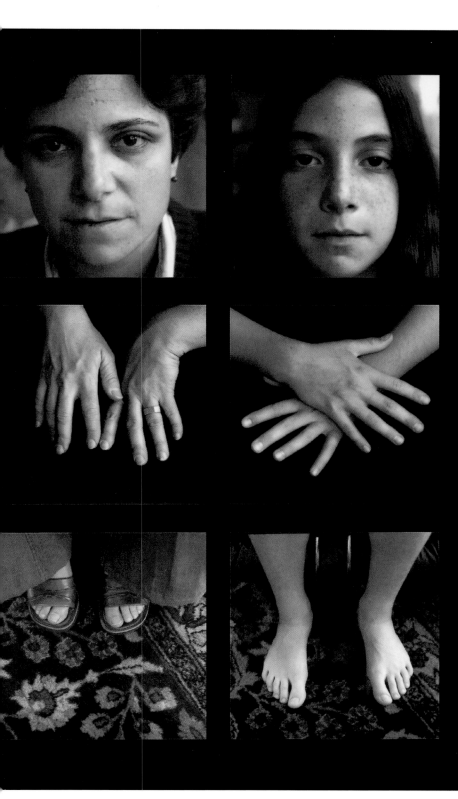

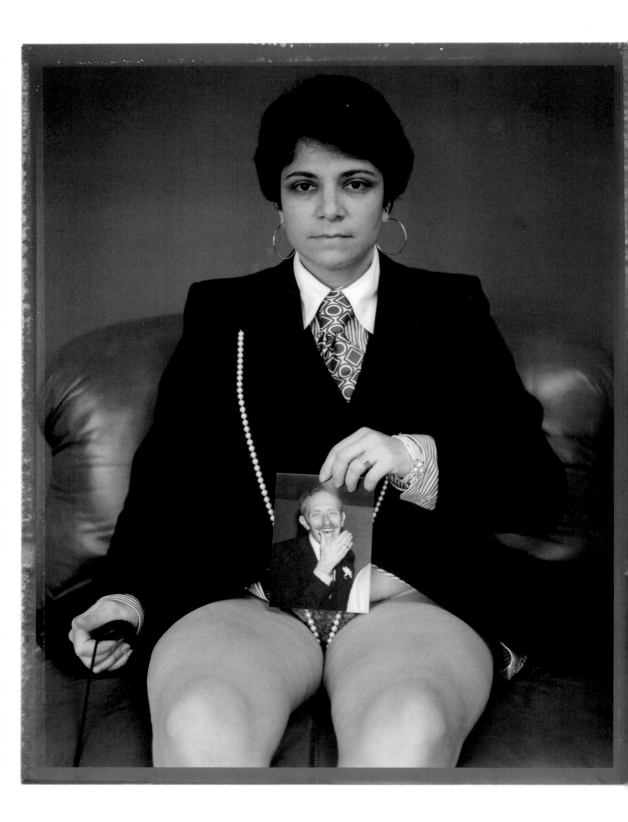

Two years after I made this self-portrait, I separated from the husband whose clothes I am wearing and whose snapshot I am holding, and began my first lesbian relationship. Soon after, Mother came to my house to tell me this story.

"Before I married your daddy I was very much in love with a man from Cincinnati. I thought we were going to be married but he jilted me. I was so hurt, so distraught, that I decided I would never be that much in love again.

Four boys had been asking to marry me. I chose your daddy because I thought he would be the most successful.

Years later, about a year before you were born, this old boyfriend came to Houston to find me and I wanted to leave Irvin for him. While I was trying to decide what to do, I told Irvin's best friend what was on my mind.

'You can't leave my friend, Irvin! It would break his heart,' he told me. So Irvin's friend made a deal with me, an unspoken deal, to keep me from leaving your daddy. We met four or five times a year at the Rice Hotel, for the next twenty years."

What was your message that day? Were you encouraging me to stay with my husband and have my flings on the side, as you did, or were you wishing you had left your marriage, as I was doing? Perhaps you were simply telling me you understood. Regardless, I resented your trying to say we were alike.

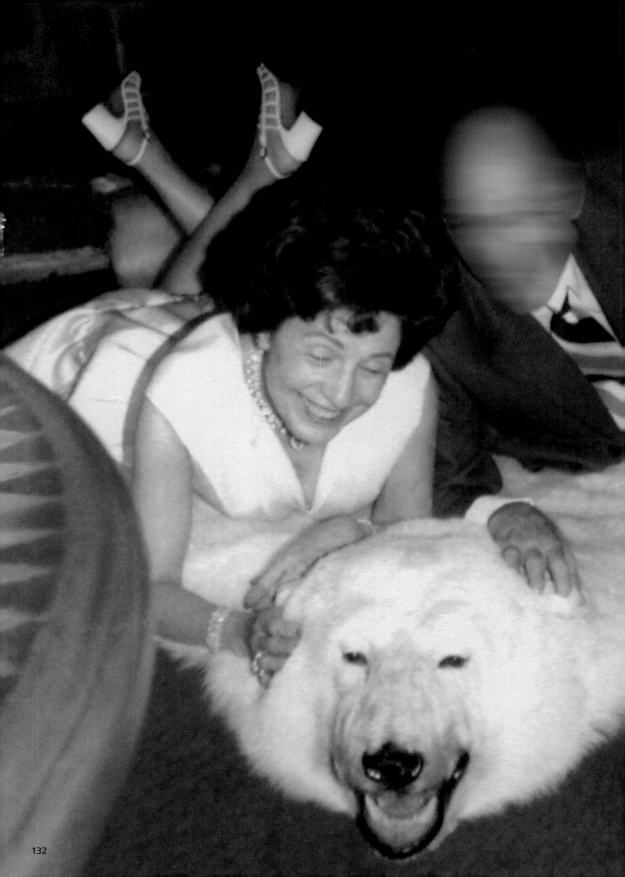

I think of you each morning,

I dream of you each night.

Since you became a part of me,

My life seems quite all right.

I didn't know what I was missing,

All those years were such a waste

'Til you taught me what love could be

And of rapture I had a taste.

I may fuss, cajole, and fume

When I can't have my way.

I don't really mean to be difficult

I only want you every day.

I've tried to analyze my feelings,

The physical is only a part:

You're sensitive, sweet, sublime,

I love you with all my heart.

— Bertha Alyce, May 1972

Here's how I see it, Mother. Your affair began in 1966 and ended in 1974. Daddy died in 1971, in Acapulco, on vacation with your paramour and his wife. You turned our family into an embarrassing soap opera.

Silence. Characteristically, you don't respond. But now, ten years after your death, I see the words on your face: "Who are you, daughter of mine, so relentlessly judgmental?" Yes, who was I? How could I? Why did you have to die for me to stop judging you?

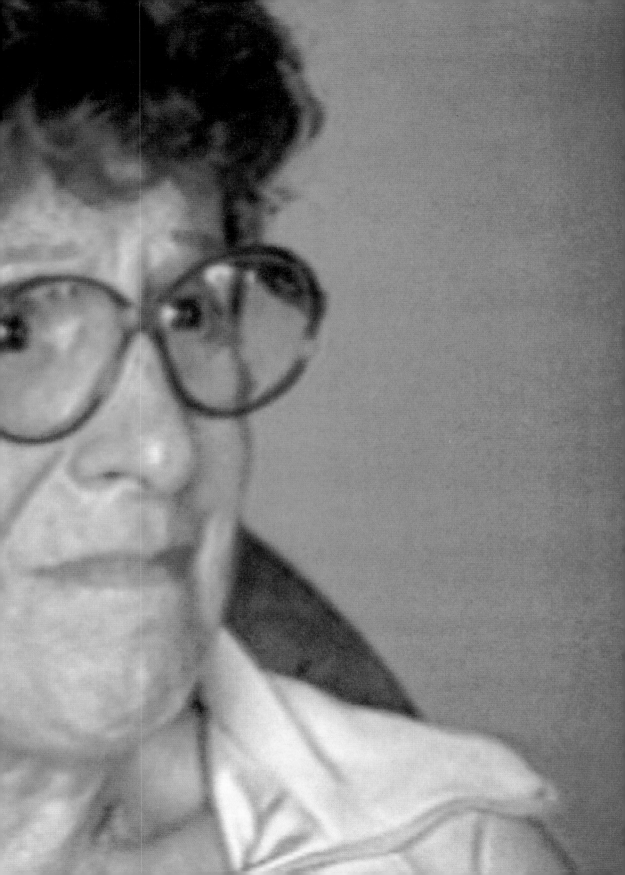

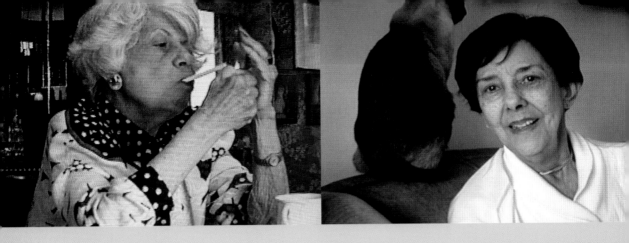

I think I blame Bertha Alyce because I think she was a flirt. She was very vain. She loved attention. And I think she set out to…and D.K. was a good looking man. I think she deliberately set out to attract him, which isn't unheard of. That's my opinion. I think a woman can refuse a relationship quicker than a man, if a man makes the first move. But if a woman makes the first move, I think he's sorta helpless.

— Jean Kaufman, friend

Sometimes they went to a motel. I wasn't so much opposed to what she did with D.K. because if a person needs that, it might make them a nicer or more loving person to the people around them. What I disapproved of was how blatant she was about it and how she didn't care who knew. She had a lot of friends who were married and it didn't mean that she would keep her hands off of their lapels, because her hands were always on somebody's lapels.

— Lorraine Kaliski, cousin

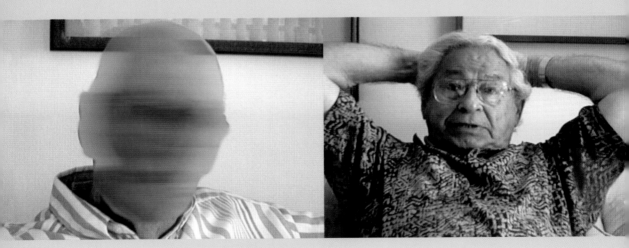

I don't think one can blame anyone for anything, but it just evolved. It had nothing to do with my being a flirt. Maybe both were flirts, I don't know. I think it was a fifty-fifty sort of a thing.

— D.K.

She knew that many people disapproved of some of the things she had done, but she didn't give a damn about that; that didn't bother her at all.

— Al Segall, second husband

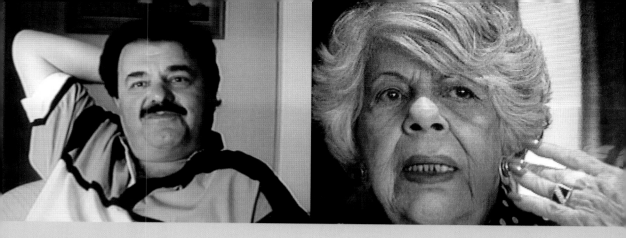

I don't think she ever felt there was anyone, man or woman, better than she was. And I think she was probably right.

— Sidney Shlenker, son

She thought she was better than everybody else. She may have been richer, she may have had better clothes, but I'll be damned if she was a better person than I was. And I used to resent it.

— Jean Kaufman, friend

Sidney: You'll never convince Jean Kaufman that Mother was a good woman. So I don't think you'll redeem your mother with those people, ever.

Gay: That's true. But the redemption isn't for them. It's for her and for me, and my camera has taken me there.

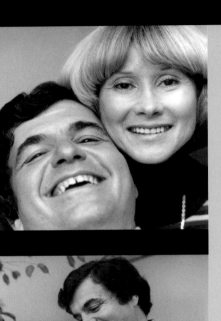

I met Bertha Alyce in the spring of 1962. Sidney and I were living together. We didn't marry for about five years. But just about a year into our relationship, Bertha Alyce began to enjoy my company, and to trust me. She told me about an affair she was having, and I was appalled because I thought she was married to the most wonderful man in the world, Irvin Shlenker. But to her, females were in her way, or not smart enough, or not good looking enough. Frankly, they bored her. She loved the adoration of men and flirting with the opposite sex.

One of my fondest memories is a trip we took to the Scandinavian countries. After a full day's walking tour — walking for her was unbearable unless she was shopping — we stopped in the hotel bar, took off our shoes and ordered martinis. When they arrived, she lit a cigarette and turned to me and said, "What a great day! Now I think we should have a drinking contest." I replied, "I can drink you under this table."

Needless to say, several hours later and a lot of guys coming over to hit on us, I was crying uncle. That was the day she asked me to call her B.A. and not introduce her as my mother-in-law. She was probably my best female friend. She was definitely a Southern Belle and very selfish, but she was never a manipulator. She was direct and to the point, so much so that it was irritating. It wasn't what she said, but how she said it. She would use a tone of voice like a slap in your face. However, when I got to know her, it was easy to overcome this fault.

— Marti Shlenker, Sidney's ex-wife

Any toughness I have I think came from mother. She was a very determined woman who was strong in her beliefs, stated them often in a curt manner. She could be very unkind, mostly to people she knew. If she had a feeling that some opinion you had was dumb, she'd say, "How could you do that?" or "How could you think that?" And you'd know she thought you were an idiot; her reaction was chilling. I never liked that about her, but every now and then I find myself doing it, too. Her one quality that I didn't like has become the part of me that I like the least.

— Sidney Shlenker, son

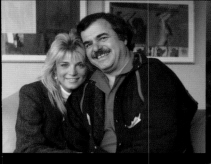

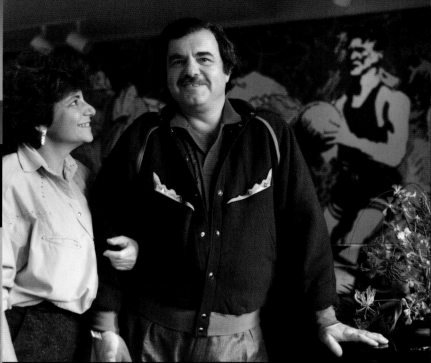

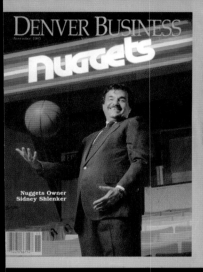

Nuggets Owner
Sidney Shlenker

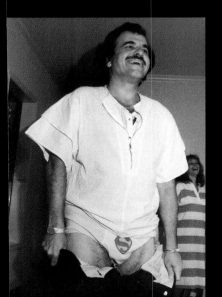

Mother adored Sidney — he was everything to her — and Daddy couldn't say no to him. He was popular with the girls and boys. The kids in high school called him King Sidney, the king without a country. Sidney thought he should have had a country. I wished that I were Sidney, and often wondered why I had to be me instead of him. While I idolized him, I also loved him; He seemed to understand my predicament in the family.

Everything was possible, even for the adult Sidney. He thought he could "have it all," both marriage and someone else on the side, all-consuming work and a person waiting at home for him. We shared the same legacy: I, too, didn't see why we had to make choices.

Sidney was larger-than-life. When he left the bank where Daddy was chairman of the board and went into the entertainment world, his career skyrocketed. He ran the famed Houston Astrodome, and it was there that he masterminded the historic Billy Jean King–Bobby Riggs tennis match. He bought cable TV stations and made millions for himself and his friends — and for me as well. He married again and became a father at fifty. When he bought the Denver Nuggets basketball team he became famous in Denver.

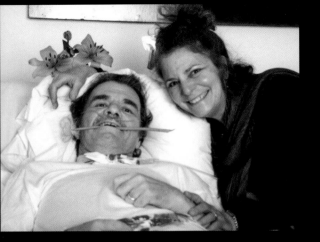

Fate got the best of Sidney. In 1998 he had an automobile accident that left him a paraplegic. In most ways his life has become the opposite of what it was. He is blessed, however, with the love of his wife and three children. Our roles are reversed now, but I cling to him as if he is all I have.

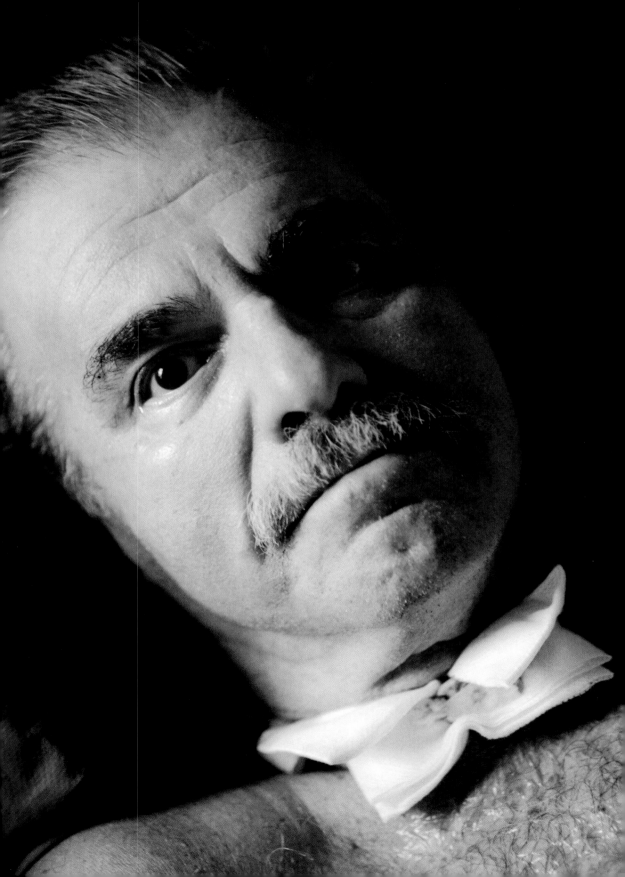

lesbian

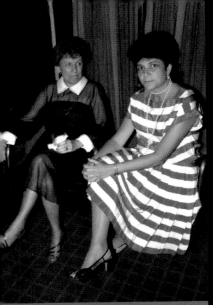

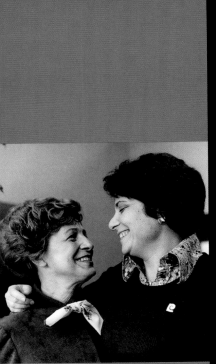

Bertha Alyce: One of my friends said to me one day, or maybe more than one of them has said to me at various times, "Is your daughter married?" "Well, she has two fine children, but she's divorced." And I tell about your children. Then they ask, "Is your son married?" "Yes, but they haven't lived together for eight years." And they say, "How can you laugh over this? Doesn't it upset you?" I say, "No. Fortunately I have found happiness in my life and if this is the lifestyle that makes them happy, what am I supposed to do, put a paper bag over my head?"

Gay: Well, but in terms of personal relationships, I'm with women instead of men. Do your friends ever ask you about that?

Bertha Alyce: No.

Gay: You have very polite friends. How do you feel about it?

Bertha Alyce: How do I feel about it? I'm not overjoyed, but if this is your lifestyle — you're at an age that this is your life. It's not MY life anymore. I brought you this far and I can't take you any farther, and neither can I force or impose anything on you in your lifestyle anymore.

Gay: But is it an embarrassment for you?

Bertha Alyce: Oh, the world is different now. That's why I guess it isn't.

Gay: I think that's something you could definitely be complimented for. That's an obnoxious way to give a compliment. I appreciate your feeling that way.

Bertha Alyce: I only accept it because it makes you happy, and that's all I want. I couldn't ask for more than that. That's all I wanted for you. That's the only reason I can accept it.

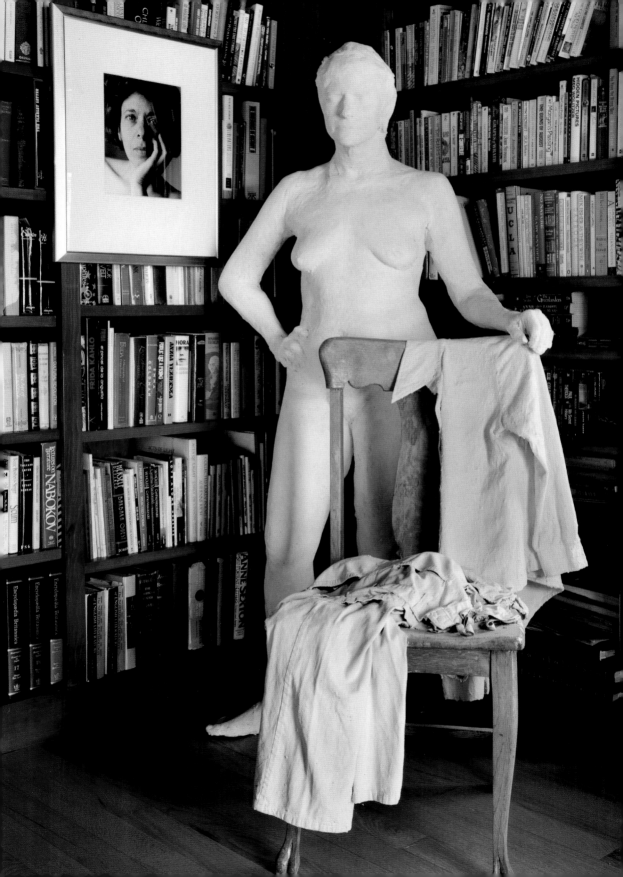

MALKA — I think that reading at the table is a gross habit. I hate to read and eat — the food gets cold.

The only time its O.K. with you for me to read is when we're in bed, before we go to sleep. And then I read one page and fall asleep.

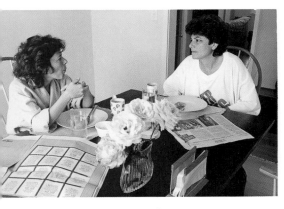
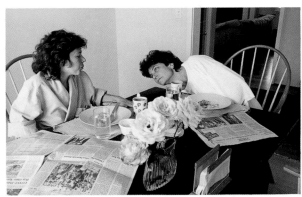

...then read — I'm sorry.
...something I've always done —
...you don't want me to,
won't. But I don't see
...something wrong with it.

You're really right. I'm
sorry. I think I got mad
because I dropped my
napkin and it was hard
to pick up.

Gay Block
Malka Drucker

 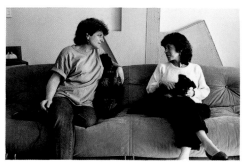

MALKA — I don't dislike these dogs. They're cute. But I hate having puppies. They're an interference in my life.

I know, Gary. You've told me this before. Why do you have to keep telling me?

Because
you to f
don't wa
think I
my mo

 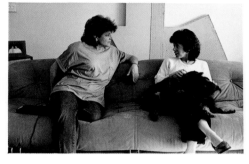 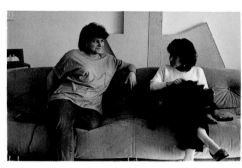

it want
. and I
ou to
hanged

If I promise to remember
you don't want puppies
and I don't take your
silence to mean you've
changed your mind,
will you stop telling
me your feelings all
day long?!?

OK

Gay Block
Malka Drucker

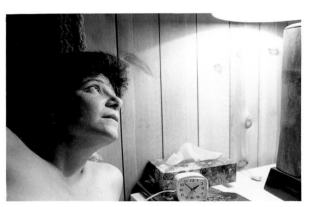 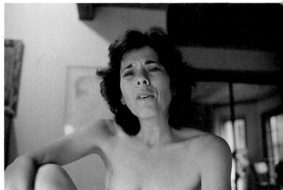

MALKA — do we have any
bug spray?

Gus. don't you know the
meaning of peaceful
co-existence?

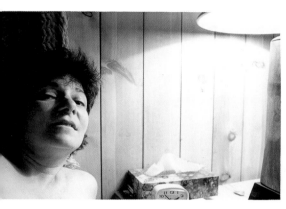

no — and neither does
that fly who's going
buzzzzzz3 3 — —

Didn't the sixties make
any impression on you?

Gay Block
Malka Drucker

What're you reading?
This is interessting - come read it.

UST FORGET IT. I'll read it
later. By myself. I
don't like reading with
you. It makes me feel
stupid because I'm such
a slow reader.

And it makes ME feel like
a superficial reader —
so shut the fuck up!

Malka Drucker
Gay Block

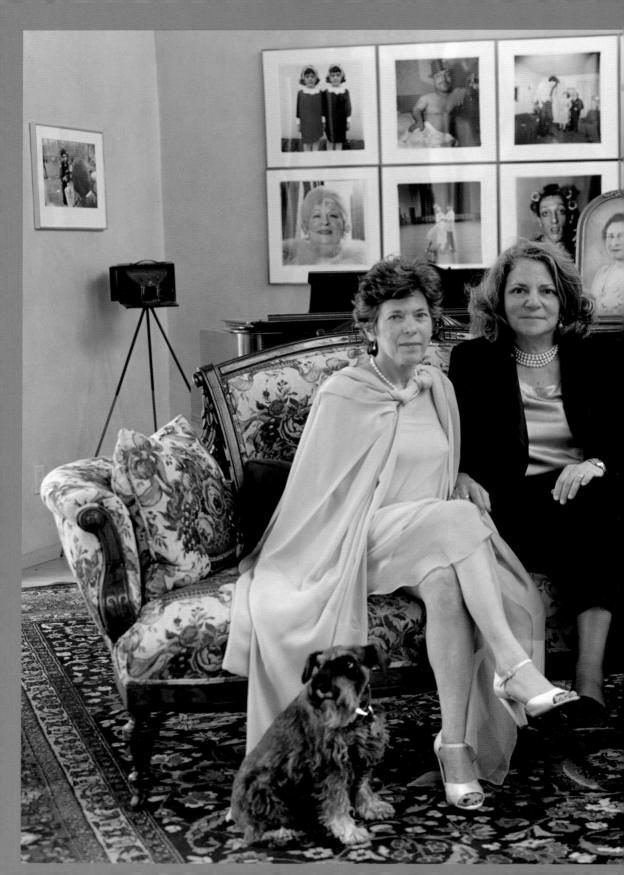

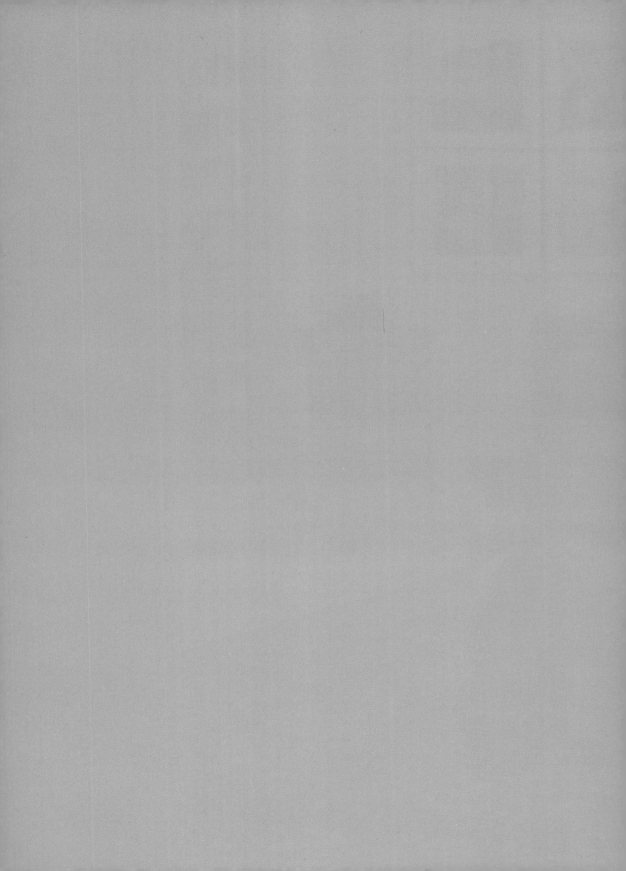

beauty

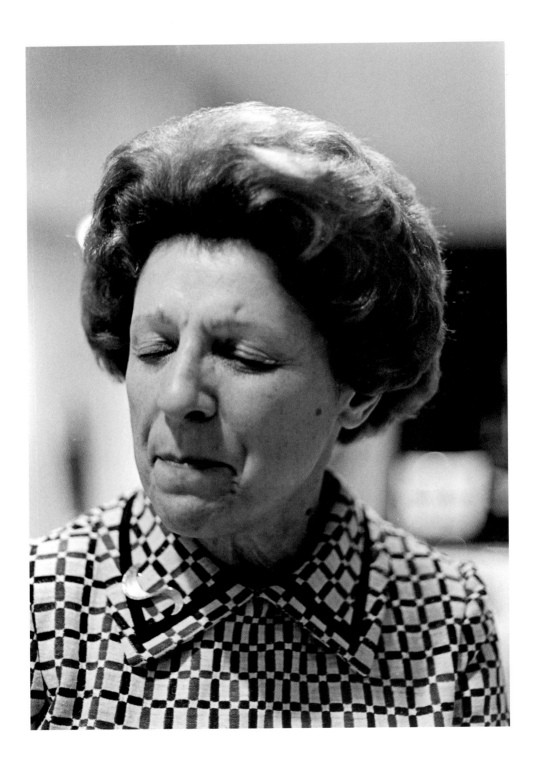

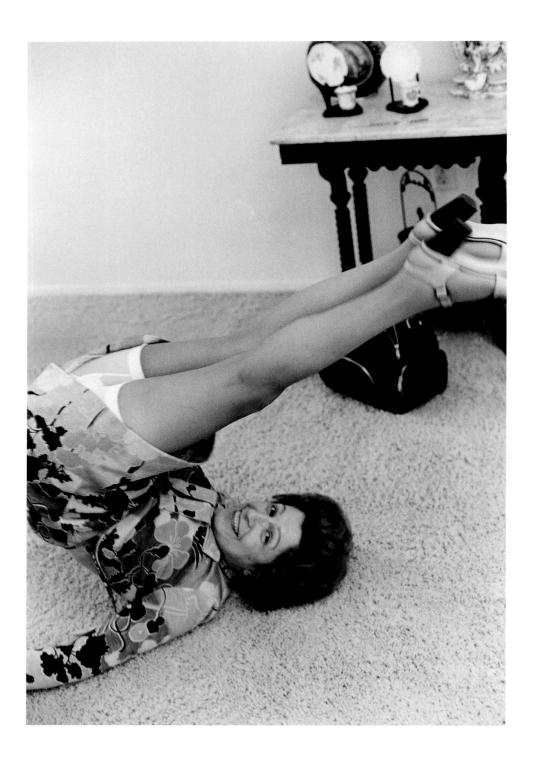

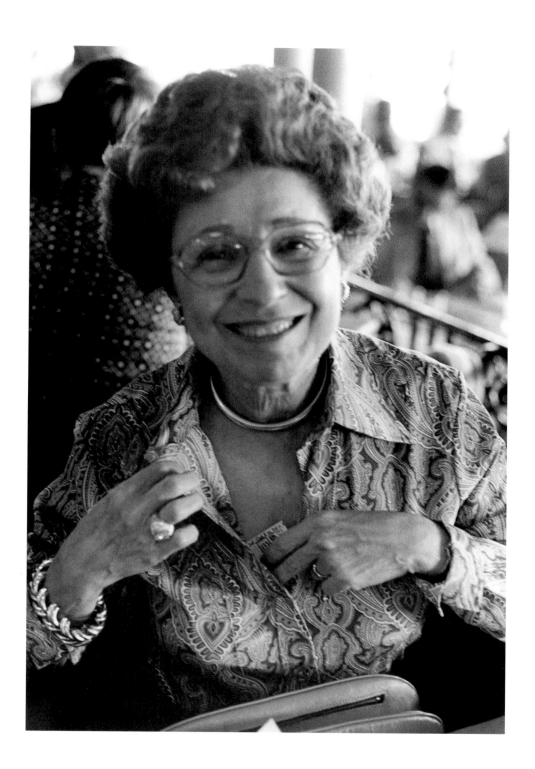

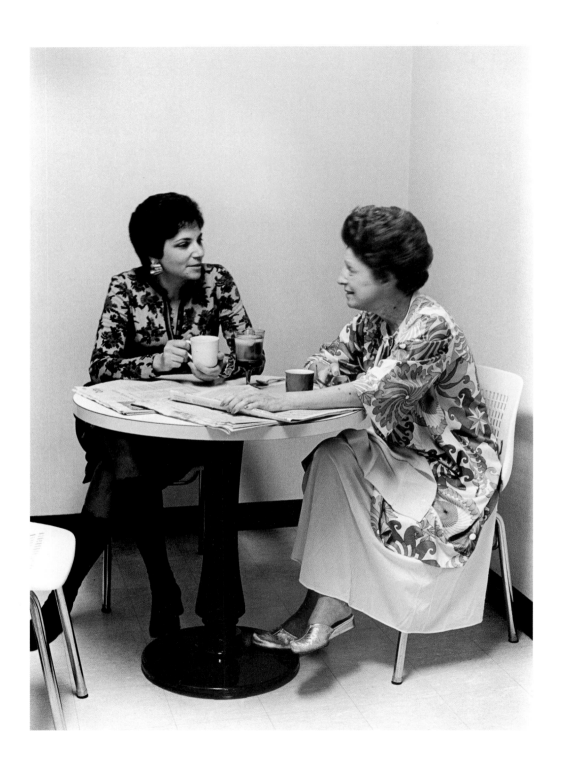

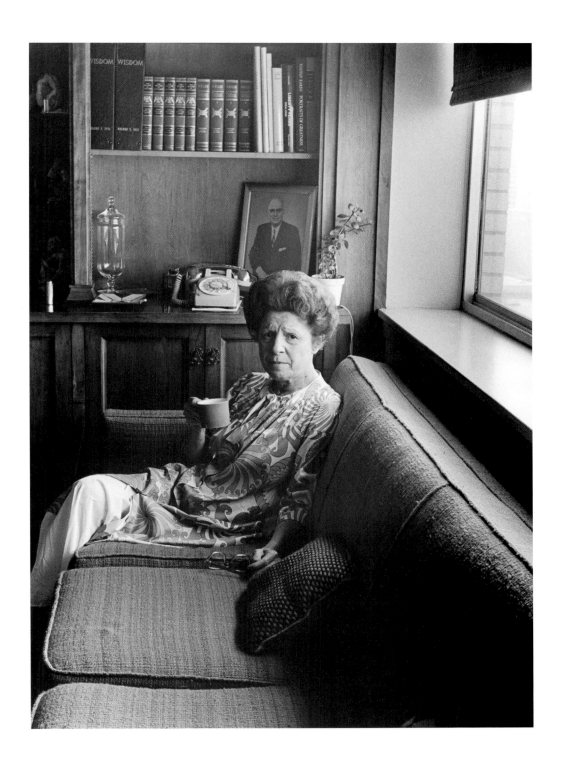

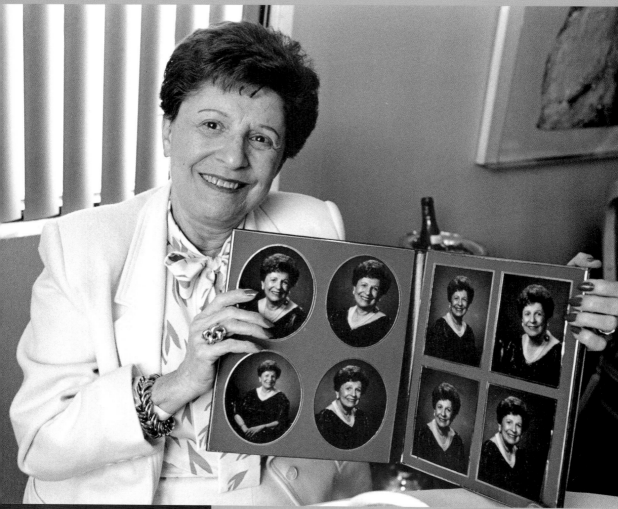

Mother was happy to pose for my pictures, but when she needed a portrait for her own purposes she went to the commercial studio. "Your pictures show all my wrinkles, Gay. I prefer Kaye Marvins' because they touch them up." I found this air-brushed portrait at the temple on the wall with all the other Sisterhood presidents. I couldn't let it stay there, fading and ugly. I replaced it with my favorite black and white portrait of her.

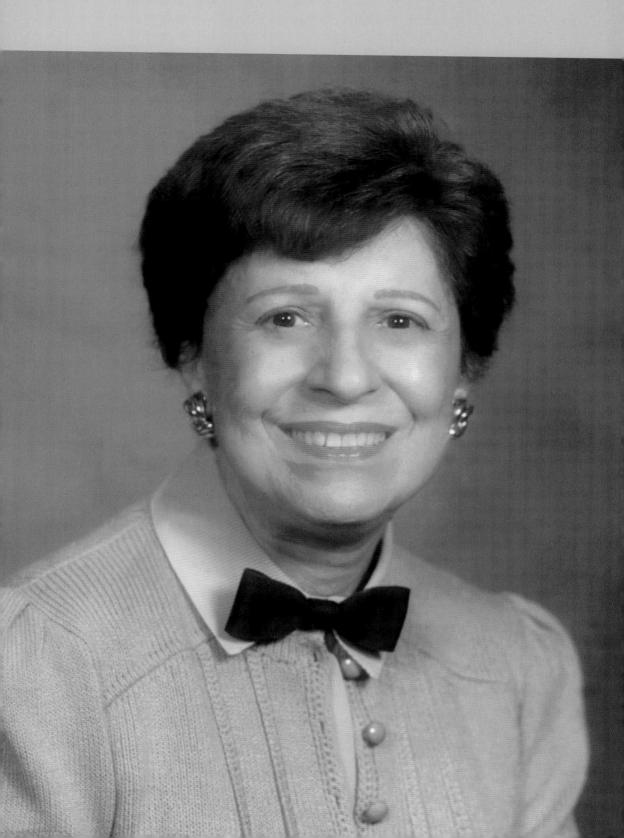

Many of my conflicts with Mother revolved around the issue of beauty. The day after she and Daddy went to a party, she would tell me about the men who had asked her to dance, which people told her she looked pretty, who said they liked her dress or her hair. I hated this litany.

Daddy often told me obliquely that I didn't measure up: "Your mother's the most feminine girl I know." But I knew his picture of her was all wrong. She wasn't feminine. She was harsh and saw all women as rivals — even her daughter. My picture of myself — which I believe she directed — revealed me as fat, dumb and ugly.

One day when I was in fifth grade something felt different. I dressed for school that morning as usual. (Mother always slept late. Freda gave me breakfast and the chauffeur took me to school.) But the difference was that I thought I looked great. I was wearing my favorite blue checked shirt, red plaid skirt, and a wide red cinch belt with a gold buckle. I had the greatest day at school: I did all my work perfectly and all my classmates seemed to think I was terrific. I came home feeling very good until Mother took one look at me and said, "Don't you know that plaids and checks don't go together?"

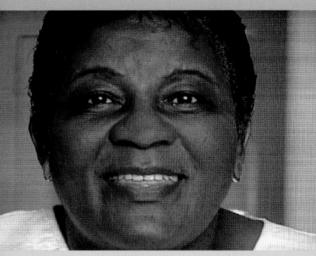

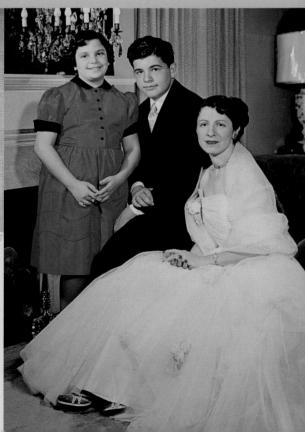

She always reminded me of Queen Elizabeth. She reminded me so much of the queen because of the way she carried herself. Everything was right in place, everything was just like it was supposed to be. She had that kind of air about her that demanded respect and attention without her ever saying anything. I just always did like her.

— Birdie Tilden, family friend and employee

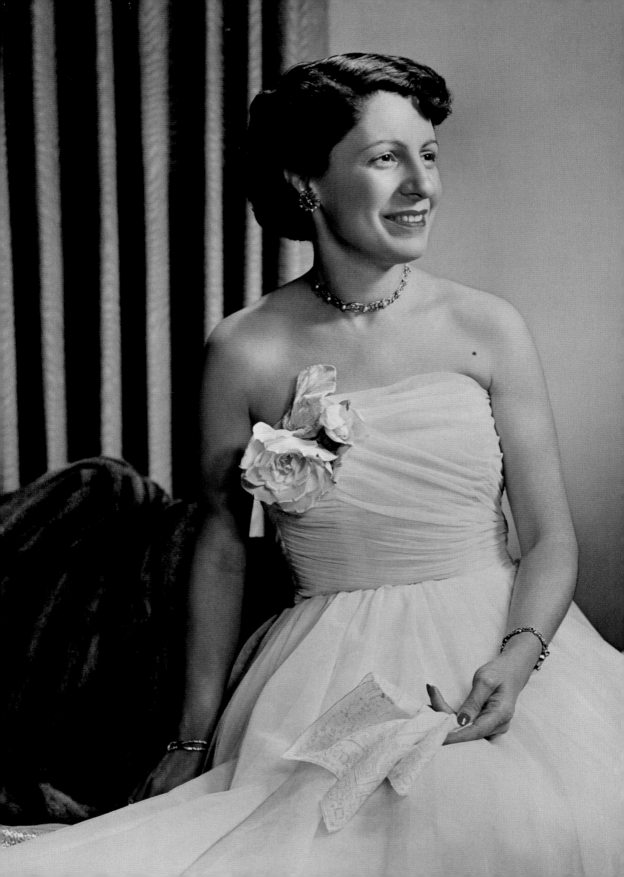

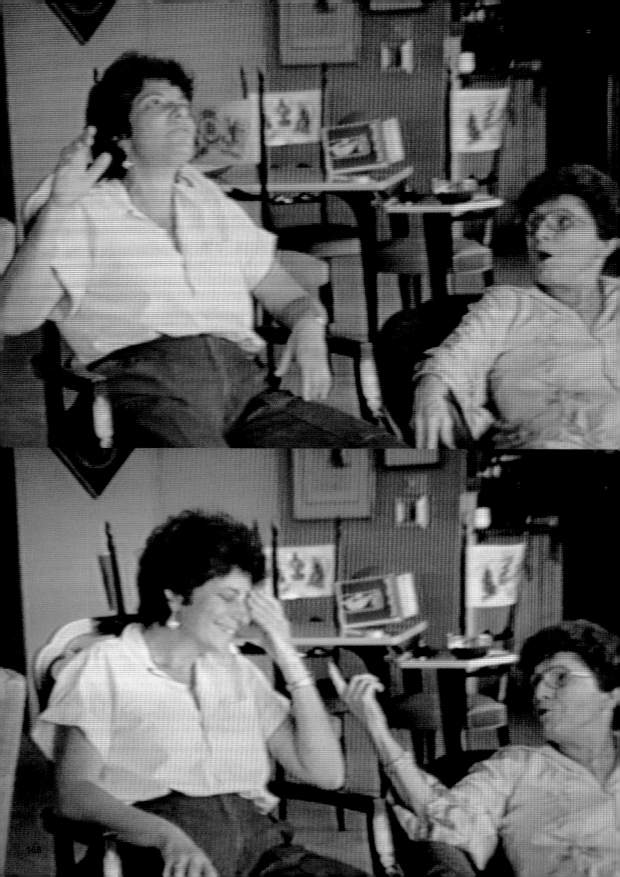

Gay: To this day I hate going shopping because when I go into a store I know everyone is looking at me, saying, "Look how fat she is! Isn't she ugly? How does she think we can put clothes on her?" because that's what you used to say when we went into a store. You would say, "You're too fat to wear the cute clothes."

Bertha Alyce: I never said that. You thought it was coming, you had it in your mind. I never said that.

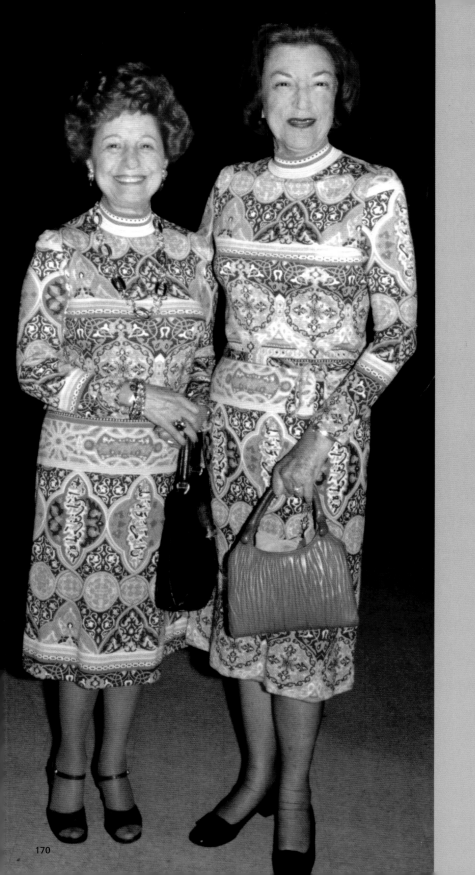

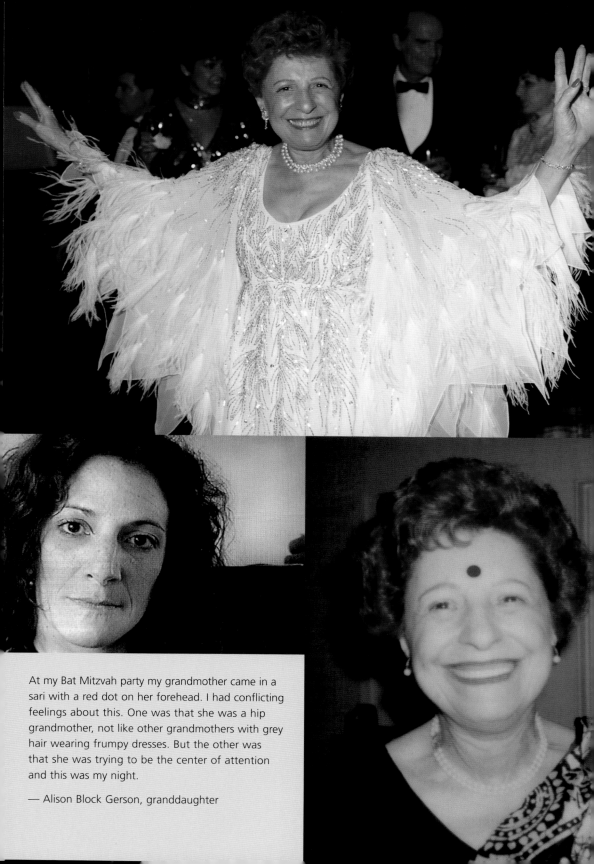

At my Bat Mitzvah party my grandmother came in a sari with a red dot on her forehead. I had conflicting feelings about this. One was that she was a hip grandmother, not like other grandmothers with grey hair wearing frumpy dresses. But the other was that she was trying to be the center of attention and this was my night.

— Alison Block Gerson, granddaughter

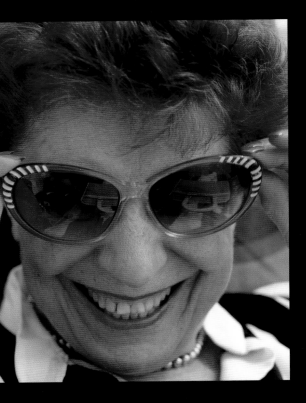

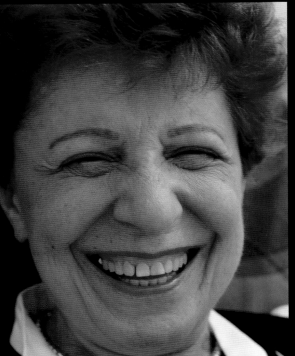

I adored your mother; I thought she was great. She was theatrical and I was, too. I loved the way she lit her cigarette. I remember being at Bertha Alyce's apartment when she was just out of her bath, and she was lovingly putting lotion on her body, very sensually, in front of the mirror.

— Carol Kaliski Wise, cousin

The only thing I ever criticized about Bertha Alyce — and I was very vocal — was her red hair. She let it get so fiery red. And, after all, it was originally dark brown, like yours and mine. She always had a very nice figure and she took pride in showing it off. She really did. She wore very low-cut dresses. I would say it was very obvious that she was very vain. And that isn't necessarily critical. She was very proud of her home, of her children. She adored that apartment at the Lamar Towers, and it was beautiful.

— Jean Kaufman, friend

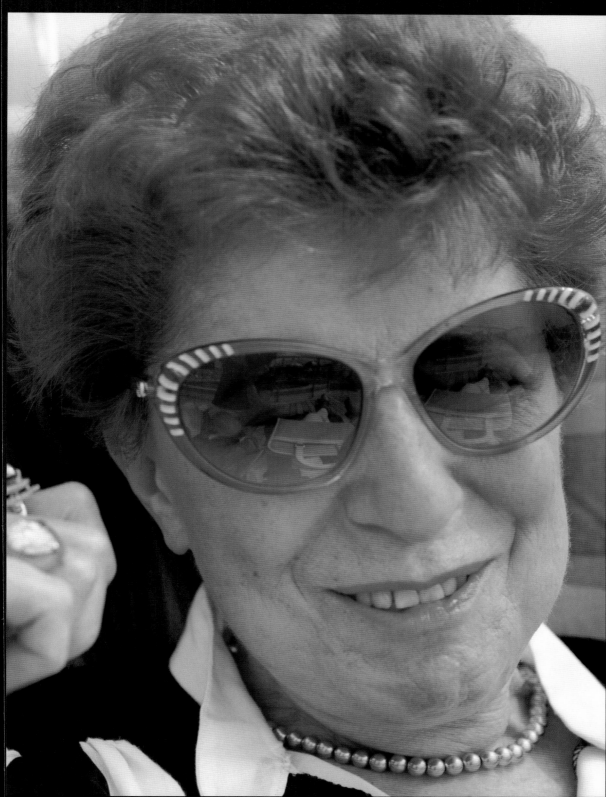

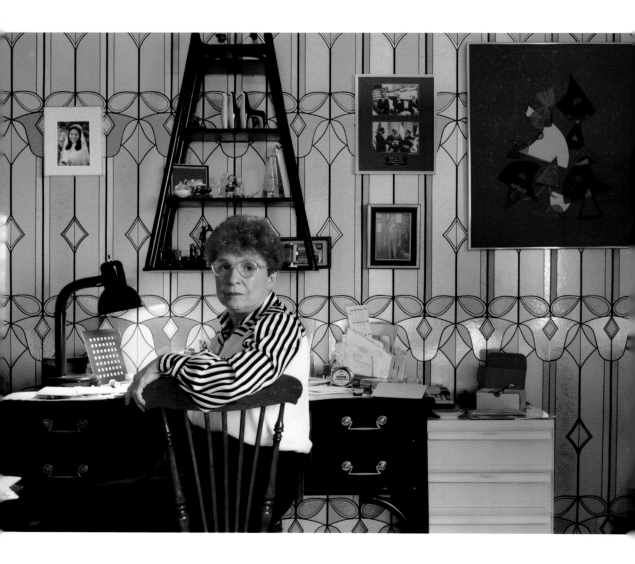

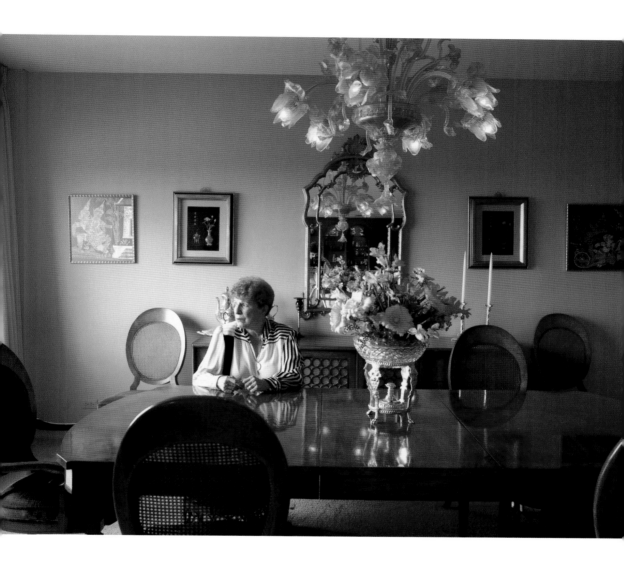

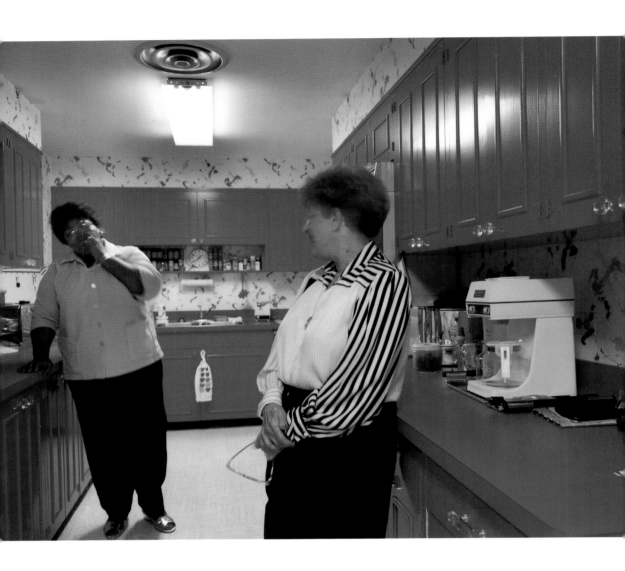

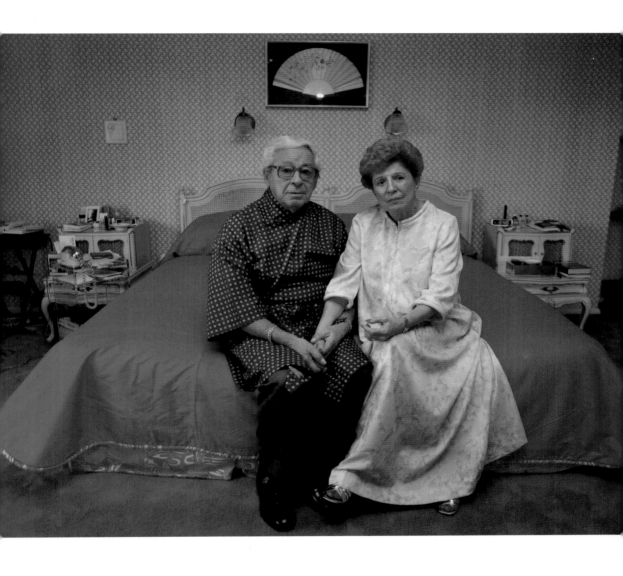

Everyone thought Mother was beautiful. I didn't see it. I photographed
her almost constantly before her death, but I rarely exhibited the
photographs. I couldn't. They looked angry to me. It was not until a
couple of years after she died that these same pictures no longer looked
angry. I could finally see her beauty, and even a touch of vulnerability.
I had begun to miss her.

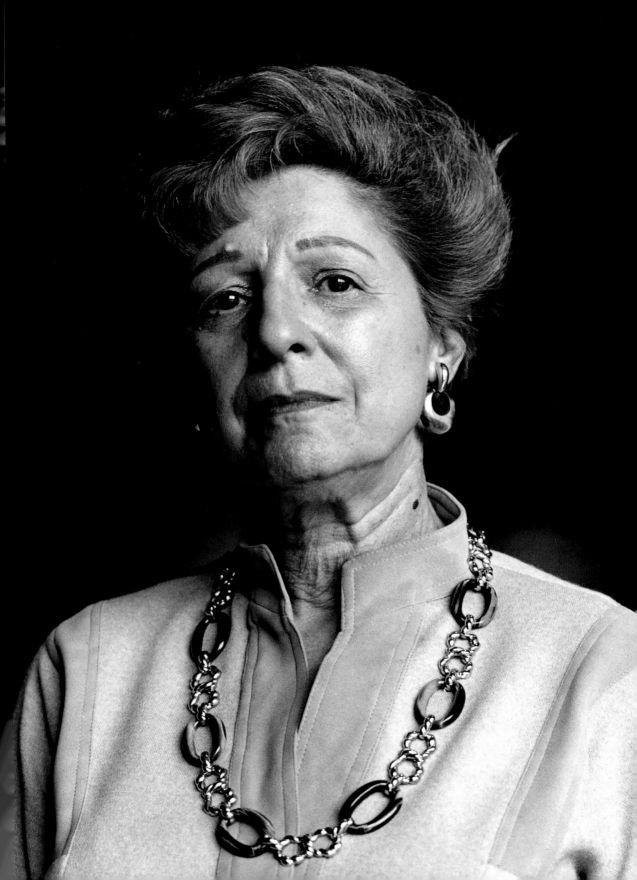

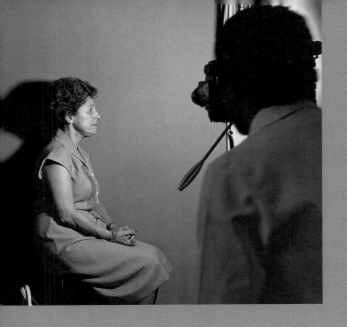

At the age of sixty-eight, Mother decided to have a facelift. Of course she didn't ask my opinion, but I was against it. I saw character in the lines of her face. This was the only beauty I was able to see there. Regardless, I documented the entire procedure.

When I feel strongly about something, I photograph it to try to get inside it, to examine my judgments. Pictures I have taken from anger have rarely been successful for me, so it wasn't surprising that when the facelift was healed I saw I had been right. She had lost her beauty, and I could not make one print that I liked. I was angry at her.

facelift

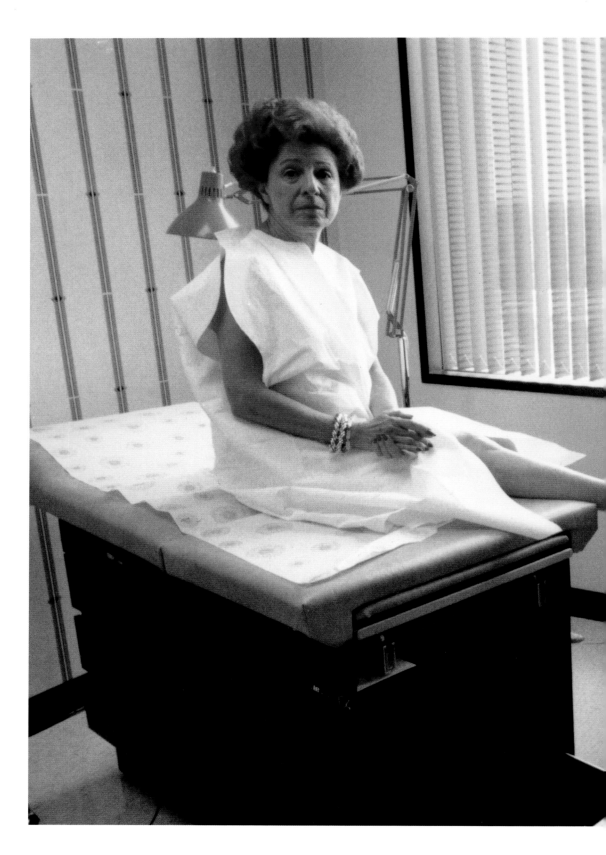

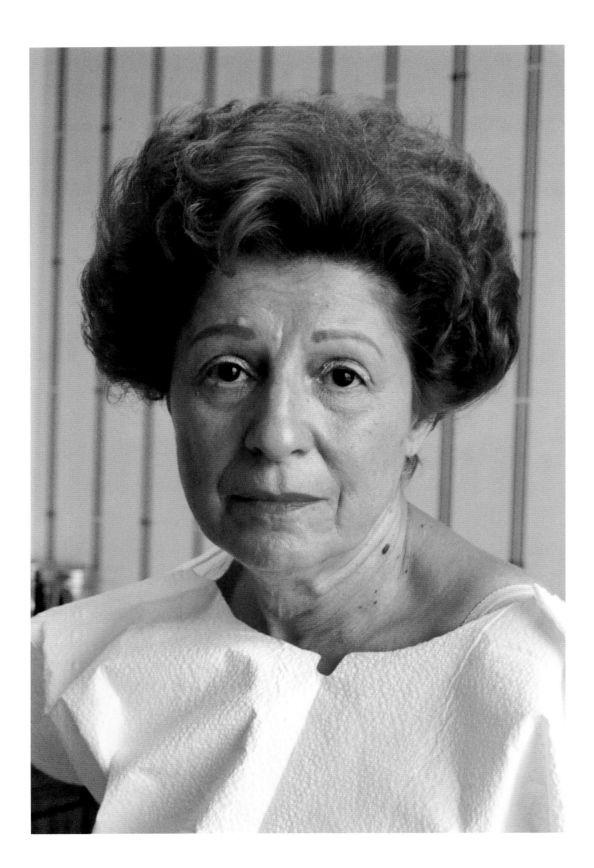

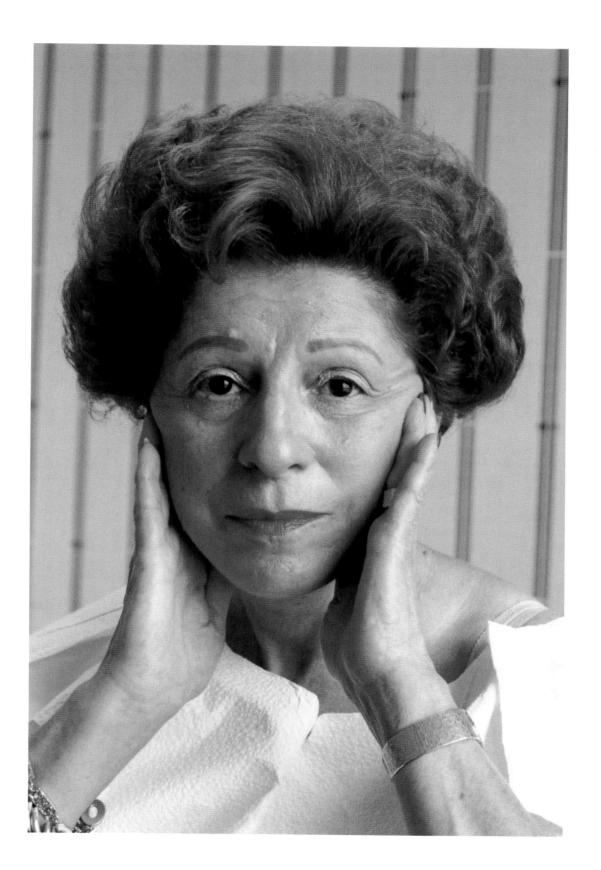

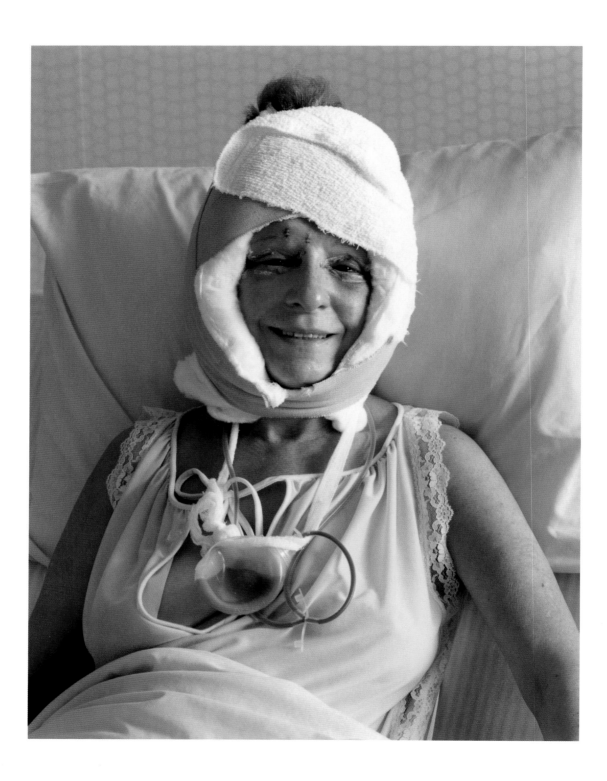

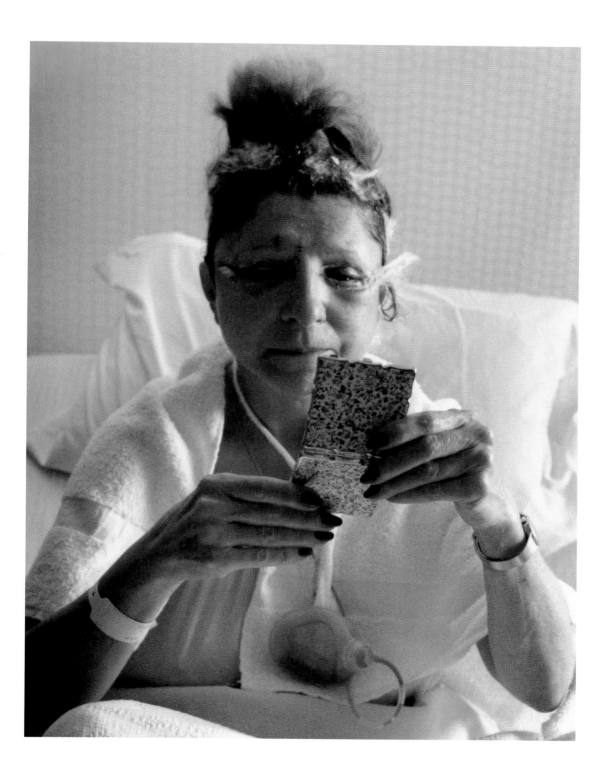

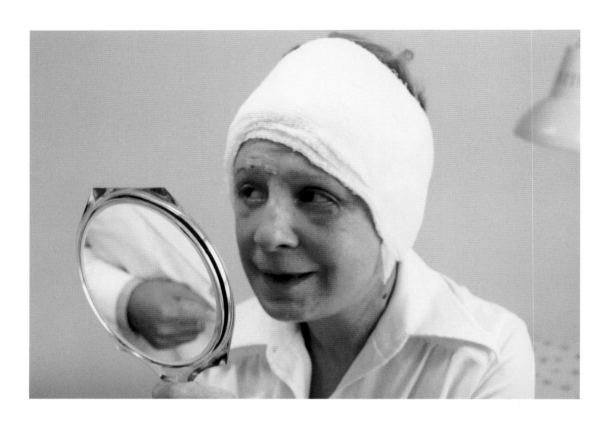

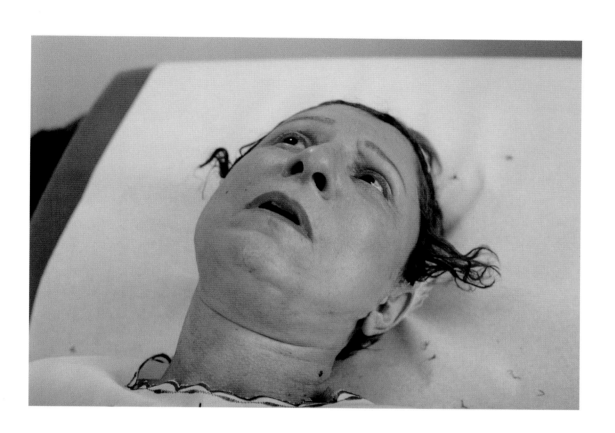

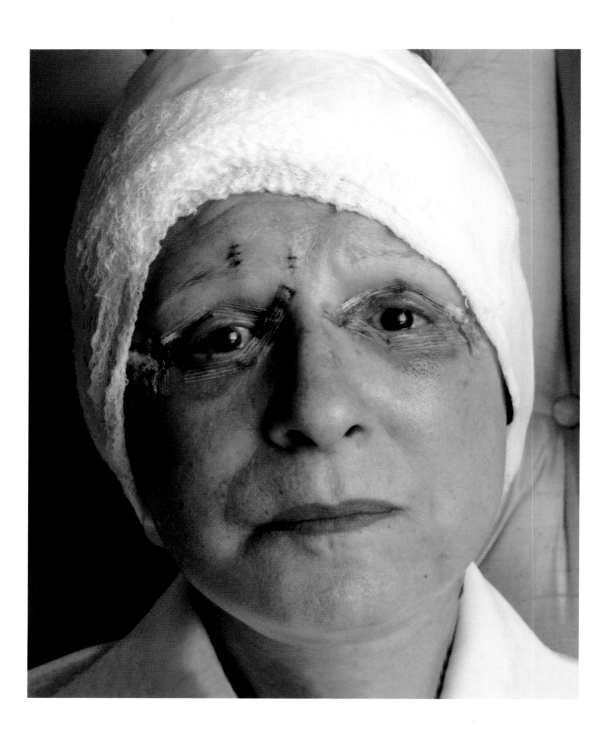

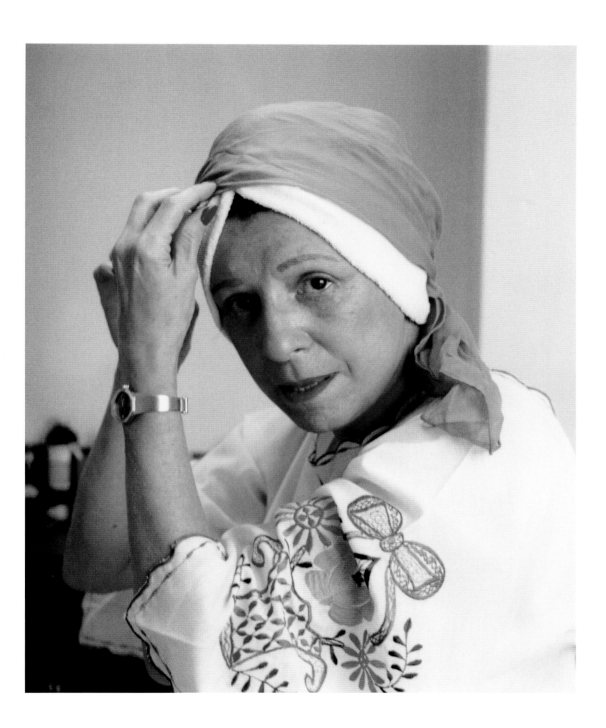

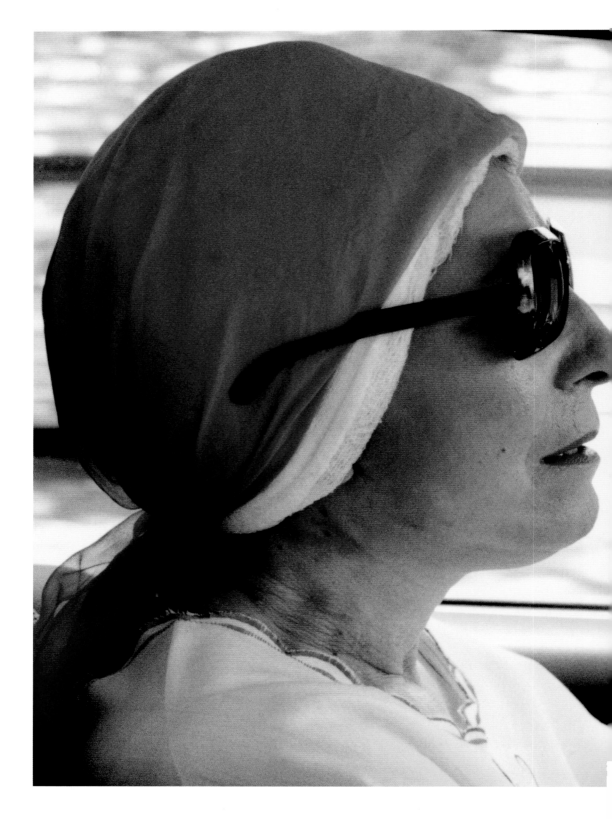

Soon after the stroke, Mother said to me: "The die is cast. My whole life has revolved around my being attractive to men. That's over now, so I'm finished."

A few weeks later she began refusing to rehabilitate, and I began pleading with her: "But Mother, the doctors say that if you work at it, you'll be able to walk again, even drive your car." She continued to resist: "After all this time, I don't want to have a falling out with you, Gay. Just don't try to tell me what to do." But I couldn't let it go. "Mother, your refusal to rehabilitate seems out of character. You've always been so strong and independent."

"It was a myth, Gay. I've always been dependent on men."

I began setting up a video camera behind me to record these insightful, revealing comments. I had never before sat with her for so many continuous hours, but I don't think she had ever been this interesting.

After the stroke, finally I could see her beauty. She was more in touch with herself and more accessible to me. When I entered her apartment, I even thought I saw her eyes light up as if they were saying, "I love you." I felt this, certainly, but not deeply. Distance, perhaps even anger, had become my habit.

Mother didn't object to my photographing her, in spite of her vanity, in spite of the fact that she felt she had lost her looks. Perhaps she hoped these pictures would live after her, or perhaps she just couldn't say no to me.

stroke

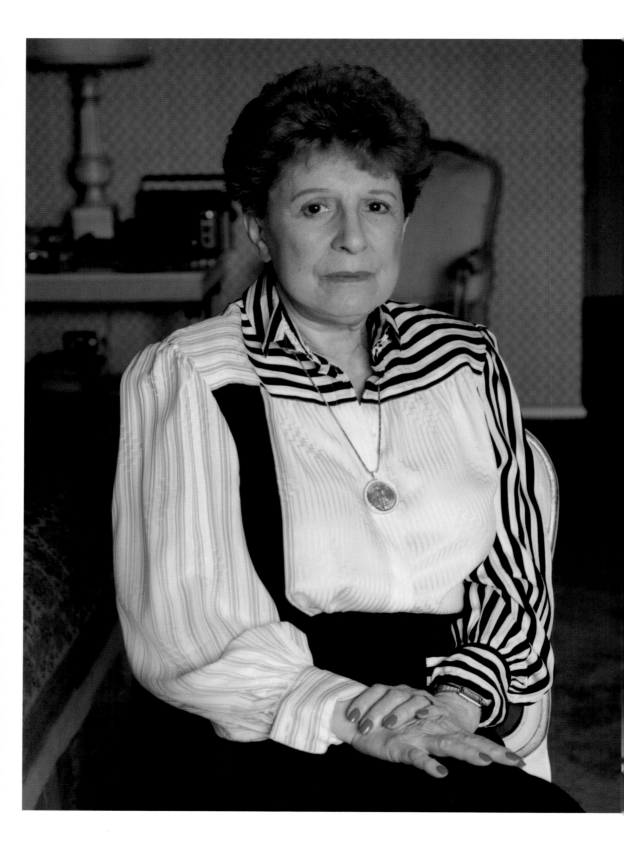

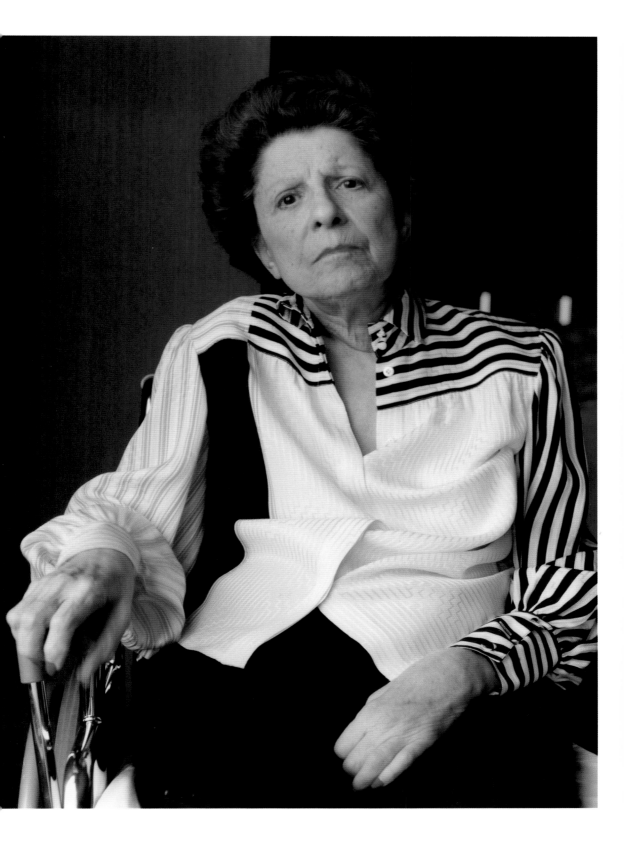

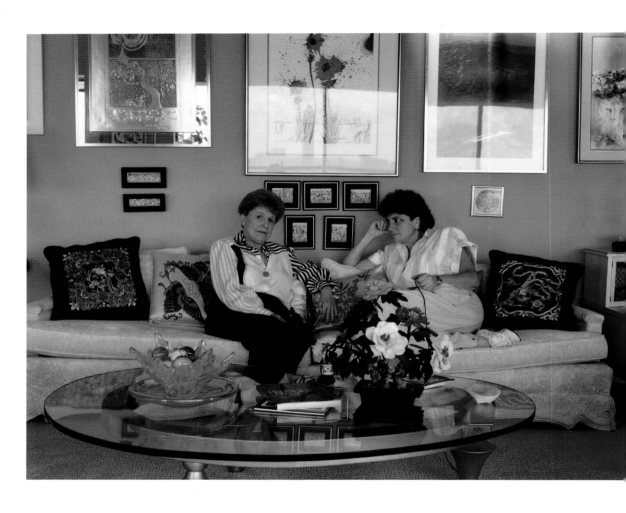

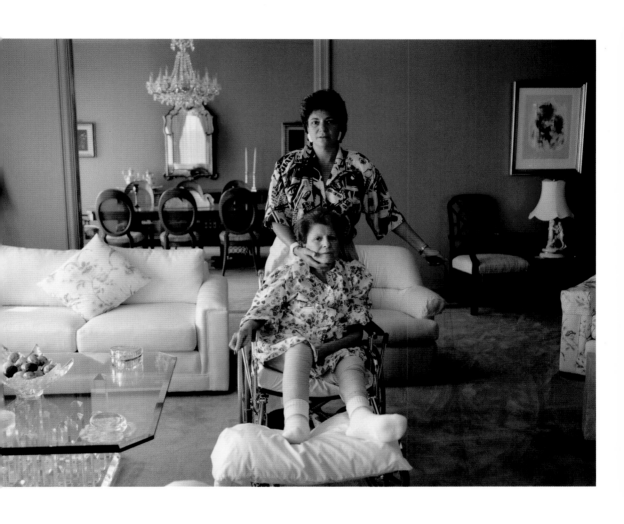

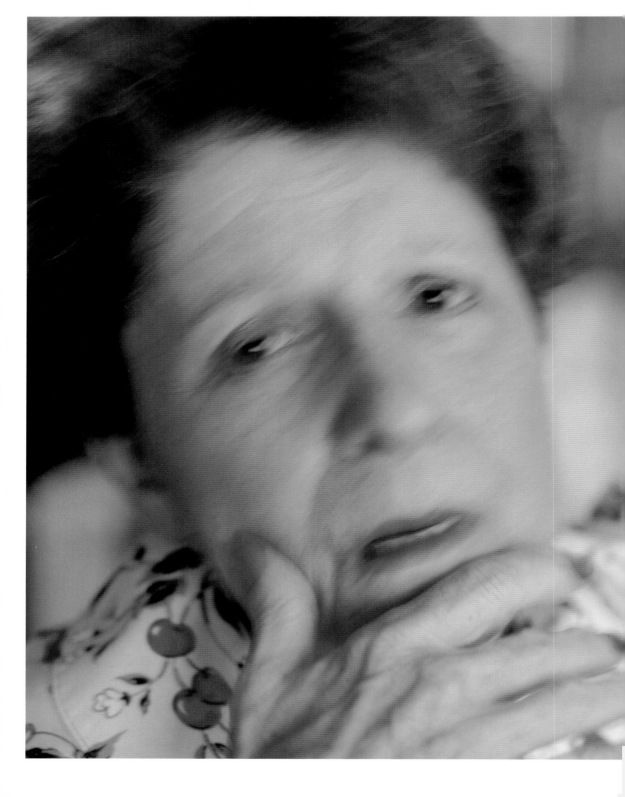

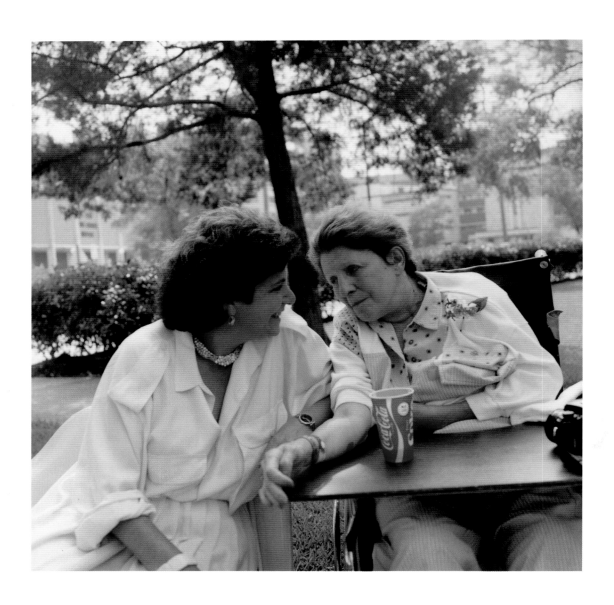

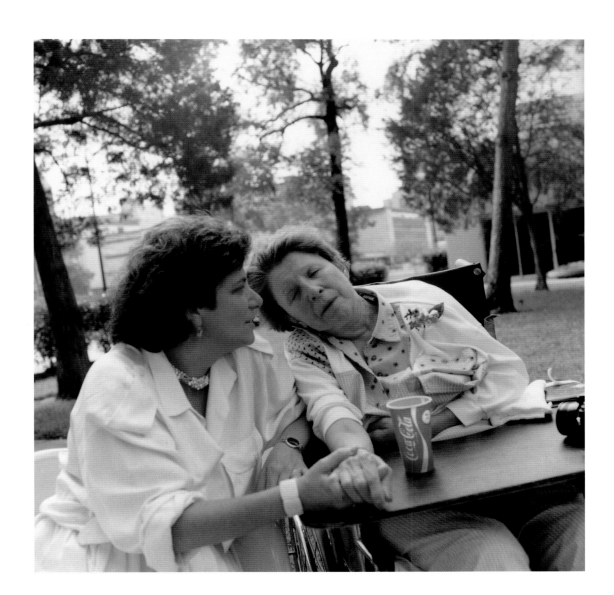

Sometimes my friends, my close friends, or family, the way they talk to me, I tell them, "Look, don't talk to me as if I don't know what you're talking about because I do know what the score is, and I do know what I'm saying and what you're saying. Don't talk to me like I don't know what I'm talking about, because I do know."

— Bertha Alyce

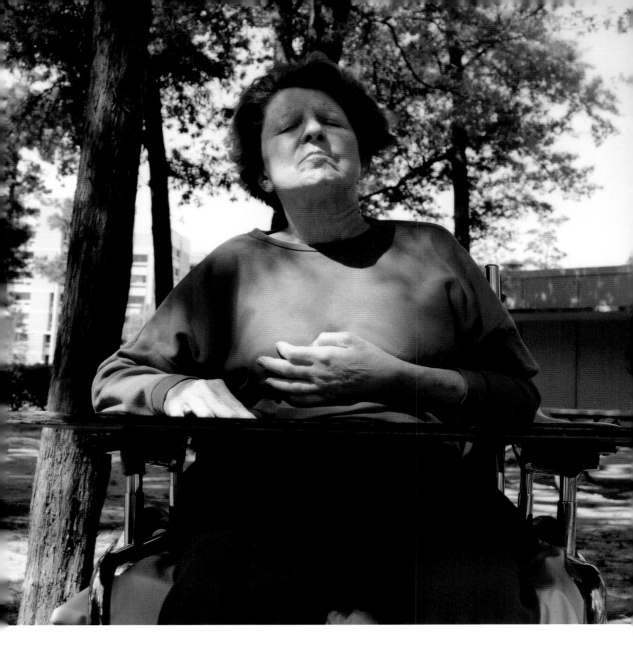

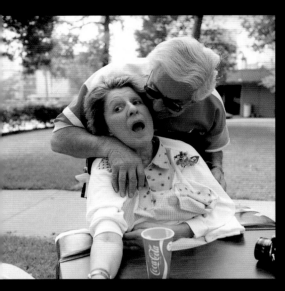

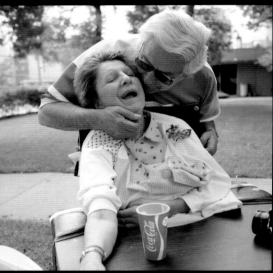

She was embarrassed having to be confined to a wheelchair. When we'd go to a party, people would flock over. "Oh, Bertha Alyce, I'm so glad to see you. You look so beautiful, you look so wonderful." When they'd leave, she'd say, "They're full of bullshit." Just like that. I give you my word, Gay. She would say, "They're full of bullshit, Al."

— Al Segall, second husband

All she was was angry. That is my definition of Bertha Alyce from the time she had the stroke, on. She was just furious that this should happen to her. She was never reconciled to it in the least.

— Jean Kaufman, friend

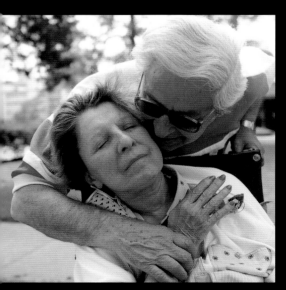

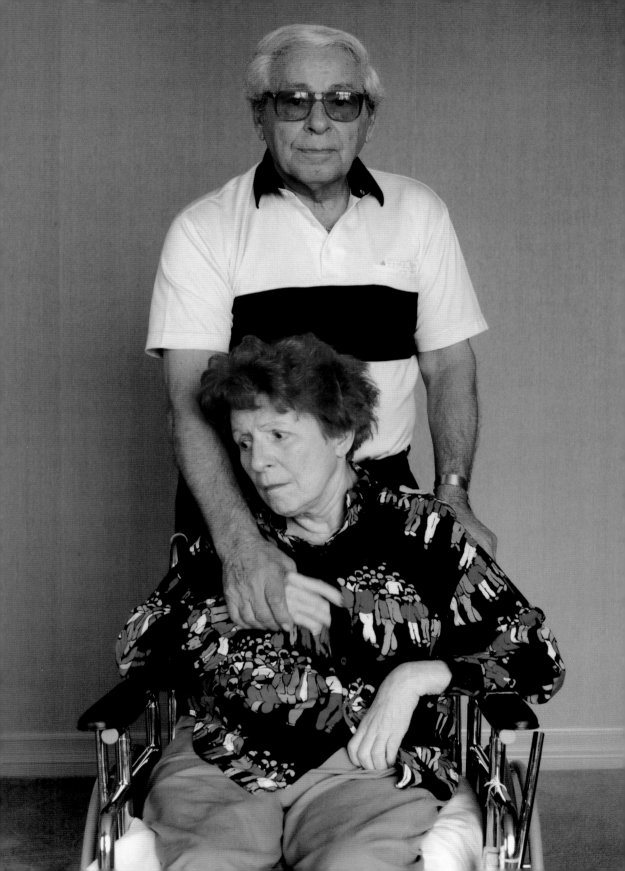

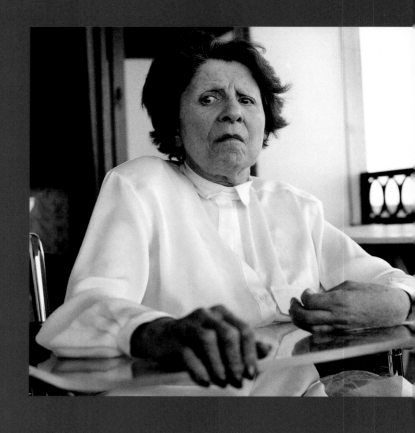

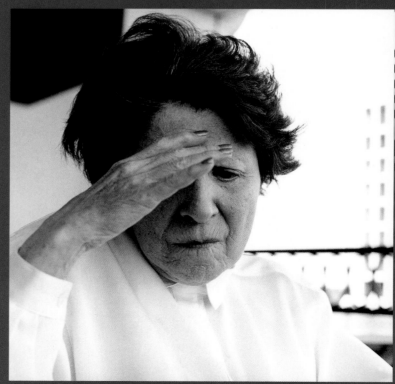

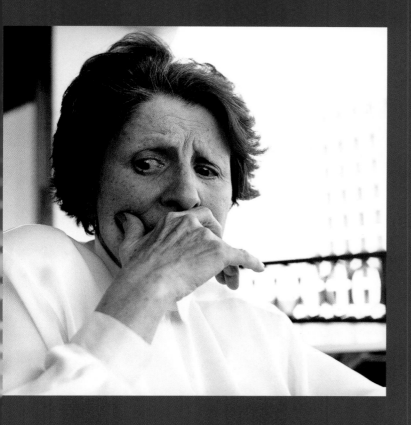

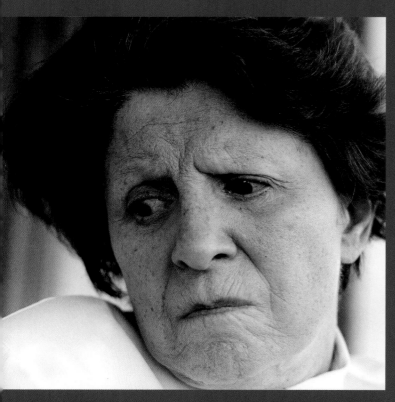

Gay: When you look back over your life, what period do you think was the best? What comes to mind first as the best time?

Bertha Alyce: I think this is the best time.

Gay: Why?

Bertha Alyce: Because I've had all these experiences in my life and each one has added to make me more understanding of what I'm seeing in the world around me and what other people are.

Gay: So you're happy now?

Bertha Alyce: I'm very happy. I think I'm as happy as an individual can be in this world. Everything can't always be perfect for anybody, exactly the way you want it.

She stares at the ceiling for several minutes.

Gay: You look as if you're seeing a movie inside your head. Are you?

She continues to stare — nods — more silence — then,

Bertha Alyce: The trouble is after a stroke, Gay, your brain is so mixed up. Sometimes you have a dream and you don't know whether you dreamed that or whether it actually happened.

Gay: That must be so frustrating.

Bertha Alyce: It's frightening.

Bertha Alyce: I was just thinking, Gay, when I die I want you to come over here. Don't take anything just because it was mine, but just if you think you'd enjoy having it at your home. Take it and know that it would make me happy to know that you have something around you that I had in my home.

Gay: Thank you.

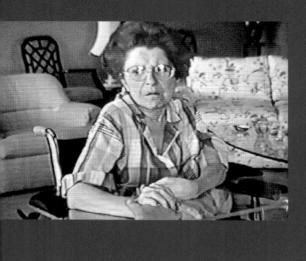
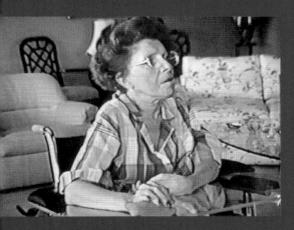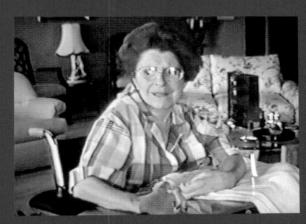
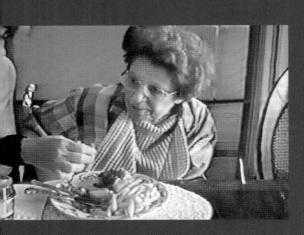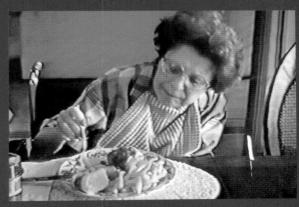

When people die, the things they leave behind seem as inert as they now are. When Mother died I looked for her in her things because, like them or not, they were mine.

I wanted to photograph all her possessions, especially her furs and jewelry. To her, they represented her position in society, the way she told people who she was. To me, they represented things I had rejected, a part of her I rejected.

The quality and quantity of her jewelry made me angry, but then I realized that although it looked very different, my jewelry would fill just as many boxes.

legacy

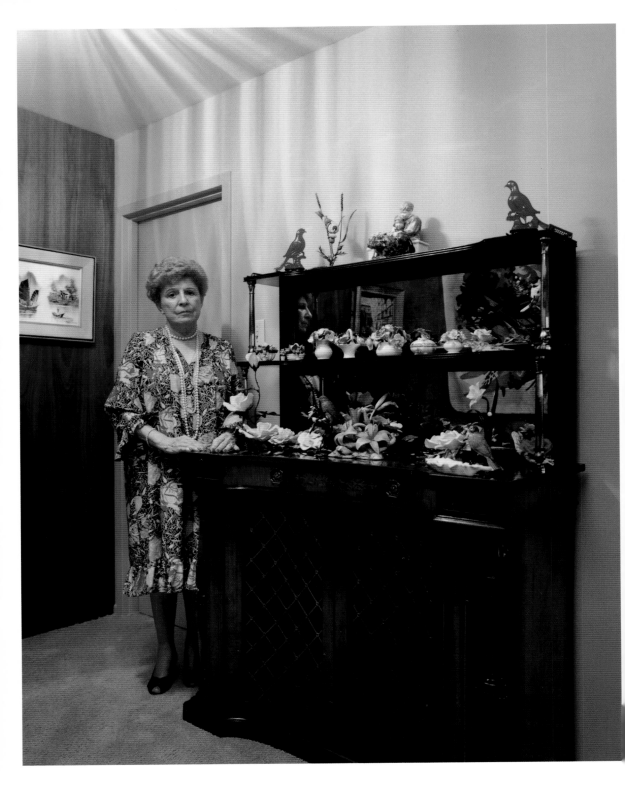

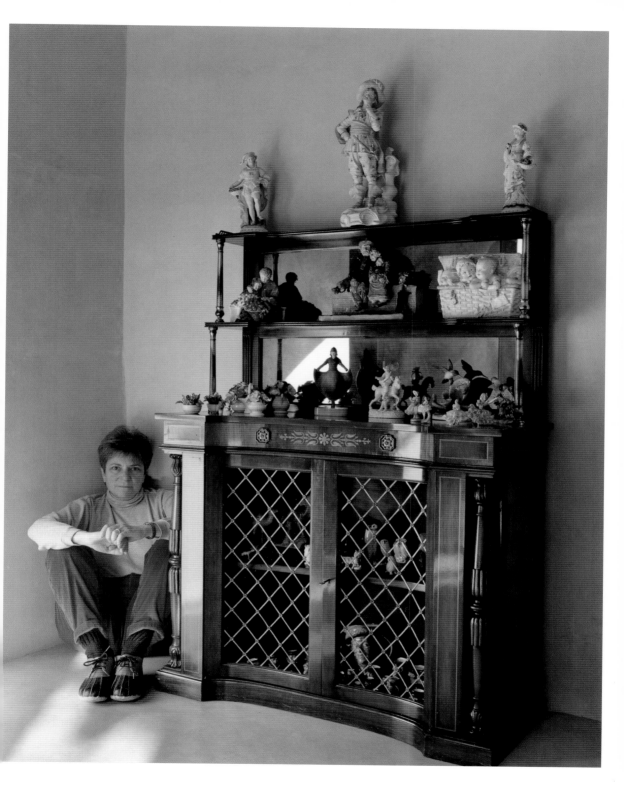

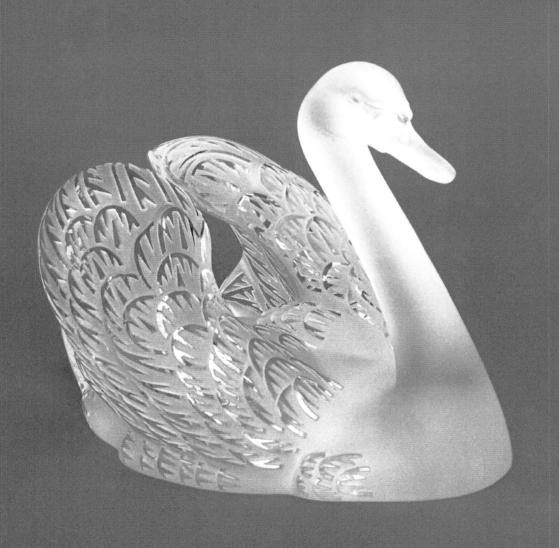

Mother is gone. I have these expensive Lalique swans that lived on her dining table. I thought they were tasteless. But now I see them as the mother swan looking down on the daughter who hangs her head.

Then I remember: she can't be cruel to me anymore. I have dominion over her. My camera owns her.

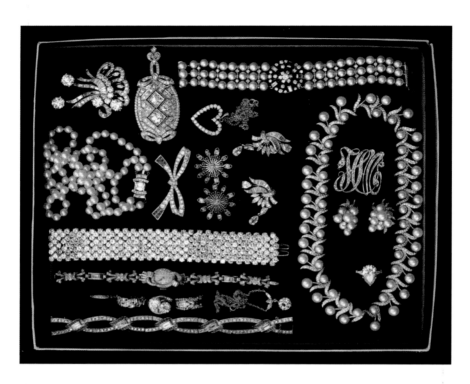

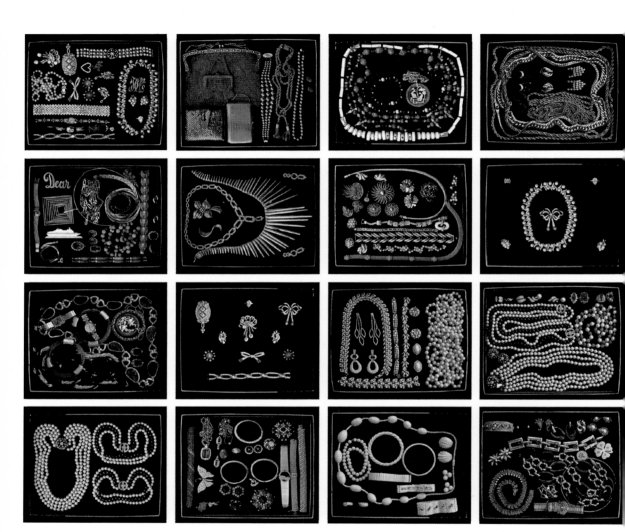

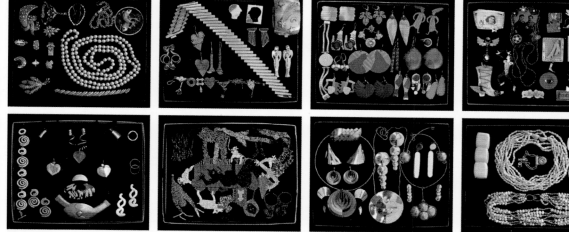
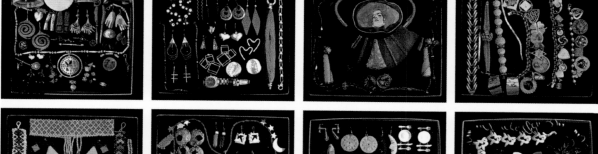
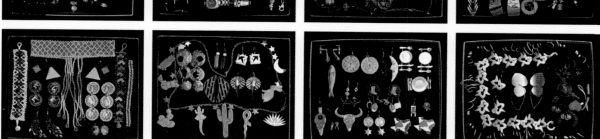

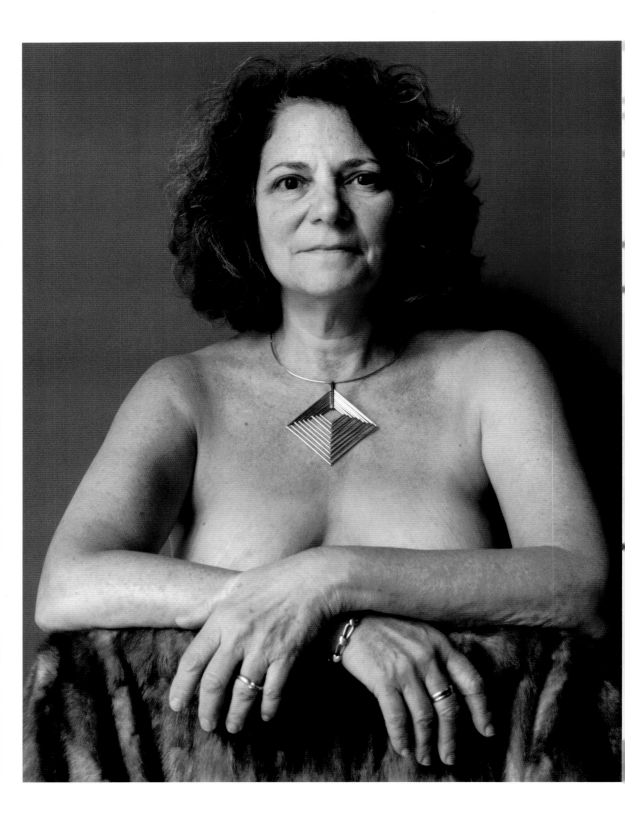

In 1982 I had my first solo museum show in Houston. As I walked into the gallery, Mother ran up to me. I expected her to say she liked my new pictures but instead she said, "How do you like my new necklace?" This became my favorite narcissistic-mother story.

Twelve years have passed. Mother has been dead for three years and I have all her jewelry. This piece stands out, different from all the rest. No diamonds — no stones at all. Recalling the last time I saw this necklace, I imagine the untold story:

You bought it especially for my opening, in my honor. You thought I would prefer it because it was designed by an artist, Agam. Right? Why couldn't you tell me you did it for me? Or why couldn't I know it without your telling me? Why do you have to be dead before I begin to forgive you?

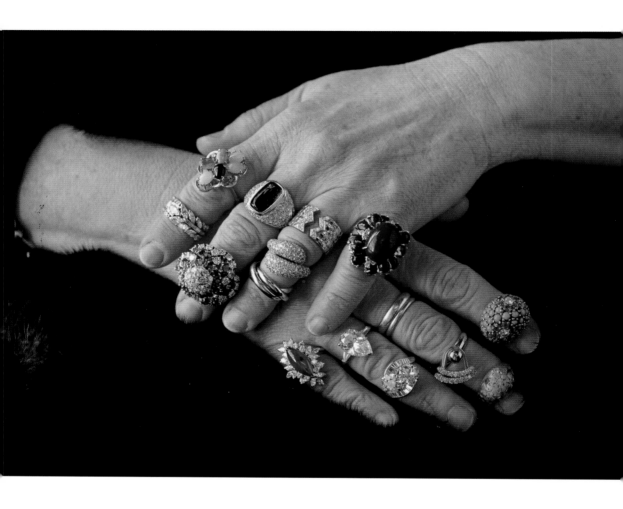

Soon after Mother died and I had all her jewelry, an image appeared in my dream: I saw her 6-carat diamond ring on a baby's penis. Suddenly I saw the similarity of genitals and jewels: both serve as symbols and expressions of power.

These jewels were gifts to Mother from Daddy. I wore them to my children's weddings.

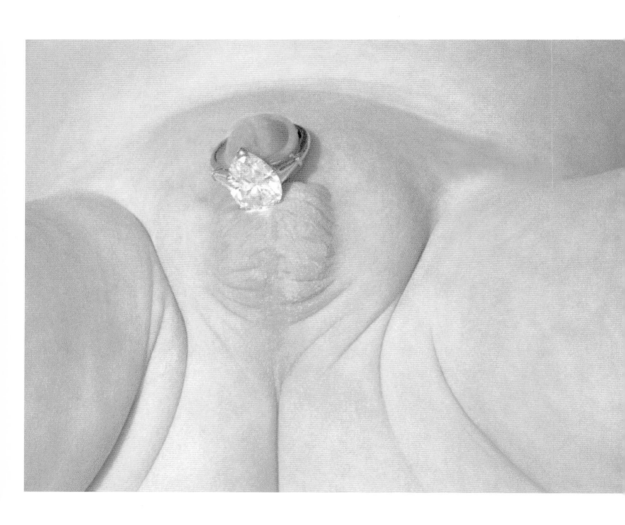

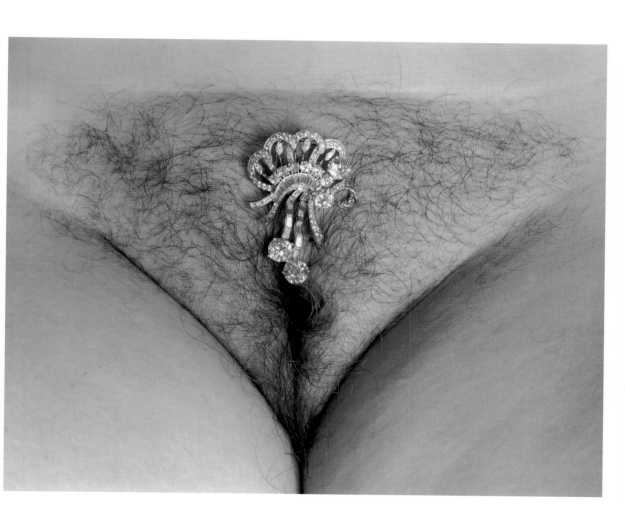

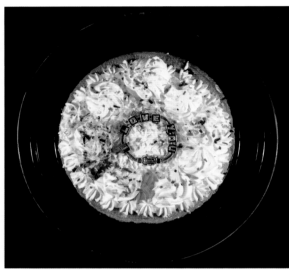

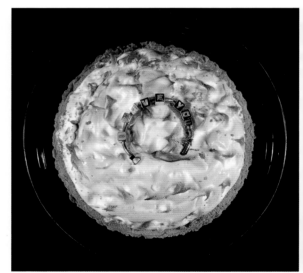

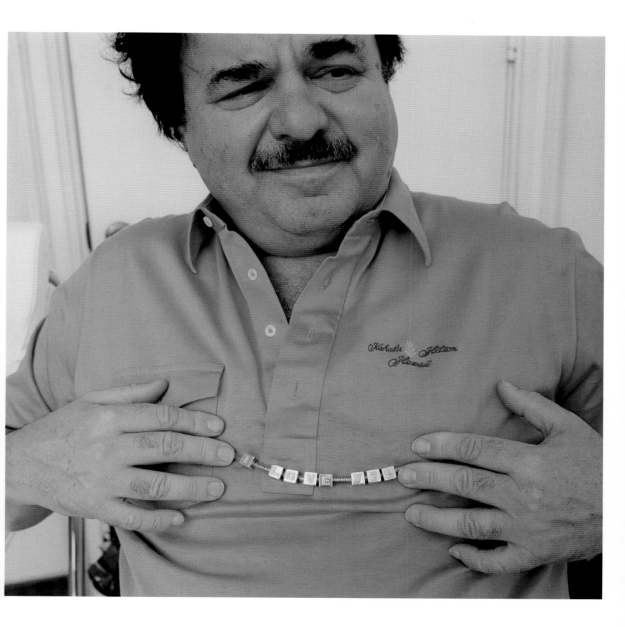

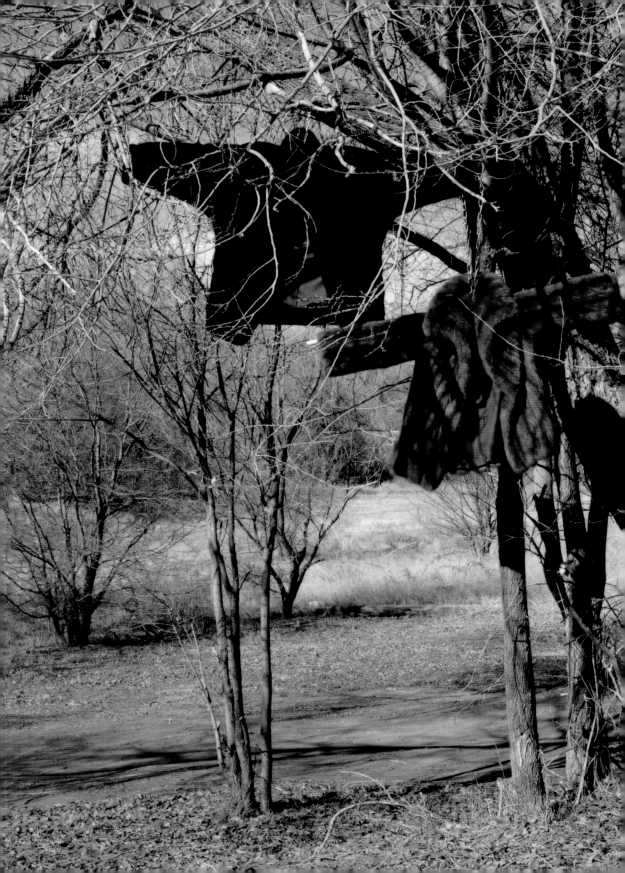

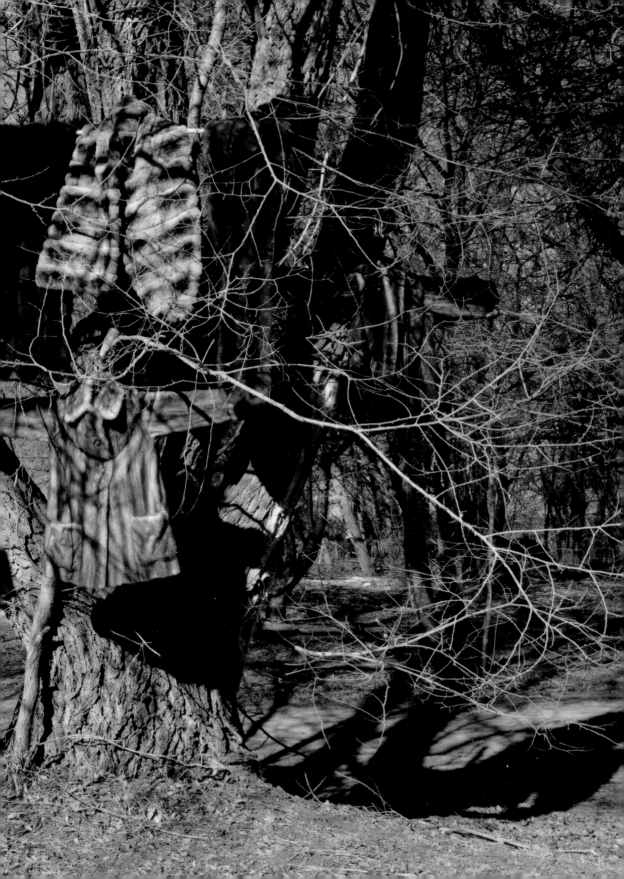

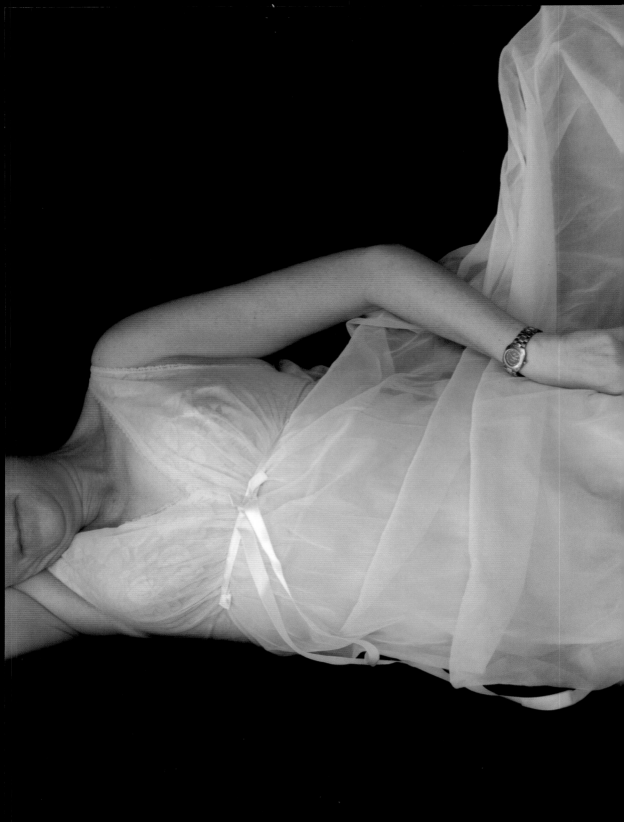

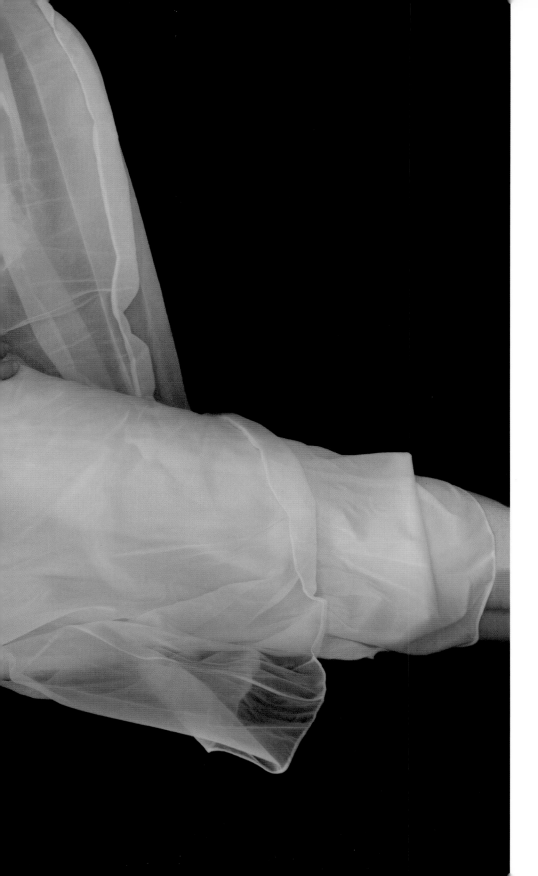

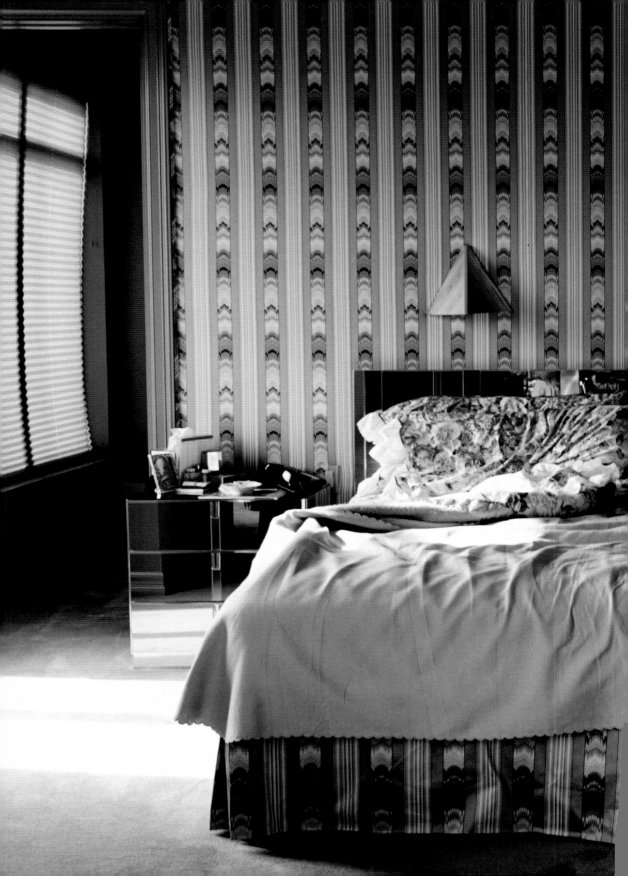

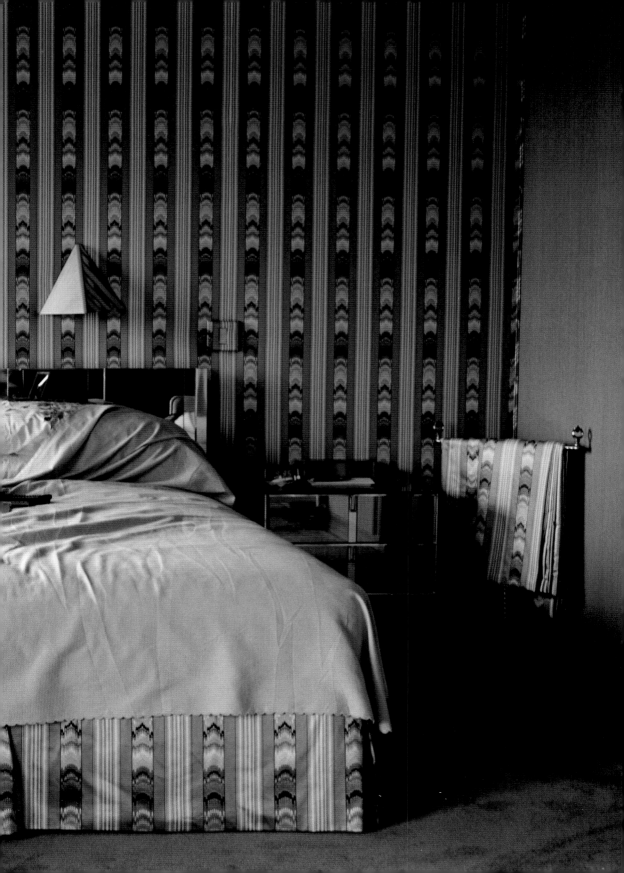

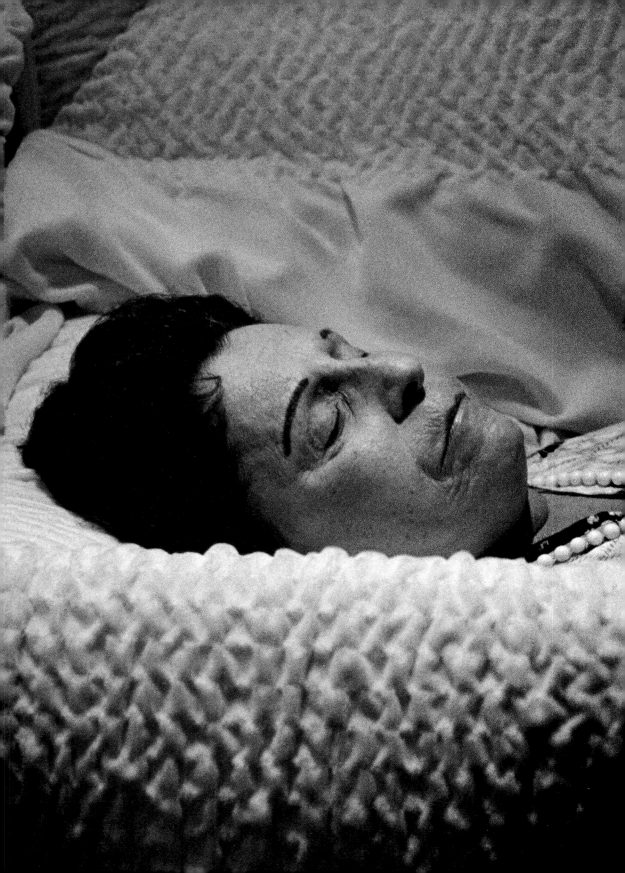

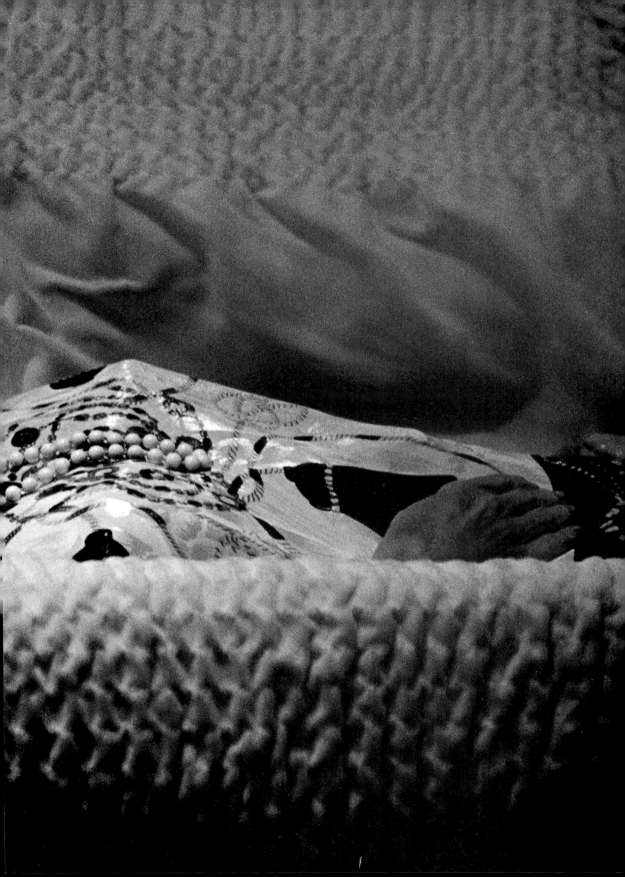

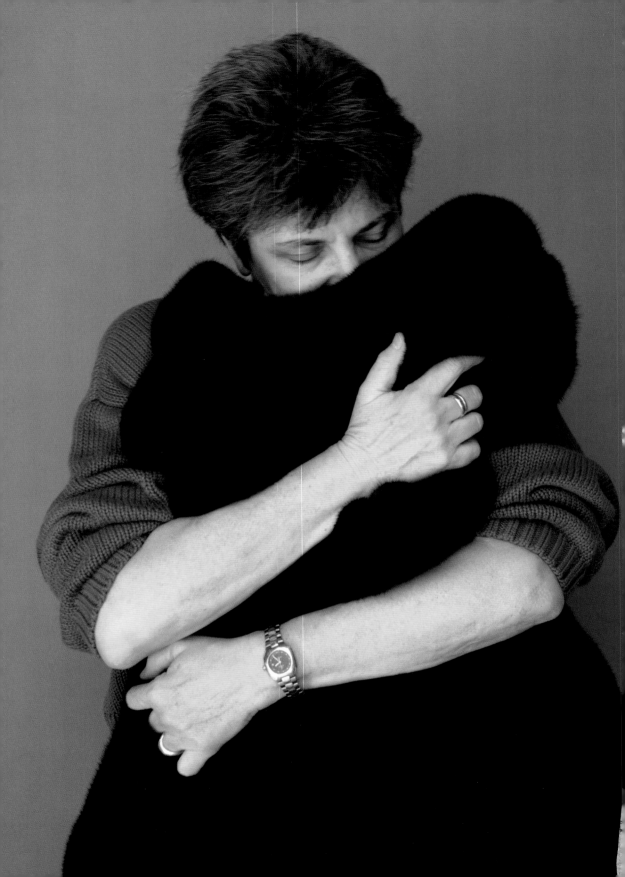

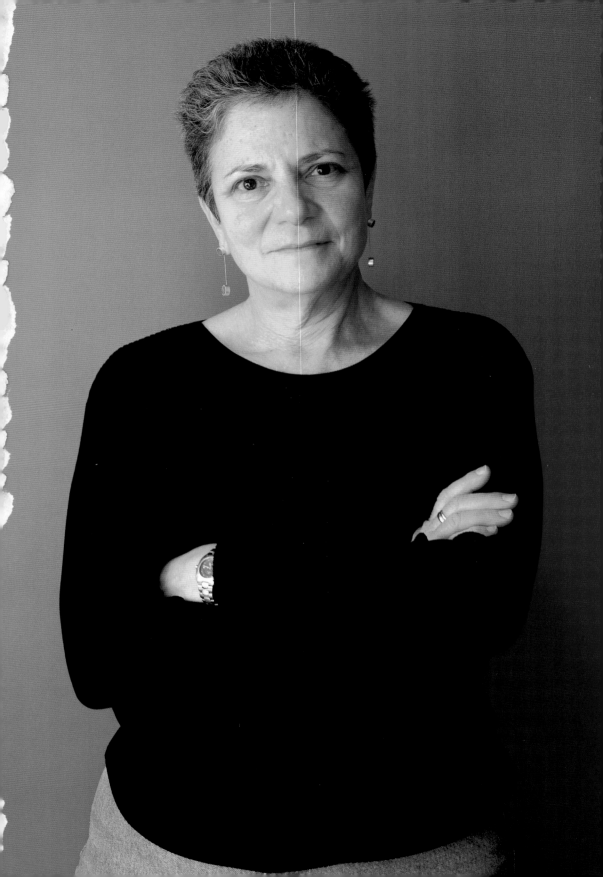

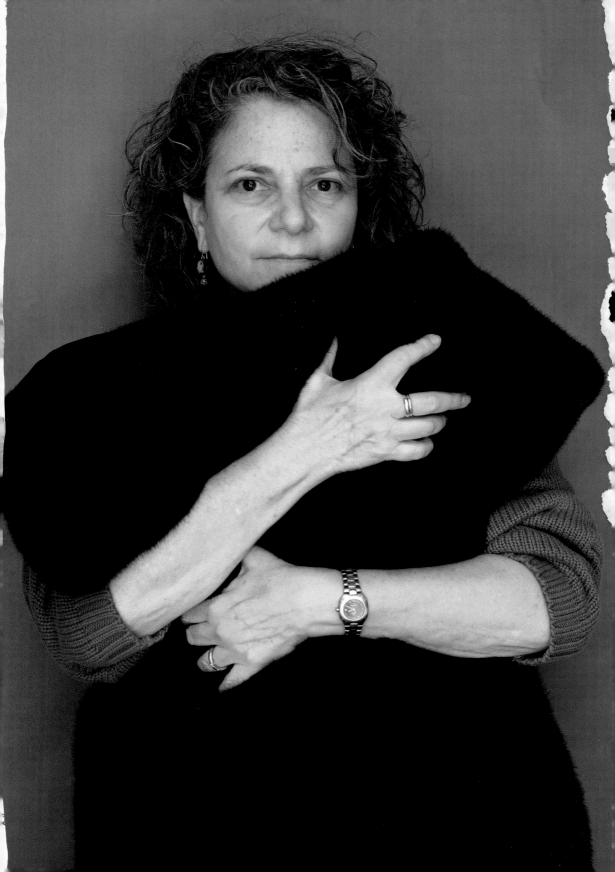

The events that happen to us in our lifetime are
what influence our days and our thinking and they
have an influence on what we look like. Because
all these things come into the picture.

— Bertha Alyce, 1991

Bertha Alyce: rePosed

acknowledgments

Some artists transform their experiences into fictive work, but in the case of this photographic book the raw source material is itself my metaphor. Since its beginning, photography has always had a dubious connection with The Truth. This book is my truth of my mother, mostly through the lens of my camera. But even with the backup of a text, it is not the whole truth of my parents any more than the known indiscretions of past Presidents Franklin Roosevelt and John F. Kennedy are the definition of their lives. Some in my family feel I have exposed things better left unsaid, and yet they cooperated with me in interviews and supported my right and my need to do the work, for which I am grateful.

Mother, of course, deserves the most acknowledgment. Why did she let me take all these pictures, even after her stroke when I know she thought she wasn't as beautiful? Why did she talk with me in front of the video camera, over and over again? After all my criticism of her mothering, perhaps she realized this was the one way she could give to me. Perhaps she wanted to help me become a successful photographer and this, in turn, might also assure her immortality.

My brother, Sidney Leo Shlenker, is the last person I would want to hurt. He told me that he didn't understand why I wanted to write this book, that it would not be something he would have done, that his parents were, for decades, the leading family in the Houston Jewish community. "Dad was the most generous, kindest man I've ever known. They both have Jewish day schools named after them in Houston, Gay." Nevertheless, he answered all my questions and encouraged me as I showed him early manuscripts. In so many ways he has been my rock. He knows that I, too, was proud of our father.

After Mother died, I asked many of her friends and family to speak with me about her. Some refused, saying things like, "Let the departed rest in peace," or, "Your mother and I were close friends and everything we discussed was confidential." Some said they were afraid I was writing a *Mommie Dearest*. This was never my intent. While my grievances against Mother exceed what's written in this book, my purpose in writing it was always to accept and forgive her. I knew I had finished the book when forgiveness overtook anger, when I could say I am grateful that these two people were my parents. I thank all those quoted herein. I deeply appreciate their candor and trust.

I thank my friend and talented artist, Cynthia Madansky, who organized this work in the early stage and ultimately designed the book. Alisa Lebow made a cohesive video from my rough cut by rewriting the script and editing the final cut. Eugenia Parry and Brent Jarrett read this work years ago when it was a three-hundred-page manuscript without pictures. They gently told me that it wasn't a book and they, along with my son, reminded me that I'm a photographer and that I must tell the story with my pictures. My dear friend, Paul Monette, writer and photo-lover of blessed memory, told me in 1994 that he loved this work and urged me to get on with it. My friends, Joan Bronk, Eve France, Anne Tucker, Susan Kismaric, Jo Ann Callis, Joe Natterson, Debbie Friedman, Stephanie Noland, Marlene Meyerson, Magdalena Salazar, Joan Myers, Cynthia Macdonald, Judy Fiskin, Jon Weiner, Wendy Watriss, and Sally Dixon encouraged me all along the way. Margaret Moore, Wendy Young, and Dianne Stromberg were my invaluable photographic colleagues and advisors. Dolly Meieran, with patience and commitment, accomplished the technical perfection of the book's design under the tireless direction of Robyn Mundy. I am particularly grateful to UNM Press, to Ev Schlatter who first acquired the book and to my editor, David Holtby, for his deep understanding of the book's content and his effectiveness in making it clearer. Kathleen Howe, curator of the University of New Mexico Museum, saw the work in the early stages and asked to see it again five years later. She, with all her professional intelligence and sensitivity, made the exhibit a reality.

Without these people, this book would not exist. And yet, there is one more, one who was there in every phase, in fact lived with Bertha Alyce more intimately than she ever intended. Perhaps she still does. Thank you, Malka Drucker, for your wisdom, your patience, your faith in me, and your love.

— Gay Block

the photographs: a consideration
by Kathleen Stewart Howe

> Perhaps true, total photography, he thought is a pile of fragments of private
> images, against the creased background of massacres and coronations.
> — Italo Calvino[1]

Gay Block was a portrait photographer from the moment she began to make
photographs almost thirty years ago. Portrait photographs are born of a complex
tension — a balancing act between the subject's awareness and the photographer's
intent. Subject and photographer are enmeshed in that moment when the shutter
winks open and details of features and expression, posture and costume are frozen
in the continual past/present of the photograph. A successful portrait photograph
persuades us that the indefinable imprint of personality is imbedded in the physical
likeness. It also suggests the photographer's privileged access, not only to the
subject physically, but to an elemental truth.

Whether they work from an intuitive empathy for their subject or from a
practiced distance, portrait makers operate in a zone of hyper-acuity, sensitive to
subtle cues that reveal their subjects. As photographers hone that sense of acute
attention, practiced subjects master strategies of expression and pose that will
project the persona they want the world to see. In this visual tug of war, deception
and perception coalesce. The event that is the making of a portrait encapsulates
this conflict as another episode in the sitter's history. The human fascination with
portrait photographs is intimately tied to our recognition of the condensed and
implied narrative, and we interrogate portraits as we would a partially revealed
history. Who is the subject? How did he or she come to be in front of the camera?
What happened at the moment the shutter opened? What will happen next?

Part of the story we try to decipher is constructed by the photographer. For just
as she directs the devouring gaze of the camera and orchestrates the effects of
light and shadow, the photographer also comes to the sitting with a sense of how
she/he will elicit a performance that yields a moment when the physical data reveal
an emotional, spiritual, or psychological reality, a moment that contains the larger
narrative.[2] Block chose as her photographic arena one in which the conflict of
access, accommodation, and privilege is staged. (Only many years later would she
understand why she had chosen that genre.) Very soon she recognized the power,
and the responsibility, that came to the person behind the camera. Her 1985
portrait of Aaron Siskind, both subject and photographer nude within the frame,
came to define her credo. (fig. 1) "I wouldn't ask someone to do something that
I wouldn't do."

Gay Block isn't a distant, silent portraitist. She wants to hear people's stories:
"I always needed to know something before I began shooting."[3] The questions
may be prosaic or probing: My, this is a lovely room, are those pictures of your
children? What led you from the cataclysm of 1930s Europe to this sunny spot in
Florida? How did you, a twenty-two year old Dutch schoolteacher under Nazi
Occupation, come to rescue Jewish children? The sense of stories lived and elicited

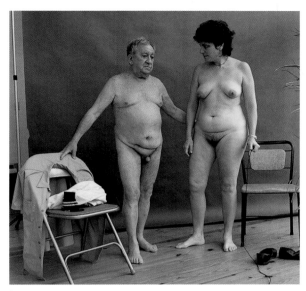

fig. 1

is in the portraits. Sometimes it is there overtly. *Rescuers: Portraits of Moral Courage in the Holocaust* (with co-author Malka Drucker) is a seamless integration of personal stories and snapshots, the larger story of resistance to the Holocaust, and formal portraits.[4] The pictures aren't illustrations, texts aren't captions, they're equal elements of a single story. "I have learned that I'm as fascinated by what people say about themselves and their lives as I am with exactly how they look."[5] *Rescuers* was the first step in a method of storytelling that lead to *Bertha Alyce: Mother exPosed*.

Even without text, stories seep out of Block's photographs. The Miami series from the mid-1980s, some of which are reproduced here as "the bubbies I wish I'd had," come without the scaffolding of written text but the stories are there. The woman in the leopard print toque and scarf pauses to focus your attention before the dénouement of a particularly compelling episode in a life full of incident. The details are almost beside the point — we recognize the storyteller and her story. In the 1970s, her fascination with portrait photography brought Block to the work of the two master portraitists of the twentieth century — August Sander and Diane Arbus. And one might look to them for her progenitors and models, yet it is her unwavering attention to her subjects' stories that aligns her with Arbus.[6]

But what happens when your subject is your mother? Her story is what you've been trying to understand for most of your life. And what if that subject is a performer, always on for the camera, so exposed she will pose nude for and with you, and yet so guarded that you will only begin to untangle her life after her death. The strategies of a single portrait sitting aren't up to that task, and the contest of perception and deception is an even match. So the photographer returned again and again to her subject; Block photographed her mother for the first assignment in her first photography class and thirty years later continued to photograph Berth Alyce even after her death. She sifted through snapshots and

conventional studio portraits; grabbed frames from video footage; read her letters; and wrote hundreds of pages trying to map the terrain of mother-daughter distance. But this obsessive accumulation of material was neither a portrait nor a narrative. It was the artist's raw material.

Bertha Alyce: Mother exPosed maps one woman's trajectory of possession, power, loss, and death against a backdrop of family and privilege. *Bertha Alyce* also maps another trajectory, perhaps one of the most heavily freighted human relationship, that between mother and daughter. Those two narratives are so compelling that it is easy to miss another narrative arc, the artist gathering increasing command of her materials — pictures made, rescued, and repurposed; words recorded, edited, and honed — and the insight to use them. If the first two narratives are persuasive, it is all the easier to overlook the third. Whatever *Bertha Alyce* might be — subsumed under the category of memoir, a genre that is variously instructive, empowering, discomforting, or titillating — no matter where along that sliding scale the reader places this book, it is most definitely a project that creates art out of experience. The artist brings pictures and words together into something more than anecdote, that moves beyond, "You think your mother is difficult, let me tell you about mine," the mother horror story one-ups-woman-ship familiar to all of us. The artist transforms the banal and personal into something that offers insight, and does so in a way that is visually compelling, emotionally engaging, and yes, beautiful.

Gay Block's portrait of her mother is made up of many photographs — 35mm frames clicked off as the photographer stalked her subject in her bedroom, recovered family snapshots, formally framed and posed portraits, unfolding performances elicited by the medium format camera on its tripod, frames from videos — all layered and sequenced, captioned and reflected on by the photographer. There are self-portraits in this portrait of the mother; Block as the foil in a beauty contest she can't win; Block draped in her mother's wedding gown, burying her face in Mother's mink, surrounded by Mother's objects. Bertha Alyce is present in all of the booty of a privileged life and the artist made portraits of her mother's possessions. The photographs of jewels and furs — fetishistic objects par excellence — become portraits of actors in the narrative. As the aphorism goes, what is a fetish but a story masquerading as an object?

Block defines herself as a photographer, yet *Bertha Alyce* is not a photographic series or a photo-essay. It has the fluidity — the movement through time and space — of film,[7] and the specificity and ambiguity of the best short story, while individual images compel the searching attention that only the best photographs elicit. *Bertha Alyce* is a hybrid project to construct a history, one of many possible versions, of a person and a set of interlocking relationships. One would think that when a portrait is constructed of innumerable pictures, stolen, constructed, recreated, and studied obsessively over thirty years; of shifting viewpoints and words edited and layered with images; such a portrait would finally confine and define its subject. Yet ultimately *Bertha Alyce* keeps slipping away from us, her story keeps shifting. "There is no hope of objectivity, only ceaseless transformation; a human being has so many facets."[8]

notes

1. Italo Calvino, "The Adventures of a Photographer," in *Difficult Loves*. Trans. William Weaver (London: Martin Secker and Warburg, 1983) 52.

2. The effort to get beneath the surface and to direct a sitting which would expose more than the body led to the portrait series, Clothed/Nude. Block advertised in the UCLA student newspaper for subjects who would allow her to photograph them in their homes in their regular attire and nude. Later she returned to the tactic, perhaps in a more playful manner, by asking friends who visited her studio to pose in their underwear.

3. The search for information about her subjects was present from the beginning. For the first ten years or more of portrait making, Block conducted formal oral history interviews, sometimes for an hour or more and often on audio or videotape.

4. Gay Block and Malka Drucker, *Rescuers: Portraits of Moral Courage in the Holocaust*, prologue by Cynthia Ozick, (New York, Holmes and Meier Publishers, Inc., 1992). The book and exhibition, which is still traveling ten years later, unites Block's portrait photographs, and Drucker's text in a hybrid form of storytelling.

5. Ibid, 254.

6. In the work she did for periodicals, Arbus wrote text to accompany her photographs. Her words frequently weren't published but, as gathered in Thomas Southall, *Diane Arbus: Magazine Work* (Lawrence, Kansas and New York, New York: Spencer Museum of Art/ Aperture, 1984), they reveal Arbus's attention to the narrative context of her subjects.

7. The project is also presented in a video, "Bertha Alyce," Gay Block, 2001.

8. Otto Dix, commenting on a lifetime of self-portraiture, quoted in Erika Billeter, *Self Portrait in the Age of Photography: Photographers Reflecting Their Own Image* (Lausanne: Musée Cantonal de Beaux-Arts, 1986) 8.

hungry

by Eugenia Parry

school of the mask

> Her life supported yours. Maybe even invented yours.
> — Grace Paley[1]

Miss Rose Lemle was vexed by fair skin that went to freckles if she forgot her parasol: in no time she looked like pastry with too much cinnamon on top. The hapless condition ruined many otherwise delightful afternoons. Beauty of face and limb for well-bred girls, around 1900, meant the unblemished whiteness of marble.

It was whispered, on good authority, that "Southern girls had the whitest skins in America because they patted themselves each night with their own warm urine, perfumed with lavender...."[2] Cosmetic from the chamber pot would have strained Rose's imagination. She took plenty of trouble to eradicate her freckle blight, probably choosing the gentle corrosiveness of lemon juice and oil of rhodium in home-made concoctions from popular French recipes, like Lola Montez's Unction de Maintenon, smeared on at night and washed off in the morning with elder-flower water.[3]

Such procedures assumed that adherents had not only the will, but, more importantly, unlimited time — exactly what Rose and the females of her class and geography suffered in abundance. Freckles remained a trial. At fifty, baked by the sun of Egypt, she was still railing against them: "Gee, it'll take me the rest of my life to get rid of the freckles I've accumulated."[4]

Freckles weren't beautiful, and pulchritude was an absolute requirement for a female's future happiness. Brains and mental curiosity? Definite liabilities. Reading produced unpleasant facial expressions. Girls were warned: men are cold and critical of a woman's intellect, but their eyes burn when they speak of a beautiful woman's charms:

> We should be enemies to ourselves if we did not employ every allowable art to become the goddesses of that adoration....There still stands the eternal fact, that the world has yet allowed no higher "mission" to woman, than to be beautiful....It may be fairly questioned if there is any higher mission for woman on earth....[5]

Rose's auburn hair was thick and wiry; on humid days — nearly every day in her southern city — it became nappy as a Negro's. Determined not to be an enemy to herself, she tried to tame the growth with the recommended ten-minute twice-a-day brushing.

Not exactly a beauty, Rose was still a belle, born in New Orleans 17 September 1886. As an adolescent, she and her chums had nothing better to do but gossip and giggle over silly stories as they paraded arm-in-arm through jasmine-scented parks and gardens in diaphanous gowns of fine lawn and muslin. In the "lime-white glare of New Orleans,"[6] quite plain young things became shimmering apparitions of the eternal feminine.

Fashion was a masquerade designed to entrap — at least to magnetize — the male gaze. Constructed by sewing women who appeared at the house every season, frocks with tight-laced wasp-waists were de rigueur, as were voluminous leg-o'-mutton sleeves. Breasts protruded, en masse, like loaves of freshly baked bread. The overt sexuality of an *avoirdupois*, given architectural authority by steel and horsehair bustles in the 1870s and 1880s, in subsequent decades softened into ample trains. Rose learned to be a goddess of adoration. As she and other coquettes batted fans and lowered eyes, they passively allowed their bodies to be seen and scrutinized, repressing their own sexuality and narcissism in a fetish of clothes.[7]

Pinching a frown into her freckled forehead, Rose may have puzzled over the mission the world allowed women and the pivotal role of its intricate subterfuge. Spirited, and a bit of a tease, she submitted nonetheless to her mother's and four aunts' coaching in every nicety encompassed by the woman's sphere: to converse tactfully and with delicacy, to raise her train while travelling the dewy paths of her neighborhood — avoiding grass clippings, dust, mud on wooden sidewalks, horse droppings in the roads, grease on trams and to be especially mindful when eating over-ripe pears or figs whose amber juice irreparably damaged fine fabrics.

Rose Lemle was crazy about figs; they became a life-long passion. At age forty-eight, on one of many summer shopping trips to New York City, she awoke with nervous agitation and throbbing pain in her neck and shoulder. Her daughter, Bertha Alyce, wrote to her fiancé, Irvin, back in Louisiana: "Darling, would you try mailing us a few figs?…Pick green ones, I think." To which empty-handed Irvin replied, "Sweetheart, I tried to get some figs for you, but the drought has about ruined them. Those few that are left are shriveled and not hardy enough….I hate not to send them…but it's just no use."[8]

Rose was disappointed. Figs wouldn't cure her this time.

Later, during the freckling trip to Egypt, which included Palestine, Syria, and Italy, she encountered figs unlike any tasted during her Louisiana Julys — huge, gooey figs from Damascus and Genoa. Some days traveling, she spurned regular meals altogether, preferring mouthfuls of fleshy pulp, seeds, and juice. "I ate figs and some more figs — the figs are wonderful — great big sweet ones."[9] Figs were more than nourishment. Liquefying on her tongue, they remained one of her supreme consolations.[10]

Miss Rose, with two doting brothers, Sidney and Leo, was the family treasure. All bloom, and to all appearances, no debilitating intellectual thorns, she was the daughter of Gottlieb Lemle, a German-born Jewish haberdasher, and Bertha Simon Lemle, proud descendant of Alsatian Jews whose ancestors acquired near-aristocratic status by having fought in the American Revolution.[11]

At the time of their marriage in the 1880s, Gottlieb and Bertha, like many of their class, relied on the commercial portrait studio camera as an important instrument through which to declare economic and social preeminence. Posing before "Moses, Artist" on Canal Street in New Orleans, each, pictured, became a well-heeled, irreproachable emblem.

Since its origin, the lens of the portrait camera had always encompassed sitters in a small theatrical space where each was encouraged to reinvent a preferred self

fig. 1

and selectively dramatize a social station. Steadied on a plaster column, mustached Gottlieb is confident in a black frock coat edged in grosgrain. Only an oversized watch chain betrays his *comme il faut* restraint. (fig. 1)

Bertha's toilette is extraordinary, even for the upholstered look of the 1880s. A gown, alternating black velour and silk stripes with satin, envelops her form like the linen of a mummy. Further wrapping the stylish encasement are small bands of crimped satin and larger ones encrusted with jet. Rosettes of jet literally drip from throat onto bosom. More strands of fine jet beads cascade provocatively beneath her waist over the groin. Had Bertha considered the overtly sexual signals governed by fashion, she would have been horrified; but high style promoted happy ignorance. Rigid as a post, she gazes beyond the frame, as if hypnotized by a mirage. Steel blue eyes and the mouth's stern incision, less than adorable, only enhance the formidable emblem.

Truly beautiful are Bertha's pale slender fingers. One wears a cameo ring. The rest of her jewelry amounts to a series of keepsakes. A brooch at her throat seems to frame a miniature daguerreotype portrait. Three other such portraits, perhaps surrounded with minutely plaited human hair, decorate her watch chain. A cool left hand gestures toward these ancestors. Thus Bertha, beginning her marriage, reveled in the current mania for self-display. Valiant in satin, velvet, and jet bagatelles, she also rehearsed a pantomime that sent a potent message. Individual qualities of character that she may have possessed were less important to her image than the indomitable architecture of her silhouette, which broadcasts the fact that she was the undisputed legatee of a revered family line, the daguerreotyped members of which, re-photographed on this occasion, she quite literally carried. (fig. 2)

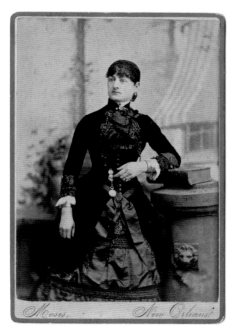

fig. 2

The Lemles' New Orleans circle was exclusively German-Reform-Jewish, an elite of mercantile families which, with the exception of the necessary complement of Negro servants, eschewed all but their own. New Orleans Creole society was similarly closed. For the Jews, keeping to themselves was undoubtedly a matter of snobbism. It was also an urgent, self-protective response to anti-semitism that had been virulent since the Civil War: "The Jews of New Orleans and all the South ought to be exterminated...they are always to be found at the bottom of every new villainy."[12] Not surprisingly, the friendships of Bertha's daughter, Rose, occurred among relatives and scrupulously chosen classmates from school.

Bertha confronted the camera's all-seeing lens, wearing daguerreotypes to define her alliances. Her daughter, Rose, like many late-nineteenth and early-twentieth-century girls, also depended on photographs to broadcast who she was or imagined herself to be. In snapshots, artfully trimmed, arranged, and pasted into an album, Rose defined herself through friends and family, and as significantly, through the prescribed mask of clothing.

It never occurred to her to deviate from the exemplar of her familiers. Any action that suggested poor upbringing was met with a haze of disapproval. It was assumed that she would maintain a spotless name by conducting herself as a lady. In photographic pantomimes, she conveyed the parameters of what she was expected to accomplish. In practical terms, this was, simply, nothing at all.

Idleness, considered an "appendix to nobility," was her entitlement. It was also her curse. She wasn't required to pursue anything but recreations and pastimes. If she craved exercise, employment, or vocation, the desires went unfulfilled. Rose never learned to gaze inward: if strange visions rose from the depths, she

attributed them to nerves. This produced a disquieted mind that feared disease, led to sullen, weeping fits, pounding fists, and a fragile spirit prone to illness which, all her life, demanded constant attention. "For what will not fear and phantasy work in an idle body?"[13] Closely observed, Rose photographed, occasionally betrayed a sub-stratum of protest and conflict which the girl, and later the woman, would never resolve and caused her profound suffering.

Rose Lemle's album,[14] from around 1900, seems like any American girl's record of the prescribed carefree idyll that conventionally preceded marriage and motherhood. This was a charade, for the album's origin coincides with a period during which she experienced grave personal loss. At fifteen, Rose was suddenly without parents: Gottlieb had died when she was ten; and by 1901, Bertha, still young, was dead as well. Maiden aunts, Cora and Estelle Simon, two of her mother's four sisters, were handed the task of raising her and marrying her off.[15] Crushed by Fate, the lovingly indulged daughter soldiered on.

Not surprisingly, she collected four-leaf clovers. (Many desiccated samples appear among the album leaves.) Motherless, she leaned on Lady Luck. Superstition became another life-long habit. Given her misfortune, she was determined not to challenge taboos. She avoided the evil powers of thirteen in any form, refusing to sit at any table set for that number. When she died peacefully in her La-z-boy at ninety-one, her family mused that her ripe old age was divisible only by the fatal number.[16]

Miss Rose maintains a shimmering energetic surface in her album. Dressed, at first, in requisite mourning black, she is resilient and full of hope. She moves through graduation, from an all girls' high school with its favorite teachers (all with German surnames) into endless recreations, friendships, and beaus (all with German surnames).

The album also documents the surface of leisured American modernity — someone's brand-new motor car, a horse-drawn water tank, flower-decked canoes filled with young men and girls, including Rose, in huge ribbonfestooned hats. That these Jewish young people fancied themselves part of an American noblesse is evident in a Marie-Antoinette-as-milkmaid-image of a cotton picking machine, attended by Negroes, where girls from Rose's set, smiling in summer frocks, fancy themselves at work.

The hand-held box camera itself was crucial to the self-imaging cult of the time. Certain album pictures feature fashionables learning to use George Eastman's Kodak and deciding how best to appear when photographed. This pantomime was not the stern studio rhetoric of Gottlieb and Bertha. It was a new theatrical schematic of seeming to be caught having a good time and appearing beautiful doing so: dapper boy-men in bowler hats and spats balance on ladders; girls in white settle into a peach tree, turning aristocratic profiles and shining coifs toward the lens. There are outings to lakes and torrents, horse-drawn surreys, a night-shot with a wagon, loaded with some twenty young people, drawn by polished horses. Rose rides bareback, or sits with a beau in a horse-drawn buckboard. Men and boys chew cigars. Smiling couples pose on porch steps or backyard swings. All epitomize the closed circle of careless privilege.

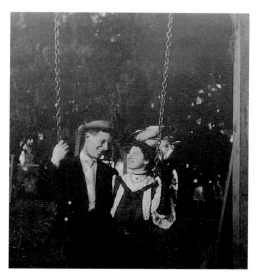

fig. 3

More important to Rose's goal of adored goddess, the album catalogues her requisite slew of suitors. Massively coifed and with flounced shoulders, she poses on a wicker settee in a photographic studio with handsomely fey Ariel Stern. Four tiny "gem" oval portraits of Ariel separate the couple from a formal portrait of the young man, onto which, borrowing a phrase from poet Robert Browning, he has written: "A BROWN STUDY CAN YOU GUESS WHAT I AM THINKING ABOUT." Another handsome Jewish suitor fills the next page where, in a snapshot shaped like a heart, Rose and this unnamed mystery man flirt before a picket fence.

There are outings to lakes where swimmers in wool bathing costumes, trimmed like sailor suits, pose near a rowboat. Rose has covered her helmet of hair with a huge bandanna. Parasols, hats, like cakes that spill plumes or artificial cherries, long black gloves, and a thousand other fripperies adorn the tableaus. In many guises, Rose is the consummate fashionable, discretely, yet resolutely on the make. (fig. 3)

But another mood jumps from the album pages. Rose, perhaps fifteen or sixteen and swathed in white, stands before a jasmine-choked fence. Her first cousin, Harold Jacobi, in white shirt, celluloid collar and tie, balances a tennis racket on his shoulder. He grasps Rose's raised wrist; she makes a hard fist that seems to conceal something precious and important at the end of a chain around her neck.

Docile Harold plays the patient pursuer. Rose doesn't struggle to free herself. She is secure, obstinate, her gesture mildly avaricious. Whether she clutches a talisman or a worthless bauble, her expression assures us — he won't get it. "A girl of fifteen generally has a greater number of secrets than an old man...," philosopher José Ortega y Gasset mused about females' perpetual self-concealment.[17] Studying

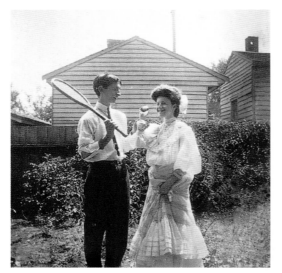

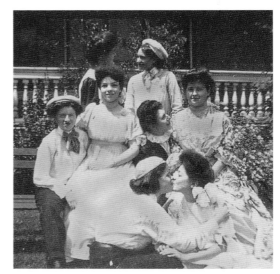

fig. 4 fig. 5

the camera, Rose betrays something homely and genuine. Her mocking, malicious grin is that of a tomboy in flounces with an unconquerable will. (fig. 4)

A curious kind of album picture elaborates this one with startling force when Rose feigns being a male. During Mardi Gras everyone donned costumes to affect new personas. Dressing like the opposite sex infiltrated much photographic posing from all periods. A staple of eroticism, it had appeared in popular lithography well before the invention of the camera. In Rose's album, boys carrying parasols and wearing women's skirts are charming in their evident discomfort.

When Rose and her girlfriends cross-dressed, their antiquated clothes seemed pulled from theatrical trunks. Forming amorous couples, some girls acted the coquette; Rose always joined those in britches who played male gallants. In one such grouping, as the shutter clicks, two girls kiss on the mouth. (fig. 5)

Rose went farther. She put on a real pair of men's trousers, swaggered before the camera, and became someone quite unfamiliar. Emboldened by the transgressive power of clothes, hands dug into pockets, legs held rigidly apart, she forsook the woman's sphere, assuming a cliched posture of patriarchal dominance. As she throws back her head, she's not grinning this time. She's laughing.

Were this all the snapshot contained it could be attributed to a flight of fancy, to any well-bred girl's latent desire for licentious, if momentary, adventure. But insolent Rose, standing like the letter A, is joined by a Jack Russell terrier. Seated beneath her thrusting crotch, the little scrapper performs on cue, resting on hind legs and raising front paws in a pose that clearly displays his penis. In the sexual displacement, Rose claimed for herself a hidden male Other. She was clearly at home.

She trimmed the photograph into the shape of a little house. (fig. 6)

The brazen image is not unique. Another from this moment shows Rose in the same trousers, posing with another girl in knickers, like a pair of Mississippi River roustabouts. They stand in a city street with clapboard-sided houses and plank

fig. 6

fig. 7

sidewalks, claiming as their support a dead tree, phallic with its sawed-off branches. The friend remains female. Rose, elbows akimbo, taunts the lens with a masculine glare. (fig. 7)

Who pressed the shutter for these trouser pictures isn't important; the photographic director was certainly Rose. The images seem less like snapshots than still frames from an extended mental cinema. Around this time, psychoanalyst C.G. Jung was absorbed by the stream of images from his own unconscious. Confronting them directly in fantasy-dramatizations, a process he later called active imagination, he codified what people had always done when they met their dream symbols and engaged them in dialogue.[18] Rose used the theater of photography in a parallel way. Silently, through play, she enacted scenes from internal dramas of a hidden self.[19]

Her desire was not necessarily to be a male. Symbolically, in a photographic moment, she seemed to want to abandon the trap of conventional expectations for her sex. Such "things that came out of nothing and meant she didn't know what"[20] would lead her to a peculiar interpretation of her roles as wife and mother. The revelatory instances of her theatricals, which she must have studied carefully as she created her album, never led to healing or self-understanding.[21]

anatomy of melancholy

> God! how is it we fail to realize that the mask of pleasure, stripped
> of all hypocrisy, is that of anguish?
> — Georges Bernanos[22]

Rose Lemle seems to have been a loving daughter and friend. Whether she was capable of genuine passion for another person remains a mystery. On 28 June 1911, at age twenty-five, she married Herman Masur, nine years her senior.

Herman, like Rose's father, was also a Jewish German-born merchant. He came from East Prussia to Monroe, Louisiana, at age thirteen and helped organize D. Masur & Sons, his father David's haberdashery business. By 1903 Herman had made so many friends in Monroe that he was able to open The Palace, then the town's only department store.

When Rose Lemle married Herman Masur in Monroe, she passed from a sheltered life with maiden aunts into one not unlike what she'd had. Choosing someone older and outside her set of young fashionables who would guarantee her the privileges of material success, she suddenly had a wife's responsibilities. "If you're sure you're in love, you'll be happy,"[23] she would later advise her daughter. Had Rose been in love? Or did her counsel warn against what not to ignore?

Prosperous Monroe, on the Ouachita River in northeast Louisiana, had closer affinities with rural Arkansas than with cosmopolitan New Orleans. It lacked a Jewish community and synagogue. This wasn't important to Rose. Her identity was more Southern than Jewish. Herman Masur, intelligent and sensitive to his ethnic uniqueness in a town without Jews, needed to confirm his origins. He rejected bacon, ate fish, and took to raising and killing his own chickens, which must have thoroughly revolted his wife. Chickens hanging by their feet and dripping blood in the yard would have betrayed violence that upset her confidence, marred her sense of propriety and entitlement, confused her need to be taken care of. She probably didn't realize that her husband's ritual slayings personalized the sacredness of his food. He never mentioned it, but the practice may have been his peculiar way of keeping Kosher.

Monroe in 1911 was pretty in an antiquated way. It prided itself on old plantation houses of wood and brick, including that of Judge Henry Bry, who grew rare specimens of camellia to enormous size and had entertained the great naturalist, John James Audubon, many of whose drawings and prints of birds were preserved there. Sycamore Hall, named for the huge tree in the front garden, the most beautiful in town, was thought to be haunted after the sensational murder of its owner's son. Immense wisteria vines of Stubbs House climbed into towering trees; its garden had an unusual patch of bamboo. City streets were named Magnolia, Plum, Orange, Roselawn, Hawthorne, Myrtle. The tranquil atmosphere of this garden city changed in 1916 after the discovery of a gas field. Practically overnight, Monroe, producing petroleum, natural gas, and natural gas liquids, became an industrial boomtown.

The change was auspicious for the clothing business. Herman, a devoted husband, built his wife an oversized Tudor-style bungalow with Gothic touches and tulip-motif balustrades on North 3rd Street, two blocks from the Ouachita levee and not far from Monroe's plantation-house showpieces. Rose had servants, a garden, and fruit trees, including figs. As a typical merchant's wife, she was expected to "keep up with the procession"[24] of her class by supervising and maintaining her husband's property. She procured furnishings, groceries; she directed her Negro help in preparing meals and in preserving figs with cloves and lemon slices in golden syrup, a confection she spread on toast.

With these duties Rose, once the enthusiastic flirt, turned into a consummate shopper with rigid notions of quality. Her preferences were not determined by an aesthetic sense — a gift she clearly lacked — but by department-store standards of manufacture and the imperative of name brands. No one could contradict her. Fresh peas were out; the maids were to serve canned Lesueur's in Limoges china ramekins. She commandeered a domestic routine: winter drapes had to be removed in May and returned to the windows by October. If a servant got ahead of the game, as Callie, her intrepid Negro, tended to do, endless remonstrations followed.

Rose decorated her high-ceilinged interiors with beveled mirrors, crystal, bric-a-brac behind glass in dark wood breakfronts, silver, heavy damask, and pieces of her mother's Victorian furniture. Floors were scrupulously polished. Fabrics and carpets were protected from sunlight to preserve their colors. The world of objects is always a kind of "dead among us," philosophers have observed about the secret life of things.[25] In this cultural code, Rose's baby grand piano, further symbol of her new life's finer acquisitions, became another attribute of the dead. She never played it.

> …every woman is something of a princess: she lives from herself and, therefore, she lives for herself. She presents to the public only a conventional impersonal mask, although variously modulated; she follows the fashion in everything, and takes pleasure in cliches and accepted ideas.…A woman's vanity is more ostentatious than a man's, precisely because it concerns itself only with externals.…but it does not generally affect her inner reality.[26]

If Rose bit her handkerchief, insisted on warm milk with every meal, toyed with her food at supper, brainlessly nibbled mid-day dinners in tea rooms and hotel dining rooms, took long "dailies," ritual naps, during the hours of Monroe's worst heat, or threw fits at the slightest deviations from her rule, she didn't know why.

> She had all her life long been accustomed to harbor thoughts and emotions which never voiced themselves. They had never taken the form of struggles. They belonged to her and were her own, and she entertained the conviction that she had a right to them and that they concerned no one but herself.[27]

Soon after her marriage, Rose took to wearing rimless spectacles with hexagonal lenses, which fixed her expression into that of an owl. The wise, teacherish appearance was misleading. Wisdom was beyond her; nor did she read. Nor did she have much patience for needlework. Aided by servants, sometimes she used the sewing machine.

Several of Rose's album photographs show her in trousers happily riding bareback. But physical exertion didn't fit with marriage. Her attitude toward exercise became practically that of an invalid. She could have gardened, played golf or tennis. But she hardly strolled the pleasant streets of her neighborhood. A Negro chauffeur drove her everywhere. The lazy habit, common among women of her

class, only exacerbated the general shrinkage she'd imposed. "I always feel so sorry for women who don't like to walk; they miss so much — so many rare little glimpses of life; and we women learn so little of life on the whole."[28]

Rose had little sense of herself in relation to the world. Life on the whole was a man's domain. She didn't crave partnership or equality. Marriage gained her the opportunity for supreme conformity, which she interpreted as a series of campaigns for getting her way. Referring to her husband as "my boyfriend,"[29] she maintained her role as coquette and his as escort. But in marrying Herman Masur, she may not have been prepared for life with someone so guileless and lacking in intrigue, someone so thoroughly good.

Rose wasn't taught to be good. Her schooling in appearances implied a "pathos of distance."[30] In contrast to his wife, who gradually became a shade of something mysteriously unexpressed, Herman was a paragon of active Jewish involvement. He believed in equality for all colors and creeds. Covert observer of Jewish dietary laws, this selfless servant of God spread humor, sympathy, and loving-kindness to others.

He was universally loved by Monroe's citizens, especially the less fortunate. His shrewd business sense, joined to a commitment to peace and happiness, led him to make hundreds of monetary loans to private individuals; if they had children he added the gift of a killed chicken. People renting his properties paid the same amount for decades. He donated to build synagogues, but he didn't neglect the Baptists, Methodists, or any church needing his help, white or Negro.

He helped direct and held stocks in several prominent banks; during the stock market crash of 1929 with his own funds he saved several banks from going under. He became the town's wrestling commissioner because he owned a skating rink with a wrestling arena where evening matches were held. He created a Boy Scout camp near Monroe. Many other charities counted on his good will: United Jewish Appeal, United Charities of Monroe, Community Chest, Memphis Home for the Aged, Leo Levy Memorial Hospital for Arthritic Patients in Hot Springs, Arkansas, and Monroe's Lighthouse for the Blind. As a Kiwanis Club member, promoting community service, high business standards, and professional ethics, in twenty-five years, no matter where he was in the world, he never missed a meeting. His discretion extended to the homeliest detail: later, finding his future son-in-law, Irvin, raiding the icebox for baked hen, asparagus salad, bread, and Coca-Cola, Herman joined him with an orange.[31]

A peculiar chemistry developed between this absorbed model citizen and his wife. Ruling alone and absolutely, Rose may have envied Herman's ability to gain so gracefully the adoration she'd learned to extract through subterfuge. Despite a veneer of sweetness, she exaggerated her mother's snobbism into an art of selfishness and unrepentant criticism. Everyone wondered how Herman endured her hectoring. He wasn't a martyr. He was supremely tolerant. Believing that happiness stemmed from the domestic realm, he may not have understood (or needed to overlook) the slamming doors and stamping feet.

Their life together became a contest of opposites. Herman's automobile of choice was an old Studebaker. Driving half-way to work, he would park in one of

his lots and walk the rest of the distance to his business on DeSiard Street. Rose was always chauffeur-driven in a white Cadillac. In New York, when Bertha Alyce and Irvin hired a limousine to attend a baseball game, Herman caught the subway and arrived first. His handwriting had the small, resolute slant of a meticulous accountant. Hers retained a school girl's puffed, flaccid letters, gaping pouches waiting to be filled.

As Herman, the careful manager, gave away more and more money, Rose, the inveterate shopper who believed only in what she could possess, began taking what didn't belong to her. Through stealing, she returned to adventures which until then had occurred as fantasies of emancipation when she was photographed. Her kleptomania became an alarming fact. Relatives confided, not without begrudging humor, that to drive Rose to a store was to find oneself suddenly an accomplice and the vehicle a getaway car when Rose emerged with her pocketbook full of meat, candy, or other purloined goods.

At home she always kept a stash of candy; her favorite brand was Russell Stover's chocolate-covered marshmallows, a commercial variant on her beloved figs. In Kate Chopin's novel, *The Awakening*, Mr. Pontellier, successful businessman, tried to compensate for his absences by regularly sending his children and wife, Edna, boxes of friandises, dainty tidbits, peanuts, fruits, patés, syrups, and bonbons. Everybody declared he was the best husband in the world. Edna, despondent, was forced to agree.[32] But fancy edibles were poor substitutes for what she felt in her marriage as the grievous loss of her true self.

> Mademoiselle offered Edna some chocolates in a paper bag, which she took from her pocket....She habitually ate chocolates for their sustaining quality; they contained much nutriment in small compass, she said. They saved her from starvation...[33]

Rose was also starving. It wasn't Herman's fault. Nor would her feelings of privation be alleviated by what she put into her mouth. In dreams she projected her fear of not getting enough onto others. Soon before her daughter's wedding to Irvin Shlenker, Rose dreamed that Irvin, having been away, returned hungry. He wouldn't let his fiancé fix him anything. He went to the refrigerator and got himself a piece of chocolate pie and some soup. But there was a dog in the house; and the dog didn't want Irvin to have these things. Rose's dream faded with Irvin trying to escape the hound, clutching his pie and soup, unable to raise them to his lips.[34]

In a strange twist, later in life, Rose couldn't eat. A benign membranous growth, which she refused to have treated, blocked her gullet. Warm milk helped, but to ingest solid food, she had to cut it into pea-sized bits which blocked her breathing. Not a meal passed when she didn't leap from the table and run to the bathroom choking, the death rattle casting a pall over the house.

In old age Rose became a voracious reader. Her texts were exclusively those of Mary Baker Eddy. Through this great and tender "Mother" of Christian Science, she found escape from unreal matter in Mrs. Eddy's belief in the superiority of Mind that cast out Evil, healed the sick, and raised the spiritually dead.[35] Guided by this new mother, Rose fell into the lap of Jesus:

So, when day grows dark and cold,
 Tear or triumph harms,
Lead thy lambkins to the fold,
 Take them in Thine arms;
Feed the hungry, heal the heart,
 Till the morning's beam;
White as wool, ere they depart,
 Shepherd, wash them clean.[36]

baby

Thousands of human beings...prolong...to the very threshold of old age,
sometimes even farther, the curiosity of their never-sated adolescence.
What can we learn from such shallow creatures?
— Georges Bernanos[37]

Kate Chopin's *The Awakening* wove a tapestry of general despair in describing the idleness and suffocating boredom of bourgeois New Orleans women. Most didn't crown their epiphanies of self-knowledge by swimming into the Gulf of Mexico and not returning to shore, as Edna Pontellier did at the end of the novel. They sacrificed what they half-realized about themselves for the sake of their children.

On 29 August 1913, two years after her marriage, Rose gave birth to her only child, named Bertha Alyce after her own dead mother and a departed aunt. Rose was no ministering angel. Attachment was expressed "in an uneven, impulsive way." She would smother Bertha Alyce with love — a mother's right — then seem to forget her.[38]

Photographed, young Rose was cheered by play. But she had no playful feelings for her child. As was customary, she relied on her Negroes for the task. The training she'd received was from the school of the mask; she instructed her daughter in what she knew, though it was the source of her feelings of impoverishment. "Reflect on the whole history of women, do they not have to be first of all and above all else actresses?" Nietzsche wrote gleefully in *The Gay Science*.[39] But to some, the idea was an outmoded absurdity.

Bertha Alyce was born just before World War I when the proud tower of nineteenth-century devotion to materialism had begun to give way; the privileged, carefree days of Rose's album were fading memories. The Great War changed forever what modern life would exact from women. To choose outside of women's self-concealing sphere, the "new woman" required schooling in different kinds of self-consciousness and guidance in the attendant risks. Southern females were slow to respond. Self-definition was based on opinions of others. To act on their deepest desires was deadly, as Chopin's *The Awakening* made devastatingly clear.

Motherhood meant dominance. In Rose's domestic cocoon, Bertha Alyce had no household responsibilities and acquired no skills, which was justified by the presence of the help. She recalled that she wasn't supposed to demand too much;[40] she was less aware that her principle job was to perform. At age two or

three she played the bride in a Tom Thumb Wedding. This entertainment was an American craze, based on the celebrated marriage in the 1860s of circus impresario, P.T. Barnum's actor-midget, General Tom Thumb, to the equally infinitesimal and aristocratic Lavinia Warren.

The Tom Thumb Wedding idealized marriage by turning it into a miniature pageant. Children, directed by adults, assumed roles of minister, bride, groom, maid of honor, best man, bridesmaids, ushers, guests, and flower girls. Costumes were like those in a real "Society" wedding. The scripts varied; some betrayed an element of self-parody: I, Tom Thumb, take thee, Bertha Alyce,…

> for better, but not worse, for richer, but not poorer, so long as your cooking does not give me the dyspepsia…; so long as all bills for millinery shall be paid out of spending money furnished by your beloved father, out of gratitude for not having you left upon his hands in the deplorable station of a helpless spinster.…

I, Bertha Alyce, take thee, Tom Thumb,…

> provided that you do not smoke or drink…that you…never mention how your mother used to cook, or sew on buttons,…provided that you carry up coal three times a day,…and put up and take down the clothes-line on wash-day and perform faithfully all other duties demanded by a 'new woman'.…And thereto I give my word and honor.[41]

Celebrating and elaborating tininess, Tom Thumb Weddings gave the ideal of marriage greater external perfection.[42] Further miniaturized through the camera, little Bertha Alyce, photographed as the bride, became a doll or captured commodity, like her mother's parlor bric-a-brac of porcelain figurines. Diminutiveness is not only an occasion of endearment; it is also an opportunity for manipulation and control. In other studio photographs, prettily dressed Bertha Alyce holds a bouquet, rides a tricycle, or plays Mama, wheeling her doll-baby in a pram.

In this "fallacious paradise," the child was mere spectacle, a pawn in the American cultural agenda that seemed to give women more options but, contradictorily, enslaved them through a pervasive cult of appearances. Photographed, Bertha Alyce's gestures weren't her own. They were imposed on her by someone else. The culture of the spectacle absolutely denied the spontaneity and emotions of real childhood. Representing visual perfection through "phantom qualities meant to elicit devotion to quantitative triviality," she became separated from her true self and lost contact with the nature of her own existence and desires.[43] Cohorts in this shadow theater that commodified the child, mother and daughter renamed one another. Innocent and malleable Bertha Alyce became Baby. She called her directing mother Dear.

But when Baby was perhaps five or six, a tragedy shook their bond to the foundations. Dear abandoned her child without explanation. She had to enter a psychiatric hospital. Baby was sent to live with relatives. In this decision Dear behaved like a single parent with no loving husband who might have doubled for

a while as a substitute mother. Even if Herman had wanted to care for Baby, the division of the sexes was so rigid that his role as provider didn't permit it.

No one spoke of Rose's abrupt departure. Her brothers, Leo and Sidney, all that remained of her family core, had suddenly died from diabetes at this time, which may account for her collapse. Perhaps she'd virtually died as well. Having neither wisdom nor courage to work through the overwhelming horror, she shut herself away with the doctors. Brutal action often gives birth to its semblable: as her own mother had done by suddenly dying, Rose left her darling motherless. Dispossessed, Baby didn't know when, or if Dear would return. Without her reflecting mirror, the little performer must have felt that she, herself, had also died.

Thus, Bertha Alyce, who from childhood had learned to gain affection with pleasing theatrics, came to mistrust intimacy and denied inner fears and feelings. Safe in the logic of commodification, she evolved from an infantilized narcissist into an adult version of the same. At twenty, she was coolly astute enough to see that Governor Huey Long was "making monkeys of the citizens of Louisiana." She also reserved for Long her highest praise: "He is phenomenal in that he always gets what he wants."[44] In the politician she recognized a fellow commodity.

Marrying Irvin Shlenker, Bertha Alyce got what she thought she wanted. She ordered her life and children — "I wanted a boy first, and then I wanted a girl. And I got it."[45] The empty claims masked lonely uncertainty. She didn't know what she could legitimately call hers.

She suspected she had her father's intelligence, but Herman, model for men, not women, hadn't encouraged her in spiritual matters or altruistic action. (The latter she would later assume by default as her dead husband's legatee.) As for educating her beyond Rose's questionable guidance, Herman never thought to intervene. Neither parent challenged the intellect she may have had or helped it flower. Worse, she seemed to lack the curiosity or self-confidence to seek influences and develop habits that would promote her own inner growth.

She wasn't interested in other people unless they proved beneficial to her. Service to others was for the hired help. Inspiration from nature, art, science, literature, history were as remote as The Man in the Moon. She liked what was easy. At twenty, her idea of culture was still the funny papers: Dixie Dragon, Little Orphan Annie, Joe Palooka.[46] Great music was Ravel's "Bolero".[47] Stimulation was ballroom dancing lessons, shared with her mother, from a teacher who came to the house. Or ball games with handsome athletes, cruises, supper clubs, cotillion balls, and especially costume parties, where one was not only seen and admired but could assume any number of fictitious identities.

Occasionally, an alternative model appeared, then disappeared like a daydream. Shortly before her marriage in 1934, Bertha Alyce met a young law student in New York City:

> She's a darling girl, very attractive and extremely intelligent. And one thing about her that is so attractive is that she is so different from the average New York girl — if you get what I mean. She graduates from Law School next year, and this summer, just for the worthwhile experience, she is clerking in a law office here.[48]

Bertha Alyce knew she could have been that New York girl. Maybe she feared, or lacked imagination for, the independent originality of such choices. In her narrow view, she selected among her suitors not a man she loved — she hadn't the foggiest idea of unconditional love — but one she calculated would earn the most money. For all her repeated protestations in letters to Irvin, she didn't reciprocate his feelings. The course was so fraudulent that substantive alternatives were deemed meaningless.

Grave distortions of character and judgment are the price for such internal denial. Bertha Alyce, door-slammer like her mother, had trouble concealing her rage. Since she'd rejected anything like an energetic commitment to work, she couldn't appreciate the commitment in anyone else. In a peculiar letter to her fiancé she wrote:

> I believe in a person being conscientious…doing all that is expected of him, and I want you to be no other way. But, my dear, there is a limit to everything. I don't believe in a person making a fool of himself for someone else, and I do hope that something can be done about it within the very near future. In fact, something must be done.[49]

Few in modern American society would equate hard work with making a fool of oneself. The attack reveals Bertha Alyce's fear of wholesome occupation that seemed to exclude her. Her secret was that Irvin's loving her had made him into the fool, and marriage to him became another of her tormenting charades.

In her ambivalence, she yielded to the baser influences of her mother's shrunken curriculum. One of Baby's and Dear's habits was to recite to each other how they'd looked at a party and whom they'd managed to impress. The institution was set in stone, for even after Bertha Alyce was married with her first child, Rose wrote to her from Egypt: "Have on my navy knit play suit and look adorable (?)" — Rose by then had developed some self-criticism — and

> …the best looking men on the boat are the officers — you…would have a grand time. One of them sent me a vase of flowers — funny?…A young man with the American Express — he is too funny for words — tries to make love to me — and I have a grand time kidding him along — and Herman dies laughing.[50]

Kidding someone along was Bertha Alyce's specialty. She believed in her absolute magnetism. Conventionally pretty as a child and young woman, as an adult she worshiped at the shrine of what she considered her beauty and assumed others did as well. This beauty, lacking the glow of inner radiance, amounted to a trim figure and a meticulously maintained, highly styled homeliness. The French understand this brand of chic; they called those hiding behind clothing *singes á la mode*. Stylish monkeys had been Second-Empire aristocrats with little to recommend their looks but the luxurious yardage on their backs.

"Truly you could wear no better masks than your own faces…who could recognize you!" Nietzsche chided in *Thus Spoke Zarathustra*.[51] Bertha Alyce's mask was indeed her own face. Who she really was remained a mystery, above all, to herself.

> Her first expression was one of tension which was not beauty....
>
> She must redesign the face, smooth the anxious brows,...wash off the traces of secret interior tears, accentuate the mouth as upon a canvas, so it will hold its luxuriant smile.
>
> Inner chaos, like those secret volcanoes which suddenly lift the neat furrows of a peacefully ploughed field, awaited behind all disorders of face, hair and costume, for a fissure through which to explode.[52]

Bertha Alyce could assume any guise she wanted, provided it didn't risk intimacy, or express genuine warmth and affection. Desperate to feel important and good, she hid her need, maintaining what she regarded, and others indulgently referred to, as her "independence." Negro servants interpreted the emotional detachment of her perfectionism as the cool privilege of white supremacy's divine right to rule. One employee, who claimed to like her, generously compared her to Queen Elizabeth II. Southern writer, Flannery O'Conner, had an ear for the atmosphere:

> "You so sweet. You the sweetest lady I know."
> "She pretty too,..."
> "...I never knowed no sweeter white lady."
> "That's the truth befo' Jesus...Amen! You des as sweet
> and pretty as you can be."
> "...Jesus satisfied with her!"
> "Deed he is."[53]

The outrageous pandering of these blacks isn't caricature. O'Conner had them direct it to a hateful white bigot. Bertha Alyce was no bigot and may have seemed queenly to some of her employees. But she could turn a fit of generosity — surprising her servants with barbecue sandwiches — into a personal attack. Always ambivalent on the issue of work, when she caught Haywood, her chauffeur, chewing his barbecue after the others had finished, she roared, "...you still eating? Now that you've eaten a horse's bait, go out and do a horse's job."[54] The outburst is as coarse as a farmhand's. The servants must have calculated that it was better to pander, retreat, bow to her superiority, or lose their positions. So much for Queen Elizabeth.

The narcissist's obsessive, "hard pride"[55] never yields power, leaves no room for intimacy or heart connections with another. Resolute in the belief that she could conquer any man, Bertha Alyce came to distrust women, generally, as "not smart enough" competitors who were "in her way."[56] Actually, she accorded these presumed inferiors too much power, believing them capable of exposing her wavering foundations and confusion about loving herself or others. When she married she had no special friend to stand up for her. Rose was her matron of honor, a comrade in arms.

Bertha Alyce's art of war relied on a paltry catechism of charm-school do's and don'ts: "When you wear red you have to wear an extra amount of rouge"; "Don't you know that checks and plaids don't go together?" Her poker-faced

fig. 8

hypocrisy concerning interior decoration: "A man in the ambitious period of his life needs restful tones…"[57] was thin compensation for the husband she cuckolded for decades.

Irvin Shlenker bravely praised his wife as "the most feminine woman I know."[58] The euphemism unwittingly denounced her as the soulless victim of a life-negating spectacle culture.[59] When Bertha Alyce dyed her hair red and flaunted low-cut necklines she became the Jezebel she must have imagined herself to be. Like — "Mae West/ Half undressed/Come up and see me sometime/And I'll show you the rest." — she thought she'd invented sex: "Men are my kind of people.…I want them absorbed in me.…The man I don't like doesn't exist.…There's a man for every mood."[60]

Her tastes flirted with the risque and vulgar. A favorite Paris restaurant was Au Mouton de Panurge. (Panurge is a character from Rabelais.) The food was shaped like genitalia. Waiters, dressed like Franciscan monks, slipped garters on the thighs of laughing female diners. (fig. 8) The restaurant's name, implying that the customers are dupes, derives from the French expression, *ce sont les moutons de Panurge*, they are led like sheep.

Unlike Narcissus, Bertha Alyce, dupe of appearances, never consulted the reflecting pool for a deeper sense of "I."[61] Inner questioning would have meant the unbearable process of sorting through the lies of her elusive shadow life. A narcissist's entire existence is a hedge against surprises. Bertha Alyce didn't count on the reflecting pool offering a vision that would unmask her. It came in the form of an unlikely warrior, her own daughter, armed with a camera.

Girl with a Weapon

> …every craftsman
> searches for what's not there
> to practice his craft.
>
> A builder looks for the rotten hole
> where the roof caved in. A water carrier
> picks the empty pot. A carpenter
> stops at the house with no door.
>
> Workers rush toward some hint
> of emptiness, which they then
> start to fill….Don't think
> you must avoid it. It contains
> what you need!
>
> — Jelaluddin Rumi [62]

Anyone can use a camera. But no photographer worth considering simply shoots appearances. For some, there's a passion to fill in a gap, solve an uneasy riddle. "The queasiness of it"[63] provokes from within.

Like many children, Gay, Bertha Alyce's only daughter, had a camera by age ten. Maybe her parents regarded the Brownie as a toy, but she felt differently, recognizing in it powers of magic she thought she'd never understand, since no one expected her to understand anything much about the "secrets of the world."[64]

She did not choose her subject. It was ready-made and rampant, threatening to suffocate her like a jungle plant. Looming, incomprehensible, dangerous, it was the flame-throwing dragon of fairy tales. At age five she took her stand against the revolting specter: "I don't want to look like my mother. I don't like my mother."[65]

Gay always believed herself fat, larger than her mother in size, but also dumb and ugly. This disqualified her as her mother's competitor. It also liberated her to observe from the margin. Joined to her artistic gift, consuming visual intuition, a quality unknown in the family, her position on the sidelines was precisely what she needed as a photographer.

At first, she was afraid to use the Brownie at home. She reserved it for Pinecliffe, a summer camp in Maine. By age twelve she began to treat the camera as the instrument of a spy: mother, with the fixed smile of a calendar girl, concealed in a bubble bath; mother absorbed in sorting through her clothing as a miser counts gold; mother in bed engulfed in a newspaper. What was this collapsed, unattainable thing? In the cold seductive mirror, her mother's drug, the girl recognized a hopeless junky, a kind of freak.

> First having read the book of myths,
> and loaded the camera,
>
> I came to explore the wreck
> I came to see the damage that was done
> the thing I came for:
> the wreck and not the story of the wreck
> the thing itself and not the myth[66]

The myth was the atmosphere that starred Bertha Alyce. The thing itself was the hole where a mother should have been. Gay, all feeling, craved warmth. She longed for her mother to read to her. But Rose never read to Bertha Alyce who had no closeness through books to offer her child. Feeling the girl's revulsion, she catered to her, tried to win her over. But Gay was an alien, "…different….a little devil." She hit, and bit, and didn't apologize. "I didn't know where you came from."[67]

The hungry outsider ate and ate. If she found her grandmother's airless house in Monroe boring and sad, she made friends with Rose by accepting her gift of the unplayed piano. She pretended interest in Christian Science. She fed from Rose's stash of chocolate-covered marshmallows.

Her expanding size and strange dark features, not conforming to their standards of beauty, alarmed Baby and Dear. In desperation, they turned to clothes to bring Gay into their dubious circle. Clothes were a fat girl's anathema; yet when she was pre-pubescent, they dropped everything, turned to the sewing machine, and made her an evening gown of aqua tulle. The result was as grotesque as their panic.

> Girl children who display a strong instinctive nature often experience significant suffering….From the time they are babies, they are taken captive, domesticated, told they are wrong headed and improper. Their wildish natures show up early. They are curious, artful, and have gentle eccentricities of various sorts, ones that, if developed will constitute the basis of their creativity for the rest of their lives.[68]

Throughout adolescence Gay compiled an archive of mental images without the camera. Some involved her older brother, Sidney. In the family knot, if Gay was a useless female, the young male was a god, the hope and favorite. At fifteen, Gay, Sidney, and their parents traveled to Europe for the young man's twenty-first birthday. In Venice, at the Royal Danieli Hotel, Bertha Alyce and Irvin shared one room of their suite and the children another. One morning Gay woke to discover her sleeping brother in the next bed with a full erection. She was staring at the penis, in the half-light when suddenly, Irvin arrived. Gay, feigning sleep, watched as her father stood magnetized by the phallus. He left and returned with Bertha Alyce. Gay, under the covers, drank in their rapture. Irvin covered Sidney. Then the parents burst into a chorus of Happy Birthday, thinking they were awakening both children. Gay remembered the incident as a sequence of images. The spy didn't know it, but she was photographing. "Every act of becoming conscious…/is an unnatural act."[69]

Gay's development using the camera was furtive and discontinuous. If the creative life is the soul's food and water, she virtually starved herself. Never believing she was any kind of picture maker, much less an artist, she tried to be her mother's daughter, dieting to conform to Bertha Alyce's notions of female desirability, marrying a young lawyer and having children. As the Houston housewife she was expected to be, she went to luncheons and played cards. Like her grandmother and mother she had no vocation, skills, or tasks to accomplish. She was nineteen before she saw her first sink of dishwater. It was as foreign to her as walking was to Rose and work to Bertha Alyce.

Encouraged by her husband, she studied to become an architect, but with children the task proved too daunting. When her father died in late 1971, her first thought was mother: Now she can't hurt him anymore. Gay couldn't stop crying and entered psychoanalysis.

In 1973 she began studying photography at Houston's Saint Thomas College. Her unlikely teacher was a painter, Joe Tate, whose chaotic enthusiasm forced the students to make more pictures than they thought possible. Tate gave an assignment: "Photograph something you need to know about." She took her Nikon Nikormat, loaded with its first roll of Tri-X, and went straight to her mother's. Arriving like an assassin, she discovered Bertha Alyce wasn't wearing any clothes.

• "There's a kind of power thing about the camera....Everyone knows you've got some edge. You're carrying some slight magic which does something to them. It fixes them in a way."[70] But Bertha Alyce, oblivious to all but her own magic, wasn't impressed. Ever at war, she competed with the camera, composing herself, coifed and manicured, as if she were already a picture of her own devising. "Each individual commodity fights for itself, cannot acknowledge the others and aspires to impose its presence everywhere as if it were alone."[71]

Her expression feigned nonchalance: the daughter and her weapon were no more important than the maid bringing a cup of tea. Gay, who'd hardly made any pictures before this moment, played along. Together, mother and daughter collaborated to produce what each, in relative ignorance, thought were "professional-style nudes. But Gay's five images contain none of the forms of such abstractions. Bertha Alyce, stark naked, is an impassive matron at home.

Bertha Alyce's contrived self-concealment only updated what her imperious grandmother, Bertha Simon Lemle, had displayed in the professional photographer's studio, and her mother, Rose, with provocative contradictions, had shown in her album. Each generation intensified a fierce need to hide against internal truths.

Bertha Alyce, self-styled pinup, wasn't a mother, nor had she ever been. This was what Gay was obsessed to verify, and the mysterious creature became the springboard for her photographic work. "Somebody else's tragedy is not the same as your own."[72] Gay would use photography to discern and clarify that difference. The task was formidable. All she understood was that the dangerous beast she'd grown up with required minute attention. She would dive into the wreck and expose the damage. Yet she hid the pictures of her nude mother. Their coldness frightened her, but they were a benchmark to which she secretly referred.

Oddly sustained by this unnatural mother-as-subject, she was unaware that she was responding to something revolutionary taking place in photography, generally. In 1972, the year before Gay made the nudes of Bertha Alyce, The Museum of Modern Art devoted a one-person show to Diane Arbus with a catalogue that remains one of the most astonishing group of images of the past thirty years. Gay and her husband saw the exhibition in New York.[73]

Gay identified with Arbus's Jewish privilege. Never having known "adversity," Arbus was puzzled by the pain of her supposed "immunity."[74] She didn't photograph her parents but went after what, as a sheltered New York, Park

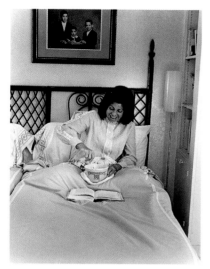

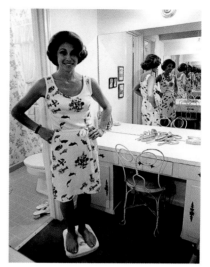

fig. 9 fig. 10

Avenue child, she'd never seen before. The intensity of her intimacy with those on the margin, from whom we're supposed to turn away, yet through the photograph, at whom we may endlessly stare, gave Gay permission, not to pursue marginal oddities, but to scrutinize her own circle of privilege.

 With the same curiosity she felt about her mother's shallowness, she took on her parents' congregation of Temple Beth Israel in Houston. In 1973, this oldest Reform temple in the Southwest raised funds by staging a musical review, called "Hello Follies." It published an advertising booklet which Gay illustrated with portraits of the congregants.[75] She asked what their folly was and followed them to card games, greenhouses, golf courses, and swimming pools. She caught a woman in bed with a gallon of ice cream; another, with a dieting fetish, posed on a scale. (figs. 9 and 10) Gay included herself standing in her Porsche. Arbus gave her the courage to stare, but in this first attempt to create a sustained body of work, her attitude toward these self-satisfied Jews was indulgent and affectionate. After all, she was one of them.

 Joe Tate had her show the Follies images to Houston photographer Geoff Winningham at Rice University, with whom she studied for over a year. She started consuming books on photography, as Rose had gorged on Christian Science. Sensitive to her interest in portraiture, Winningham told her to look at August Sander's photographs. She went to The Museum of Modern Art and was amazed by the intensity of their cool beauty.

 Through Winningham, Sander, and Arbus, she knew she had found her work. Comfortable recording Jews, and bitten by the rebellious counterculture spirit of the 1970s, she went after the temple again in 1975. It was another way to confront what she felt was the emotional bankruptcy of her parents. This time she made a 16mm.-Bicentennial film about Beth Israel, based on portrait stills with a new 4x5. Interviewing the same self-indulgent bourgeoisie, she expected to find the

shallowness she'd seen before. In some cases she did, for to these Reform Jews, Jewish Orthodoxy was tantamount to obscenity. "We live with the A Jews," one boasted.[76] She also found something else. During her interviews, by paying greater attention to her subjects, she had to confront her own prejudice about them. Behind their veneer of material privilege people with rich family histories forced upon her a recognition of the layers of courage and sadness in the lives of American Jews.

In the fall of 1976, Garry Winogrand taught at Rice. In his class, she showed him the still image portraits that appeared in her film. To him they suggested Arbus's faces — "they're like reading road maps." She wasn't imitating Arbus, but she had begun to chart her own photographic course. With a 4x5 Toyo-Field camera, she went to her mother-in-law's house to continue the portraits of upper-middle-class Jews from her "community of origin."

Among the women socializing, playing cards, and in the faces of other women and their children, she found palpable sadness. Even heavy make-up couldn't conceal the misery betrayed by their distancing postures. These were soul mates, with the same stunted feelings she'd endured as a girl. The so-called, "mothers and anti-mothers,"[77] were modern equivalents of the idleness and dispossession that Kate Chopin catalogued in *The Awakening*.[78]

> I can look in the eyes of strangers and
> find you there,…
> and I smell you always…
> …not a day goes past that I am not
> turning someone into you.[79]

No matter whom or what she photographed, it was always Bertha Alyce.

In 1977, armed with a noisy 2 1/4 Rollei SL-66,[80] she returned to the mother's apartment — "Never having had you, I cannot let you go…"[81] — and chose a symbolic moment that underscored her parent's life of lies. It was the day after her dead father's birthday. She baited the trap, announcing she'd photograph Bertha Alyce bare-breasted.

For this document she included herself as her mother's opposite. Next to the daughter with dark circles under her eyes and no make-up, whose every feature was an affront to her self-image, the coifed and manicured mother smiled, but tremulous anxiety showed on her face. Gay, on a mission, stared into the lens, expectant and fearful, as if down the barrel of a cocked rifle.

Bertha Alyce was threatened. She subverted Gay's plan by attacking the girl and her weapon. Mother and daughter, side by side, were a contest that Bertha Alyce had to win. "Too bad your breasts aren't as pretty as mine," she mused, then flicked her nipples with an order: "Come on, little fella! Wake up! Stand up!"[82] It was a ploy to enhance her physical superiority, but the vulgarity recalls the nudist-camp riddle, recorded by Arbus: "What kind of bees give milk?…Boobies."[83]

These mother-daughter images are not portraits. Their 1970s theatricality "which may be the single most pervasive property of post-modern art," ritually stage Gay's fury. "A work of art will reveal itself within the mind of the beholder as something

other than what it is known empirically to be."[84] Arbus called this "the flaw...the gap between intention and effect."[85] Gay gives us not two women, but bodies as images of inequality, of domination and submission which encapsulate perpetual conflict. Conflict would be recognized as the core of camera consciousness:

> In front of the lens, I am at the same time: the one I think I am, the one I want others to think I am, the one the photographer thinks I am, the one he makes use of to exhibit his art.[86]

In 1967, Duane Michals had staged a spurious photo-document of a loving couple, on which he wrote: "This photograph is my proof," followed by "a pathetic little narrative" which purported to show the pair at the moment of their supreme happiness before everything went wrong. It also tried "to make concrete, in order to possess, not only another's most intimate feelings but also the other herself."[87] Gay and her mother, bare-breasted, are Gay's "proof," her possession of truth. Ignorant of her daughter's motives, Bertha Alyce swallowed the bait and revealed her true colors. The photograph from the sitting which later moved Gay — Bertha Alyce gazing lovingly on the now smiling daughter — also is a performance. However deeply felt at the moment, for Gay the mother's look simulated an "original" that had never been.[88]

> You are not yourself.
> I am the real thing.
> I am your reservoir of poses.
>
> Your money talks.
> Your moments of joy have the precision
> of military strategy.
> You destroy what you think is difference.
>
> You are an experiment in terror.

Barbara Kruger amazed an audience with these statements of social indictment as a kind of poem in 1984.[89] Gay, an amateur following nothing but a trail of feeling, driven by debilitating, unexpressed anger, had already devised her own illustrations for Kruger's attacks.

Gay's book, *Bertha Alyce*, collects all kinds of photographs besides her own. It is essentially a scrapbook of evidence that puts her mother on trial. Like a legal prosecutor, Gay delivers the incriminating testimony with pictures and an assortment of witnesses. When a couple of these participants suddenly break rank and ask: Why are you doing this book? we realize that the players, meant to review the case of Bertha Alyce from within, have joined her audience of reader-witnesses and review it from the outside as well. In this post-modern environment, "ritual and narrative share a concern for audience, the engagement of a community."[90] We, the jury, will decide, but Gay's informants already have.

Gay is in deadly earnest. She doesn't allow us to laugh at her appalling mother. One begins to feel pity for Bertha Alyce, as one might for a caged monster. In family snapshots, home-movie stills, or in Gay's own portraits, commentary politicizes the pictures, and Bertha Alyce becomes the self-incriminating defendant.

The book is a performance piece, a mock-courtroom drama, where the core story is never completely told.[91] This is why the present essay dwells so lengthily on Rose, her parents, album, married life, and on Bertha Alyce as a child and young woman — to step outside the project with a series of family tales that Gay's conception necessarily forced her to ignore.

The photographic rituals (including Gay performing), the spoken narratives that she recorded, directed, and arranged in the book tell her version of the story. They also expose her own ambivalence. The project indicts the parent and attempts to redeem her. It also wants to show how Gay saved herself. Her motives recall a Jenny Holzer truism: "In a dream you saw a way to survive and you were full of joy."[92]

Gay's intentions throughout *Bertha Alyce* can be explained through many of Holzer's recitations of banal wisdom:

> A single event can have infinitely many interpretations.
> Anger or Hate can be a useful motivating force.
> Being Judgmental is a Sign of Life.
> Children are the cruelest of all.
> Even your family can betray you.
> Expressing anger is necessary.[93]

Gay not only defines her position. She plots transformation. Deploring her mother's face-lift, Gay recorded its stages in some of her strongest portraits. They surpass the Follies photographs by unflinchingly confronting what seemed to her to surpass skin-deep foolishness. More profoundly they join Guy Debord's, declamations regarding life and death in contemporary society to the fact of Bertha Alyce's entrapment: "…under advertising's bombardments it is simply forbidden to get old. Anybody and everybody is urged to economize on an alleged 'capital of youth'…"[94]

After her stroke, Bertha Alyce, in a wheel chair, tells another story through confused self-questioning, and clarifies her burden as a commodity:

> …the self, under siege by the presence/ absence of the world,
> is eventually overwhelmed;…The individual, though condemned
> to the passive acceptance of an alien everyday reality, is thus driven
> into a form of madness in which,…he entertains the illusion
> that he is reacting to this fate.…'a torturing feeling of being at
> the margin of existence.'[95]

After Bertha Alyce's death, Gay, the only daughter, received a hoard of her possessions. Bric-a-brac, furs, clothing, jewelry, photographs, letters turned her into a crazed archeologist and became a principle source of inspiration. The quantity led the portraitist to turn to still life, which she also used to intervene in Bertha Alyce's story and stand it on its head.

Every composition she created from this pile of booty moralizes with the contest strategy of the bare-breast portraits. Photographing herself, as if having donned her mother's wedding gown, she makes us aware that the garment doesn't fit. Standing naked, half into the satin thing, but too big to put it on, she declares her freedom.

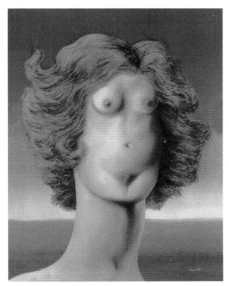

fig. 11

Still lifes comparing her mother's jewelry of precious stones and metals with her own operate similarly. "The ruling class, made up of specialists in the ownership of things who for that very reason are themselves owned by things, is obliged to tie its fate to the maintenance of a reified history."[96] Gay's jewelry still lifes recall a family tradition. Her great grandmother, Bertha Simon Lemle, had posed in the photographer's studio, wearing her daguerreotyped ancestors as jewelry, and with "the dead among us,"[97] fashioned herself, beyond portraiture, as living history.

Gay carefully arranged Bertha Alyce's jewelry into twelve compositions, together forming a grid. She configured her own jewelry similarly. Wanting to fill the frame with each grid, she had to stand so far back that the distinctions she wanted to draw between the two women occurred as abstract patterns. It is as if we were flying reconnaissance over a jewelry world, mapping with the camera, trying to draw conclusions from adornments, which in the arrangement and vantage point have lost their particularities as things. The jewelry, like alphabet letters, becomes two different texts. Each, in its unique language, gives clues as to how we must interpret it.

Looking closely at certain treasured jewels, Gay became their conscience. She treated all of Bertha Alyce's goods as booty, falsely gained adornments of a cheat. One of the most stunning and original images in the book is a close-up of Gay's own pubis, on which she placed Bertha Alyce's fabulous diamond pin, a gift from Irvin and worn often. Like Surrealist painter Rene Magritte who, in "The Rape," 1934,[98] imagined a nude female torso as the puckered face of a violated prude, Gay reconfigures Bertha Alyce — adorned cunt — with her own. (fig. 11)

Dropping her mother's gold and diamond I LOVE YOU bracelet, also Irvin's gift, into a series of gloppy, food-store-chain pies and cakes, Gay expanded the

discourse on fraud. As with the bare-breast portraits, she includes herself for comparison, this time as the absent glutton. Traces of her consumption of the sweets, a bite here, a slice there, are deliberate violations. But in one, the entire strawberry cream cake has been devoured, leaving the precious, ignobly worn bracelet half-submerged in a gooey pool of red jelly.

soulskin

> To lose the pelt is to lose one's protections,…warmth,…
> early warning system,…instinctive sight.
> — Clarissa Pinkola Estés[99]

As a young married woman Gay liked wearing an old fur coat that had belonged to her grandmother, Rose. It was a three-quarter-length mink, but the pelts were drying up, and the thing was full of holes. She tried to get it repaired. The furrier said it was too far gone. She wore it anyway. She didn't need to do this. She had plenty of coats. But she wanted Rose's coat. She didn't think about it this way. She didn't think about it at all.

Rose hadn't been important to her. Skin-deep, obsessed by freckles and figs, she was a lost soul, shadow figure, petty tyrant and thief, Christian-Science fanatic. But Rose left photographs of another male self who fantasized breaking out of the female charade. When Gay declared her lesbianism she photographed herself in men's clothing. "Her life supported yours. Maybe even invented yours."[100]

She owned Rose's album. But she never reflected on Rose's explorations as a transvestite. Besides, this isn't how things work. Rarely are artists influenced directly. Seizing upon certain things or strategies, they confirm what's already been brewing.

Among the possessions Gay inherited from Bertha Alyce was a sizeable collection of mink coats and stoles. Gay hung them all on a tree and photographed them as a group. Like Rose, ignorant that her passion for figs connected her to ancient traditions of magical beliefs, Gay, led by instinct, didn't know that her need for Rose's coat and attraction to Bertha Alyce's pelts connected her to an equally magical thread of human psychic history. Jungian analyst, Clarissa Pinkola Estes, explains:

> If we delve into the symbol of animal hide, we find that in all animals, including ourselves, piloerection — hair standing on end — occurs in response to things seen as well as to things sensed. The rising hair of the pelt sends a 'chill' through the creature and rouses suspicion, caution, and other protective traits. Among the Inuit it is said that both fur and feathers have the ability to see what goes on far off in the distance, and that is why an angakok, shaman, wears many furs, many feathers, so as to have hundreds of eyes to better see into the mysteries….

In hunting cultures, the pelt is equal to food as the most important
product of survival....Psychologically, to be without the pelt causes
a woman to pursue what she thinks she should do, rather than
what she truly wishes. It causes her to follow whoever or whatever
impresses her as strongest — whether it is good for her or not. Then
there is much leaping and little looking. She is jocular instead of
incisive, laughs things off, puts things off. She pulls back from taking
the next step, from making the necessary descent and holding herself
long enough for something to happen.[101]

Increasingly aware of her work as a photographer in a family where no woman
had worked for generations, it's no wonder that Gay needed Rose's pelts.

Nor is it an accident that Gay chose for the cover of her book on Bertha Alyce
a peculiar self-portrait. Eyes closed, she embraces one of her mother's expensive
minks. Nose hidden, she seems to search for the mother's scent — I smell you
always — perfume that once had made her sick. She holds the mother-pelt as if it
were a precious child, cherished friend, or lover. She accords respect to the talisman,
which, if properly handled, will guide and support, allow insight into mysteries
that will help her live. In what to the mother was just another trophy, the daughter
finds "proof," not more evidence of a narcissist's failure. In the leavings of the
dead mother, she discovers an emblem that signifies her own change of heart.

A woman has to be her own hero. The princess cuts off her hair,
blinds her eyes, scores her arms, and rushes wildly toward the mouth
of the dragon. The princess slays the dragon, sets off on her own
quest. She crushes her crown beneath her foot, eats dirt, eats roses,
deals with the humility and grandeur of her own human life.[102]

notes

1. Grace Paley, *Just As I Thought*, New York, Farrar, Straus, Giroux, 1998, p. 246.

2. M. F. K. Fisher, *A Cordiall Water, A Garland of Odd and Old Receipts to Assuage the Ills of Man and Beast*, San Francisco, North Point Press, 1981, p. 44. There were many tried and true recipes for removing freckles with urine. Fisher cites one from Provence: a wineglass of urine was mixed with a tablespoon of good vinegar and a pinch of salt. After standing for twenty-four hours, the mixture was patted on the freckled skin, left for a half-hour and rinsed with plain cold water. Ibid.

3. To remove freckles, *à la Maintenon*, one dissolved 1 oz. Venice soap into 1/2 oz. lemon juice, 1/4 oz. bitter almond oil, and 1/4 oz. deliquidated oil of tartar. In the sun the mixture thickened into an ointment, to which one added 3 drops of oil of rhodium. At night, the unction was spread on the speckled face and hands and in the morning washed off with pure water or, if convenient, elder-flower and rose water. See Madame Lola Montez, Countess of Landsfeld, *The Arts of Beauty or Secrets of a Lady's Toilette, with Hints to Gentlemen on the Art of Fascinating*, New York, The Ecco Press, 1978, pp. 79-80. The influence of Lola Montez, one of the most popular arbiters of beauty, was pervasive in America, no less so in cities of French origin. She dedicated her book, written in the 1850s, "To ALL MEN AND WOMEN of Every Land, Who Are Not Afraid of Themselves, Who Trust So Much in Their Own Souls That They Dare to Stand Up in the Might of Their OWN INDIVIDUALITY, To Meet the Tidal Currents of the World…"

4. From undated letters to her daughter, Bertha Alyce, written on a cruise to the Near East, August-September 1936 (henceforth abbreviated Letters from the Near East). Among Family Papers belonging to Gay Block, Santa Fe, New Mexico (henceforth abbreviated Family Papers).

5. Montez, p. ii.

6. Eudora Welty, *The Optimist's Daughter*, New York, Vintage International, 1990, p. 12.

7. Sigmund Freud discussed this masquerade in 1909. See "Freud and Fetishism: Previously Unpublished Minutes of the Vienna Psychoanalytic Society," ed. and trans. Louis Rose, *Psychoanalytic Quarterly*, 57 (1988), p. 156, cited by Emily Apter, *Feminizing the Fetish, Psychoanalysis and Narrative Obsession in Turn-of-the- Century France*, Ithaca, Cornell University Press, 1991, p. 80.

8. Letter written from New York, July 1934 (henceforth abbreviated New York Letters). Family Papers.

9. Letters from the Near East, Family Papers.

10. It was pure instinct. Had Rose been aware that her need for figs connected her to a complex history of mythological associations and beliefs, who knows what the consequences would have been? The fig was a symbol of man's enlightenment through the feminine-maternal principle. According to the Aggadah, the forbidden fruit of The Tree of Knowledge in the Garden of Eden was the fig, not the apple. Buddha was protected by the Bodhi Tree, the Tree of Wisdom, or the (*ficus religiosa*), The Holy Fig, when he received his own enlightenment. The fig was a common Indo-Iranian symbol of The Great Mother the "primeval mother at the central place of the earth," whose branches ascended to heaven, with fruit shimmering like stars. Gaulish gods, called Dusii, were "fig eaters" parallelling the Homeric "lotus eaters," both of which symbolized the female genitals. The fig hand (*mano in fica*) a fist with the thumb projecting between the second and third fingers, was a sign that protected against evil spells and was incorporated into love charms sacred to Venus. Dried figs were womb symbols placed in the tombs during the early Egyptian dynasties for the rebirth of the dead. See by Barbara G. Walker, *The Woman's Encyclopedia of Myths and Secrets*, San Francisco, HarperSanFrancisco, Division of HarperCollins Publishers, 1983, pp. 307-308; and The Woman's Dictionary of Symbols and Sacred Objects, San Francisco, HarperSanFrancisco, Division of HarperCollins Publishers, 1988, pp. 470-471; 473; 484-485.

11. One of Bertha Simon's ancestors was Samuel Mandel Marks (Marques) who fought in Captain George Turner's Company in the First Regiment of the South Carolina Infantry of the Continental Establishment, commanded by Colonel Charles Cotesworth Pinckney. The National Archives in Washington D.C. still has the payroll slips that verify his service, dating December 1779; January 1780; February 1780. Family Papers.

12. "A reporter for a New Orleans news agency" writing during the Civil War. Quoted by Adrienne Rich in *What Is Found There, Notebooks on Poetry and Politics*, New York, W.W. Norton & Company, 1993, p. 23. Oscar Handlin in "American Jewry," *The Jewish World: History and Culture of the Jewish People*, New York, Harry N. Abrams Publishers, 1979, writes, "…as the nineteenth century drew to a close, Americans, bewildered by change, sought to place the blame for all the nation's troubles on outside conspiratorial forces. Farms, factories and money supply were in perennial disorder; and many troubled citizens believed the fault somehow sprang from the strange cities, monstrous in size and frightening in their combination of wealth and poverty. There, perhaps, was the seat of an alien conspiracy directed by the Pope, or the Jews, or the anarchists or the bankers….it was tempting to ascribe…the social disorders…to the immigrants and to speculate that, if only [they] could be shut out, perhaps the country would revert to its earlier purity." pp. 278-279.

13. "Causes of Melancholy" were as old as the gentry itself. The words are Robert Burton's from the year 1621, in *The Anatomy of Melancholy*, ed. and intro. by Holbrook Jackson; with a new intro. by William H. Gass, New York, *New York Review of Books*, 2001, p. 242.

14. Among the Family Papers.

15. Her maternal grandparents were still alive, dying in 1910 and 1913. Family Papers.

16. Conversations with Gay Block, Santa Fe, New Mexico, Summer 2001. All specific information about Rose, her daughter, Bertha Alyce, or her granddaughter, Gay, that is not this author's interpretation, or derived from photographs and documents in the Family Papers, is based on these conversations and henceforth will not be cited in the present text.

17. José Ortega y Gasset, *On Love: Aspects of a Single Theme*, trans. by Toby Talbot, New York, Meridian Books, Inc., 1957, p. 134. Ortega, born in Madrid in 1883, is reflecting on paintings in a 1918 exhibition; his views specifically reflect those of the period described in this part of the present essay.

18. See in Barbara Hannah, *Encounters with the Soul: Active Imagination*, as Developed by C. G. Jung, Boston, SIGO Press, 1981, chapter 5, "An Ancient Example of Active Imagination, The World-Weary Man and His Ba," which deals with an Egyptian example from 2200 B.C., pp 83-105; and chapter 6, "An Early-Twelfth Century Example of Active Imagination, Hugh de St. Victor's Conversation with His Anima," pp. 106-132.

19. Marie-Louise Von Franz, *Individuation in Fairy Tales*, Dallas, Spring Publications, 1982. "One of the royal ways for attracting and constellating one's own unconscious is by…playing, and producing the fantasy images in the way they come." p. 172.

20. E. M. Forster's *A Room with a View*, New York, Vintage Books, 1986, originally published in 1908, examines the "nerves" of his young heroine, Lucy Honeychurch, who, after having "psychology" explained to her, was able to dismiss "all the troubles of youth in an unknown world." p. 165.

21. *A Blue Fire, Selected Writings* by James Hillman, intro. and ed. by Thomas Moore, New York, HarperCollins Publishers, 1989, pp. 57-59. "Active imagination aims…at story or theater…." p. 57.

22. Georges Bernanos, *The Diary of a Country Priest*, trans. by Pamela Morris, New York, Carroll & Graf Publishers, Inc., 1983, p. 124. Seemingly unrelated to the soulless Jewish affluence addressed in the present essay, Bernanos's moralizing Catholic novel, first published in 1937, reflects with exquisite sensitivity on bourgeois boredom, hypocrisy, greed, and lust as manifestations of a universal disease.

23. Rose, quoted by Bertha Alyce in New York Letters. Family Papers.

24. Kate Chopin, *The Awakening and Selected Stories*, ed. and intro. by Sandra M. Gilbert, New York, Penguin Classics, 1987, p. 101. Written in 1899, this novel, set in New Orleans and its environs, is a poignant source of emotions experienced by Southern women, for whom, like Rose, the revered woman's sphere was fraught with silent inner conflict and untold suffering.

25. Susan Stewart, *On Longing*, Baltimore, The Johns Hopkins University Press, 1984, p. 57.

26. Ortega y Gasset, pp. 131-132.

27. Chopin, pp. 96-97.

28. *Ibid.*, p. 165.

29. Letters from the Near East. Family Papers.

30. Ortega y Gassett, quoting Nietzsche on women's innate "distinction," p. 134.

31. Based on information from Bertha Alyce in New York Letters. Family Papers.

32. Chopin, p. 50.

33. *Ibid.*, p. 97.

34. From Bertha Alyce writing to her fiance, Irvin Shlenker, New York Letters, Family Papers.

35. Mary Baker Eddy, "Miscellaneous Writings, 1883-1896," collected in *Prose Works Other Than Science and Health with Key to the Scriptures*, Boston, The First Church of Christ, Scientist, 1953, pp. 25-28.

36. From Mary Baker Eddy, 'Feed My Sheep,' "Poems," *Ibid.*, p. 397-398. Compare this surrender to Rose's report to Bertha Alyce from the Holy Land in 1936: "Then we saw where Jesus was born and where he ascended into heaven, etc, believe it or not that's their story." Letters from the Near East. Family Papers.

37. Bernanos, p. 125.

38. Chopin, p. 63.

39. Quoted in Henry M. Sayre, *The Object of Performance: The American Avant-Garde since 1970*, Chicago, The University of Chicago Press, 1989, p. 145.

40. Text in Gay Block, *Bertha Alyce*, p. 44.

41. Stewart, pp. 120-121. This is one typical script. Stewart describes other interpretations of these weddings from many time periods.

42. *Ibid.*, p. 122.

43. Guy Debord, *The Society of the Spectacle*, trans. by Donald Nicholson-Smith, New York, Zone Books, 1995, pp. 18, 23, 40. Debord's famous diatribe perfectly characterizes the modern social disease of self-praising, trivializing unreality that encouraged Bertha, Rose's mother, as well as Rose, herself, and led to the agonized distortions of Bertha Alyce.

44. Bertha Alyce in New York Letters. Family Papers.

45. Text in Gay Block, *Bertha Alyce*, p. 64.

46. While she was in New York in the summer of 1934 she had Irvin cut these funnies from the Louisiana papers and send them to her. New York Letters, Family Papers.

47. Gay Block later learned that her mother had enjoyed concerts of serious music but had kept it a secret.

48. New York Letters, Family Papers.

49. *Ibid.*, italics mine.

50. Letters from the Near East. Family Papers.

51. Quoted in Sayre, p. 35.

52. Excerpted from Anais Nin, *A Spy in the House of Love*, in *Women of Words, A Personal Introduction to Thirty-Five Important Writers*, ed. Janet Bukovinsky Teacher, Philadelphia, Courage Books, an imprint of Running Press Book Publishers, 1994, pp. 132-133.

53. Flannery O'Conner, "Revelation," from *Everything that Rises Must Converge*, 1965, New York, Farrar Straus & Giroux, Inc. printed in X.J. Kennedy and Dana Gioia, *Literature, An Introduction to Fiction, Poetry and Drama*, 7th edition, New York, Longman, 1998, pp. 375-376.

54. Text in Gay Block, *Bertha Alyce*, p. 74.

55. The expression is from Ovid, *The Metamorphosis*, quoted by Thomas Moore in "Self-Love and Its Myth: Narcissus and Narcissism," *Care of the Soul, A Guide for Cultivating Depth and Sacredness in Everyday Life*, New York, HarperCollins Publishers, 1992, p. 57.

56. Text in Gay Block, *Bertha Alyce*, p. 122.

57. *Ibid.*, (First quote from Jean Kaufman video interview), pp. 150, 82.

58. *Ibid.*, p. 150.

59. Debord, pp. 14-15.

60. Diane Arbus, "Mae West: Once Upon a Time," (published as "Emotion in Motion"), *Show*, January, 1965, in *Diane Arbus, Magazine Work, 1960-1971*, texts by Diane Arbus, Thomas W. Southall, ed. Doon Arbus and Marvin Israel, Millerton, Aperture, 1984, p. 58.

61. Moore, p. 68.

62. *The Essential Rumi*, trans. by Coleman Barks et al, San Francisco, HarperSanFrancisco, 1995, p. 24.

63. Diane Arbus, *Diane Arbus, An Aperture Monograph*, New York, The Museum of Modern Art/ Millerton, Aperture, 1972, p. 1.

64. Text in Gay Block, *Bertha Alyce*, p. 82.

65. *Ibid.*, p. 66.

66. Adrienne Rich, "Diving into the Wreck," *Diving into the Wreck, Poems 1971-1972*, New York, W. W. Norton & Co. Inc., 1973, pp. 22-23.

67. Text in Gay Block, *Bertha Alyce*, p. 64.

68. Clarissa Pinkola Estes, "Exile of the Unmatched Child," *Women Who Run with the Wolves, Myths and Stories of the Wild Woman Archetype*, New York, Ballantine Books, 1992, p. 173.

69. Rich, "The Phenomenology of Anger," *Diving into the Wreck*, p. 31.

70. Arbus, *Diane Arbus Monograph*, p. 13.

71. Debord, p. 43.

72. Arbus, *Diane Arbus Monograph*, p. 2.

73. In 1976, she bought Arbus's "A family on their lawn one Sunday in Westchester, N.Y.", 1968, 7th unnumbered image in the *Diane Arbus Monograph*. Eventually, she would own all the photographs illustrated in that publication (Arbus printer, Neil Selkirk's set), as well as all those in *Diane Arbus Magazine Work*.

74. Arbus, *Diane Arbus Monograph*, p. 5.

75. Family Papers.

76. In the film's sound track. Ironically, the film, made in 1975-1976 by Gay Block and Linda May was titled *A Tribute to Spirit: the Beth Israel Experience*. Family Papers.

77. Text in Gay Block, *Bertha Alyce*, p. 30.

78. Gay knew Chopin's book. She found younger versions of the same overpowering sadness later, in 1981, when she photographed the girls at Pinecliffe, her summer camp in Maine, where for seven years she had also sent her own daughter. The girls are beautiful and cold. No one smiles. Each is an impenetrable bulwark against psychic pain and isolation. As she portrays their ungenerous bearing, they seem destined to become the kinds of absent mothers she feared and detests.

79. From "Possessed," *The Dead and the Living, Poems by Sharon Olds*, New York, Alfred A. Knopf, Publisher, 1991, p. 33.

80. She acquired the Rollei on the advice of Aaron Siskind who told her to stop trying to make portraits with a 4x5.

81. Olds, "Possessed," p. 33.

82. Text in Gay Block, *Bertha Alyce*, pp. 21, 22.

83. *Diane Arbus Magazine Work*, p. 69.

84. Sayre, quoting Howard N. Fox, p. 9; and note 16, p. 272.

85. Arbus, *Diane Arbus Monograph*, pp. 1-2.

86. Roland Barthes, *Camera Lucida, Reflections on Photography*, trans. Richard Howard, New York, Hill and Wang, 1981, p. 13.

87. Sayre, p. 60.

88. *Ibid.*, p. 65.

89. Quoted in *Ibid.*, pp. 192-193.

90. *Ibid.*, p. 17. Using photographic ritual and narrative to portray engaged communities became one of Gay's and her partner, Malka Drucker's, consuming interests. See Gay Block and Malka Drucker, *Rescuers: Portraits of Moral Courage in the Holocaust*, prologue by Cynthia Ozick, New York, Holmes & Meier Publishers, Inc., 1992. In their current project Gay is photographing and Malka is rendering the stories of a vast community of women spiritual leaders in America.

91. Sayre, p. 25.

92. *Ibid.*, p. 203. Holzer began the *Truisms* in 1978.

93. *Ibid.*, p. 198.

94. Debord, p. 115.

95. *Ibid*., p. 153.

96. *Ibid*., p. 106.

97. See note 25.

98. As a former Houston resident, Gay would have known it directly since it belongs to The Menil Collection there. See exhibition catalogue, *Magritte*, text by Sarah Whitfield, London, The South Bank Centre, 1992 cat. no. 63, and color illus.

99. *Women Who Run with the Wolves*, p. 269.

100. See note 1.

101. Estés, pp. 268-269.

102. Louise Erdrich, *The Blue Jay's Dance*, New York, HarperPerenniel, Division of HarperCollinsPublishers, 1996, p. 104.

Printed and bound by Sung In Printing Korea, Ltd.

Text set in Frutiger and Sabon

Art direction by Cynthia Madansky

Production by Dolly Meieran

Scanning by Sung In Printing Korea, Ltd.,
Wendy Young, and Dianne Stromberg

DVD produced by National Tape and Disc Corp.